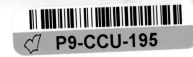
To my JC.
♡ Mum
5-11-92

How to
Improve Your
Photography

A guide to seeing and making better pictures

HPBooks

How to
Improve Your Photography
A guide to seeing and making better pictures

Notice: This material was first published in England in the magazine You and Your Camera, produced by Eaglemoss Publications Limited. It has been adapted and re-edited for North America by HPBooks. Some of this material has also appeared in three smaller books from HPBooks: **How to Compose Better Photos, How to Use Light Creatively,** and **How to Make Better Color Photos.** The information contained in this book is true and complete to the best of our knowledge. All recommendations are made without any guarantees on the part of Eaglemoss Publications Limited or Price Stern Sloan. The publishers disclaim all liability in connection with the use of this information.

Published by HPBooks, a division of Price Stern Sloan, Inc.
11150 Olympic Boulevard, Suite 650
Los Angeles, CA 90064
ISBN: 0-89586-121-6 Library of Congress Catalog No. 81-83084
© 1981 Price Stern Sloan, Inc.
12 11 10 9 8
Printed by Dong-A Printing Co. Ltd; Seoul, Korea, Represented by Codra Enterprises

©1981 Eaglemoss Publications Ltd., 7 Cromwell Road, London SW7 2HR England

Book Editor: Caroline Ollard
Editors: Christopher Angeloglou, Jack Schofield
Art Director: Carol Collins
Contributing Editors: John Bell, David Brown, Michael Busselle, Laurence Esher, Richard Greenhill, David Kilpatrick, Ken Kirkwood, Barry Lewis, David Pratt, David Reed, Ekhart Van Houten, Suzanne Walker

Cover Photo: COMSTOCK INC./Tom Grill

Contents

Pictures with Purpose

You will probably be disappointed with your pictures if you can't remember why you bothered to take them. When you have a photographic goal in mind, you will expose, compose, and control the light to do photographic "justice" to the scene that first attracted you.

A good photo shows the viewer the things that captured *your* interest and compelled *you* to make the picture. You use the photo to communicate your interpretation of a scene, an event, an object or a person's appearance.

Sometimes this is not as easy as it seems. What you do is take the three-dimensional world and limit it by recording it onto two dimensions. There is no sound, no taste, no scent, no touch. The photo is a visual message only. The basic challenge of photography is to catch the viewer's interest and communicate something by your choice of composition, viewpoint, lighting, and exposure.

SEE THE SUBJECT

When you are attracted to a scene and want to photograph it, decide what interests you most. Ask yourself some questions about what you see. What do you want to record? Is it the color, the graphic design, the interplay of light and shadow, subject movement, the mood of the scene, the way the subject looks?

When you have the answers, you can concentrate on getting those elements on film and excluding others. The photographic decisions that help you do this are made *after* you decide what you like in the scene. This book will help you make these decisions to get the picture you want.

See the Center of Interest—Isolate the most important element in the scene. If the subject is a landscape, for example, is it a line of distant hills that pleases you most? Is it the effect of the sunlight on the trees? Or, are you attracted by a cloud formation?

When you know what you like best in a scene with many elements, make that the center of interest in your picture. It doesn't have to be in the center of the frame, however. The viewer of the photo should *also* interpret that element as the main subject, regardless of where it's located within the frame. Other elements should support the center of interest. This is what makes a good photo.

To do this you must learn to see your subject *objectively*, just as a camera does. When we look at a scene, we tend to concentrate on areas that interest us most, ignoring things we don't want to see. Your impression of a scene can also be affected by your mood, past experiences, and surrounding sights, sounds, and smells. A camera lens can't do this. It "sees" whatever is in its field of view. When you are composing the scene while looking through the camera viewfinder, be sure to exclude irrelevant or confusing elements

▼▶ A common fault with many photographs is that they are made from too far away from the center of interest, and from the wrong angle. Sometimes, the background is confusing.

All of these criticisms apply to the photograph below. The flamingo's back is turned and the background is neither sharp enough to show detail nor blurred enough to be unobtrusive.

The photo at right, made with a telephoto lens, is much better because the center of interest is obvious. Shapes and bright colors show well. Even if you don't have more than one lens, you should find a viewpoint that gives the photo you want. The photo at far right also shows a good view of the flamingoes, and accentuates color and design.

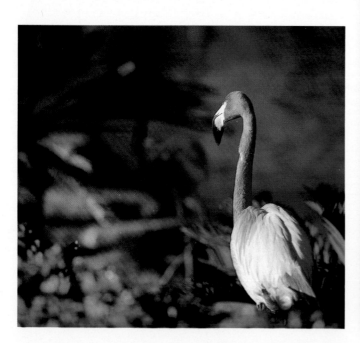

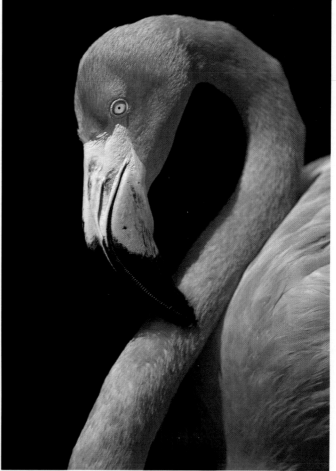

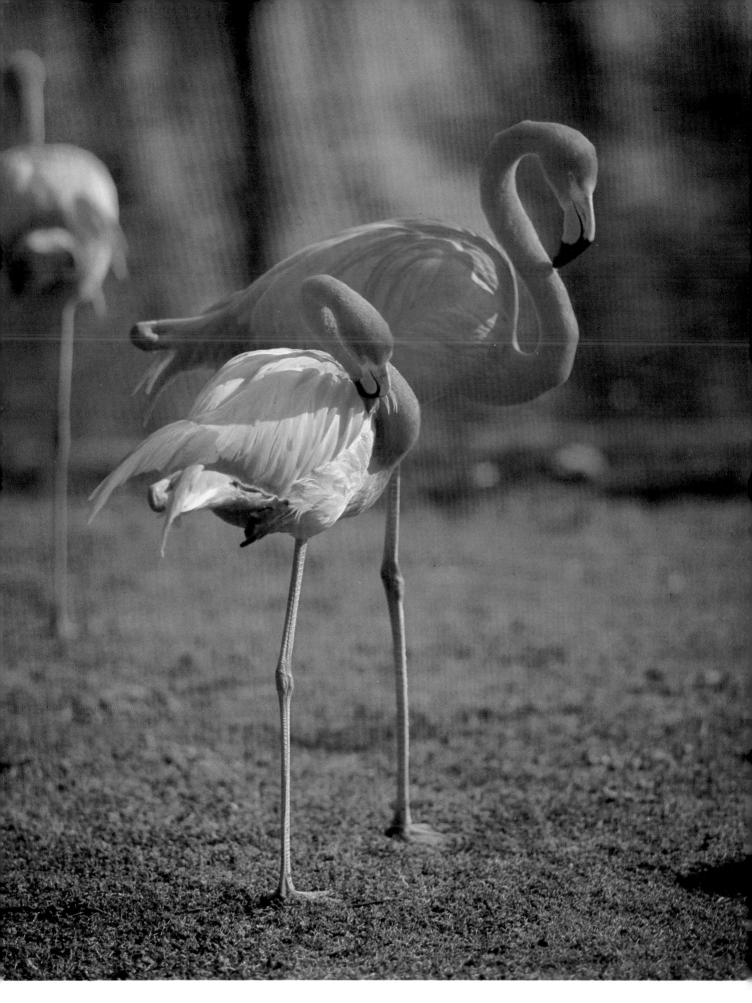

that detract from what you perceive as the center of interest.

The Reason for the Picture—You should also know *why* you want to capture the scene on film. Are you photographing for your own enjoyment? Are you recording an important event? Is the picture for someone else? The answers may affect the way you make the photograph.

For example, do you want to stress the mood the environment puts you in or only the geographical details of the landscape? The first treatment is an artistic interpretation that will affect the emotions of the viewer. The second is more straightforward and reportorial. You have to use filtration, films, lenses and composition for the results you want.

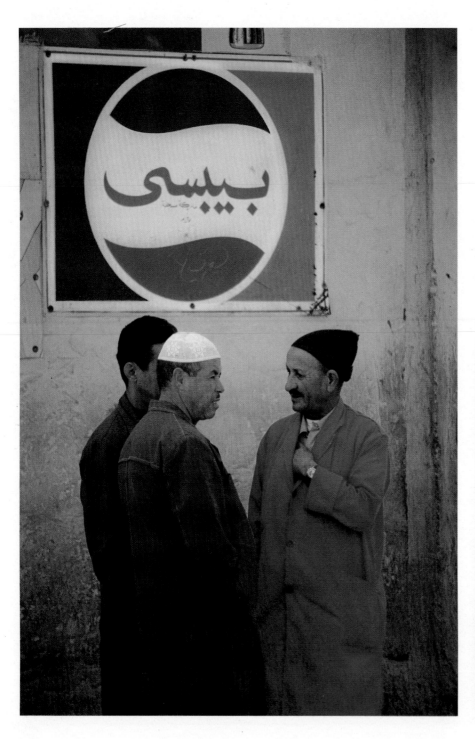

In this scene Michael Busselle was attracted by the group of people and the relationship between the traditional colors of their clothing and those of the modern poster. The picture below does not communicate this at all. It doesn't stress the center of interest. By moving in closer and excluding unnecessary elements to make the picture at left, he conveyed his message. When in doubt, keep the image simple.

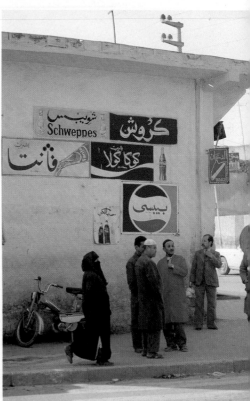

The photo at right has effective composition and good exposure. However, it has a poorly defined center of interest. The photo below benefits from a longer-focal-length lens and the striking contrast of the open doors to the rest of the scene. They help define the center of interest.

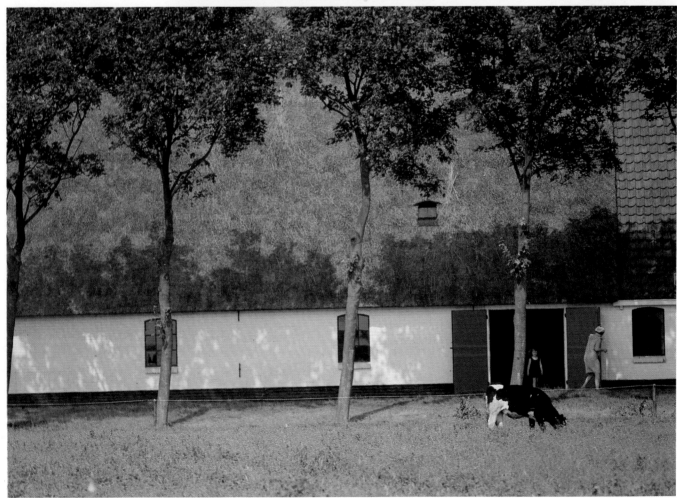

▶Many of our reactions to color depend on how it appears in nature. Red, orange and yellow are considered warm colors because we associate them with the sun. We can almost feel the heat of a picture when these colors are included. Photo by Alex Langley.

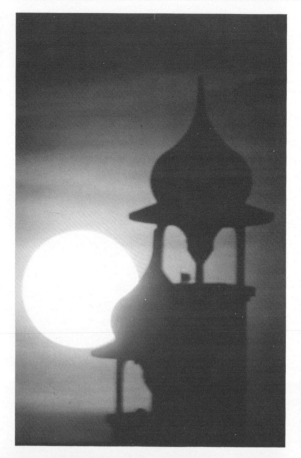

▲The blue shadows of this picture are due to light from a blue sky. We often see this with snow and ice, so we think of blue as a cold color. Photo by Ernst Haas.

◀ Careful selection of viewpoint eliminated distracting areas of color that would have conflicted with the mood of this scene.

▶No dominant mood is apparent in this picture by Suzanne Hill. Although the gaiety of the flowers is apparent at first, the darkness of the water and background creates a somber feeling.

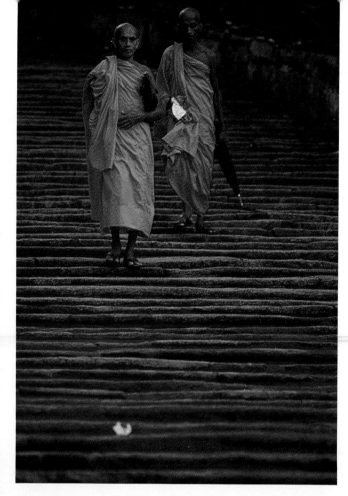

▲To create the appropriate mood for this picture, John Garrett surrounded the subjects with plenty of space. Slight underexposure strengthened the color of the robes, emphasizing the dark, somber background.

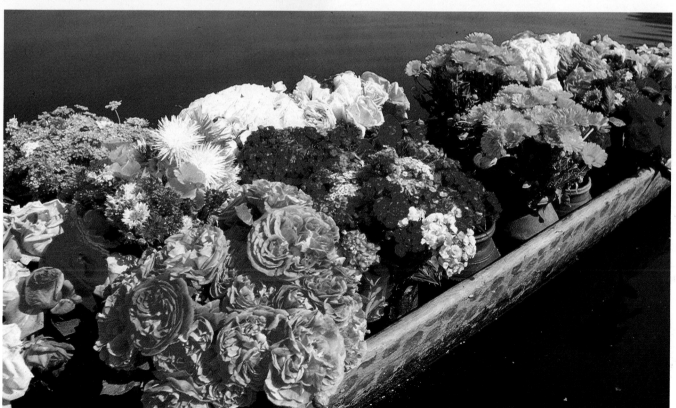

Composing the Picture 1

Contents

Composing in the Viewfinder

The panoramic view on the right is very much as people see it—but we subconsciously focus on certain details as our eyes scan across the landscape. What each person notices is very much a personal choice—it may be the form of a particular tree, the pattern made by branches, or the position of a figure.

When you take a photograph you make two decisions—*what* to include and *when* to press the shutter button. For both, you should consider how to compose the picture—in other words, how to show the subject in the most effective way.

Good composition may mean simplifying your photograph by changing viewpoint—moving higher, lower or to one side. Certainly it means thinking about the direction and quality of the light. Composition makes the difference between a photograph that is muddled or boring, and one that looks right.

HOW TO SEE BETTER PICTURES

Some people have a natural ability to see good composition right away, but most of us have to keep looking and experimenting until we start seeing well-composed photographs. Remember, this is something anyone can do, no matter how simple or elaborate the camera.

Photography is concerned with showing how the world appears as shown in a rectangular or square area on a flat piece of photographic paper. The question is, which parts of the scene or view should you include or leave out? This depends not only on the main center of interest, but also on the visual appeal of shapes, colors, patterns and textures. Moving around while looking through the viewfinder helps you emphasize important aspects and isolate them from the overall view.

Look also at the way objects may be "cut" by the edges of the picture. The hard lines at the edges of the viewfinder give a definite border to what you select. In a photograph you might cut part of your subject, or you can use this border to contain entire subject. This is another difference between seeing the scene as the human eye sees it and composing it for a photograph.

To become more aware of composition, it is helpful to make a cardboard viewing frame. Then look through it at familiar objects, such as parts of your home, people's faces or landscapes. By imposing this frame on what you see, you'll start to discover interesting "pictures" you may not have noticed before.

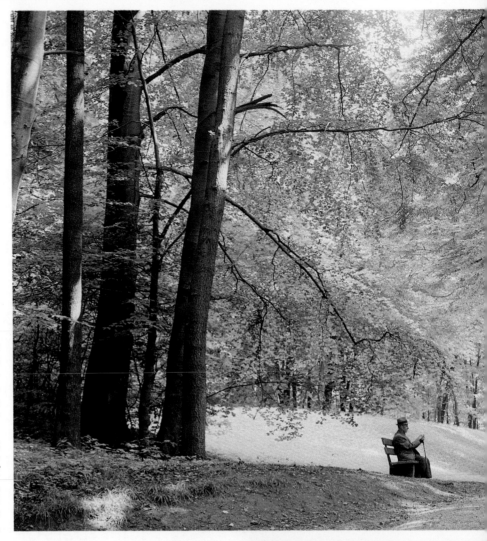

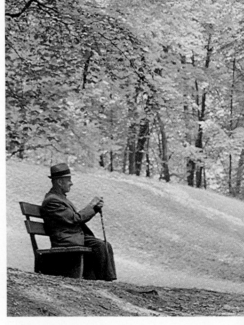

▲▶ You can choose which part of a general view to include in the picture. With a static scene such as a landscape, you have time for careful composition in the viewfinder. Experiment by changing camera position and moving closer to parts of the scene to find out how this affects what you see in the viewfinder. Photographing people in a landscape gives a sense of scale and often contributes to the balance and interest of the composition.

▶ Center: Showing a detail may say as much about a scene as the larger view. In a woodland, the fresh green leaves of spring create an unforgettable image, so why not move in and capture that quality by filling the frame with it? The skill is seeing the detail and then isolating it from the overall view.

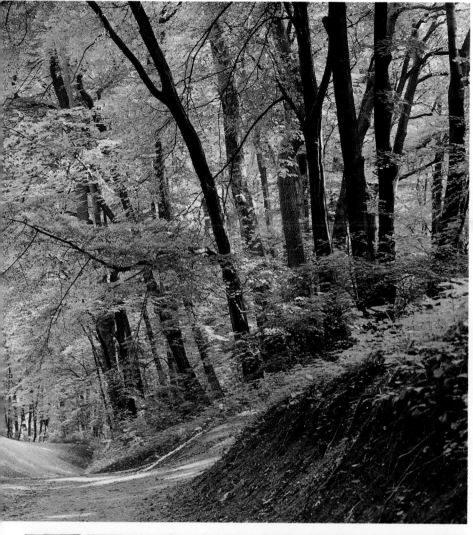

▼ Tall trees are best represented in a vertical format. By moving in close, you can emphasize the soaring quality of the trees, patterns of light and shade, and rough texture of bark against a lacy canopy of leaves. You can later strengthen the vertical shape as shown here by trimming the print, or *cropping,* to make a narrower shape than the original film format.

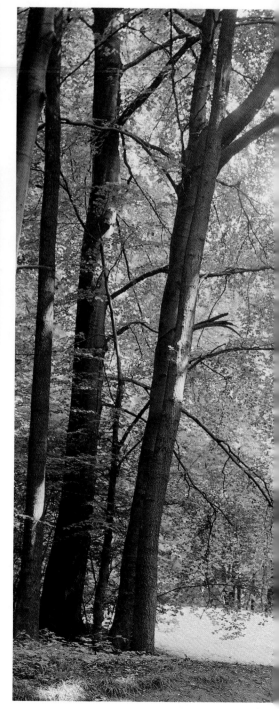

USING A VIEWFINDER

Some people find the camera viewfinder awkward and inhibiting—a mechanical block between them and the subject. Using a cardboard viewing frame to find an image you like can help you compose better.

Whether you use a viewing frame or the camera viewfinder, this section will help you explore the effects of changing viewpoint. Following sections show how to compose more complicated photographs of people, buildings and landscapes.

Start by looking at just one simple object and *seeing* it as divided into three main elements—the *subject*, the *rectangle or square* imposed by the picture format and the *spaces around the subject*.

As you look at the subject, notice the importance of the spaces surrounding it—both the shapes they make and the way the shadows fall. The strength, position and shape of the shadows help define the subject's three-dimensional form.

CHOOSING A TEST SUBJECT

This will depend on how close the camera lens can get to the subject. Check the minimum focusing distance of the lens, then pick something that fills the viewfinder. If you can get as close as 18 inches (45cm), you might choose a cup and saucer. If the minimum distance is about three feet (90cm), choose something larger with an interesting shape, such as a lamp or a watering can.

Try to choose a neutral background that does not interfere with your perception of

LONG VIEW
Start by looking at the subject from as far away as possible. Then keep moving in, searching for the right balance between the subject and the space around it. A long view has a different mood than a close-up.

CLOSE-UP
Move in until the subject fills the frame. Visualize this with both horizontal and vertical formats. The closer you get, the more you become aware of shape, and how light and shadow give the subject form.

DETAIL
Move as close as your camera lens will allow. While looking through the viewfinder, move the camera to try different compositions. Interesting lines, textures and patterns may emerge.

the subject. You may be able to isolate the subject from distracting surroundings by placing the subject on or in front of a large piece of background paper, in an empty room, on a white sheet or on your lawn. Position the subject so it is lit by natural light from the side. Unless you are experienced with electronic flash, don't use it at this point. The light has such short duration that you can't be sure what effect it will create.

With a simple subject like a chair, you have two choices in finding a point of view—either move the subject or move the camera. It's a good idea to get into the habit of moving the camera rather than the subject. Thus, when you photograph an immovable object such as a tree or building, you will be accustomed to finding the best viewpoint by moving yourself rather than the subject.

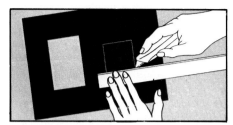 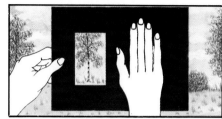

THE VIEWING FRAME
This will help you see better pictures. You can use a plastic slide mount, but a larger, black cardboard frame is easier to handle and helps isolate the subject better. To make a cardboard frame, you need a steel ruler, a piece of matte black cardboard, a sharp knife and a pencil.

On the black side of the card, in separate areas, draw a rectangle in the proportion of 2:3, such as 2x3 inches (5x7.5cm), and a square with 1 inch (25mm) sides. Cut on the black side of the card along the edge of the ruler so the edges are clean.

View from the black side. Close one eye and look through the frame at the subject, moving the frame toward and away from you until the subject is framed in a pleasing way. Everyday objects make effective pictures when they are well composed, and background clutter is minimized.

THE FORMAT
There are two photographic formats—square and rectangular. The size of the rectangle varies, but the 2:3 proportion applies closely to 35mm and 110-size film formats. If you have viewing frames in both shapes, you can compare the effects of the square and rectangular formats—a point to consider if you buy another camera with a different format. Some people are devoted to one format and find it hard to work with the other. Start by looking at the subject from the same viewpoint through one frame and then the other. Of course, you should try the rectangular format both vertically and horizontally.

 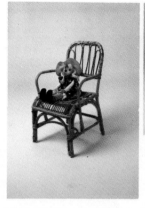 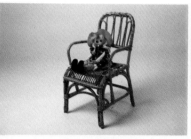 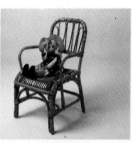

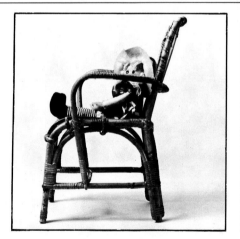 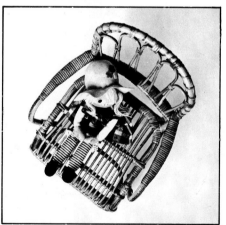 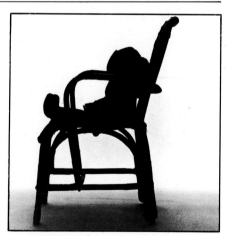

LOW LEVEL VIEW
Now try a lower viewpoint: Does the subject look best from ground level or a little higher? Is the subject identifiable? Should you move around to find a better vantage point?

FROM ABOVE
Use a chair or stepladder to look straight down at the subject. Shapes and outlines change form and the ground or floor becomes the background. This view gets immediate attention because it is unusual.

SILHOUETTE
Arrange the lighting so the background is brighter than the subject and then adjust the viewpoint until you see the most satisfactory silhouette. Notice how this simplifies the photograph by presenting only the essential shapes.

Where to Put the Horizon

In photography, as in painting, the horizon is an important element for emphasizing the subject and balancing the picture as a whole. The horizon also gives a sense of scale to a landscape, whether it is a towering mountain range or a smooth, glassy sea. The way you balance the composition adds to the visual impact of what you are trying to convey.

HORIZONTAL OR VERTICAL?

Most cameras produce images in a rectangular format. This gives you a choice between composing *horizontal* or *vertical* photographs.

Horizontal photographs have the horizon parallel to the long side of the picture. This emphasizes the space from left to right. The viewer's gaze follows along the horizon the same way you scan words on a page. This gives horizontal photographs a sense of "wide open spaces," but you need to include some foreground objects to give the picture a feeling of scale and perspective.

Vertical photographs can convey a feeling of depth, depending on how the horizon is handled. You tend to "read" the scene from the foreground back, and then up to the sky. With a high viewpoint, you can normally include a lot of detail in this type of composition because the landscape appears to extend from the viewer's feet up to the horizon and sky.

When photographing a landscape, practice composing both horizontally and vertically through the viewfinder or viewing frame.

WHERE TO PUT THE HORIZON

The classic "comfortable" position for the horizon is a third of the way down the frame. But if you want to create a more dramatic effect, position the skyline higher, lower or in the middle.

▶ Locating the horizon one-third of the way from the top of the picture gives a comfortable, but rather predictable, result.

The four photographs at the bottom of these pages show the effects of positioning the horizon. From left to right:

With no horizon, the subject is isolated and given prominence.

With the horizon in view, the subject is placed in its setting.

A larger sky area is often dramatic, but this halfway split can be an uneasy compromise.

A low horizon makes full use of the sky's dramatic potential without detracting from the subject.

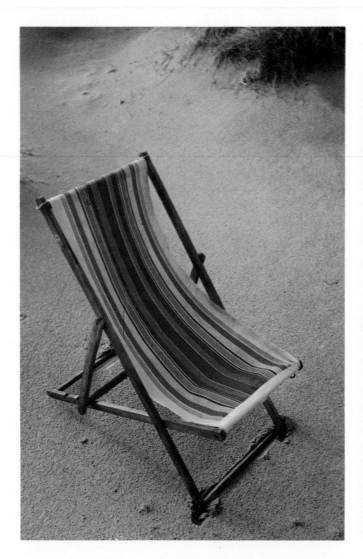

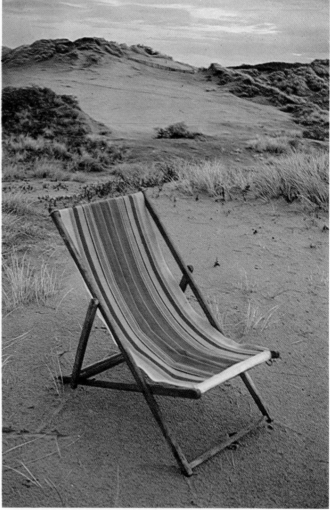

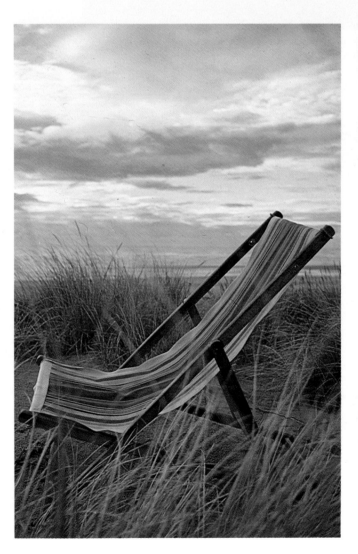

1/3

2/3

THE CLASSIC SOLUTION

Most Western painters from the Renaissance up to the end of the 19th century were preoccupied with breaking landscapes down into foreground, middle distance, background and sky. One of the formulas they developed, based on a ratio of one-third sky to two-thirds land, is still useful in composing photographs. No one quite knows why, but this proportion gives a harmonious, satisfying balance to most pictures. Whenever the photographer breaks away from this classic formula, he probably—either consciously or unconsciously—intends to create a more emphatic picture.

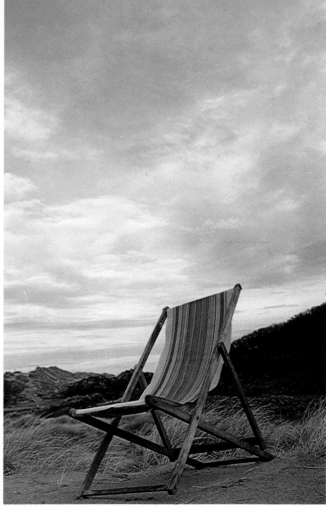

◀ Far left: Here you see a centered subject and classic horizon. Emphasis would differ with a lower horizon. Photo by Spike Powell.

◀ The centrally placed horizon combines with bold vertical and horizontal lines to give balance to this urban landscape. Photo by John Bulmer.

▶ Here foreground is the subject; the horizon simply acts as the end of the picture. Photo by Barry Lewis.

▼ In this landscape, the low horizon places the emphasis on the sky. The house is balanced by the cloud mass. Photo by John Bulmer.

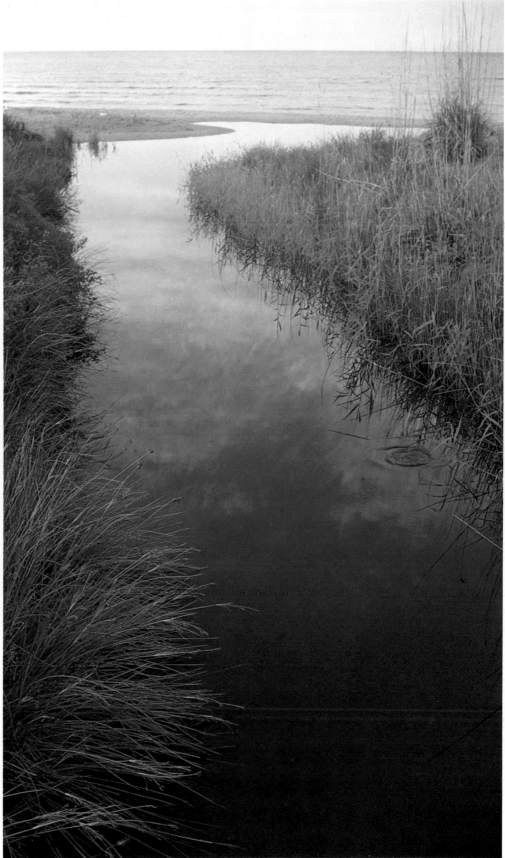

Using the Background

Many amateur photographers concentrate most of their attention on the main subject, with little thought for the background. Yet the background can be of vital importance—a cluttered or intrusive one can ruin a perfectly good photograph. When the background adds something to the subject, it can make the overall image more meaningful.

Watch for three main things about the background—*false attachments, competitive elements* and *intrusive light or color.*

FALSE ATTACHMENTS

When people appear to have lamp posts sprouting from their heads, or branches growing out of their ears, these are "false attachments." It's easy to miss these when looking through the finder. If you notice it, move the camera until the "attachment" separates from the subject.

COMPETITIVE BACKGROUNDS

These include the kind of general confusion or jumble that you should be able to

◀ The small picture at the bottom of page 26 shows what can happen if the background is left to take care of itself—the girl disappears into the muddle and the photographer has inadvertently included his own reflection in the mirror. In the larger photograph on the same page, Homer Sykes moved the toymaker away from the messy part of the background and asked him to stand so his head was clear of the paraphernalia on the shelf.

▶ If you are using large depth of field, look carefully at the background. The chimney growing out of the subject's head is typical of the "false attachments" hidden in many backgrounds. A slight shift of camera position would have avoided this. Photo by Tony Evans.

▼ Subjects with complicated patterns or shapes can merge into a patterned background and become confusing. Put the wallpaper out of focus by using a large aperture; the flowers then stand out from the background. Check the depth-of-field scale and viewfinder image to make sure you have the zone of sharpness you need. Photo by Colin Barker.

eliminate. If you cannot rearrange the background, you will have to move the subject, but there are many cases where you do not have such control over the subject, such as in candid photography or when you are photographing something immovable like a statue or a building. In such instances, try altering the viewpoint. This may also help to solve tonal problems, such as when a statue seems to merge into the trees behind it instead of standing out.

INTRUSIVE LIGHT OR COLOR

Light or color can also distract from the main subject. In a scene there might be a strong light source that draws your eye away from the main subject. Or perhaps an area of strong color, such as a bright curtain, dominates the scene when the subject is wearing muted, delicate colors. Here again, the answer may be to move either the subject or the camera. Alternatively, you can put the background out of focus by reducing depth of field.

Become aware of these distractions. Do this *before* you take the picture. To handle backgrounds successfully so they contribute to the overall effect of the photograph, consider them as part of the picture you see in the viewfinder. The background should not be an afterthought, but an integral part of the composition.

▼ The two photos below show how an intrusive spot of color in the background distracts the viewer from the subject. Although the background is intentionally out of focus, the bright yellow spot commands your attention first. Omit the splash of yellow and you are attracted straight to the subject. Photo by Homer Sykes.

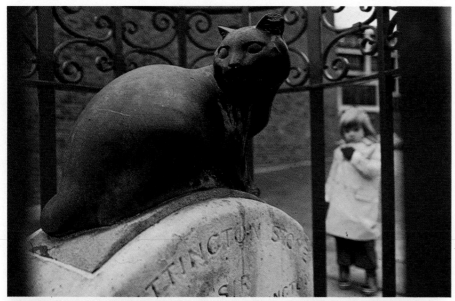

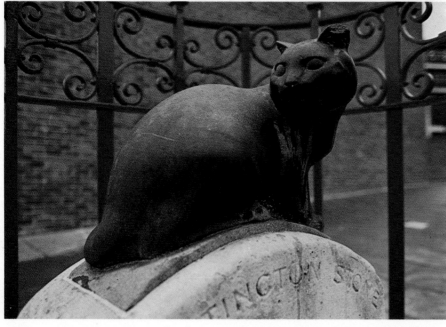

◄ The combination of a gray subject and poor light means that the subject merges into the background and details are obscured.

▼ Poor lighting caused the subject to disappear into the background in this photo of the New York skyline. However, in the middle, the sunlight has highlighted a group of buildings and lifted them out of the monotone of the background. Photo by Tomas Sennett.

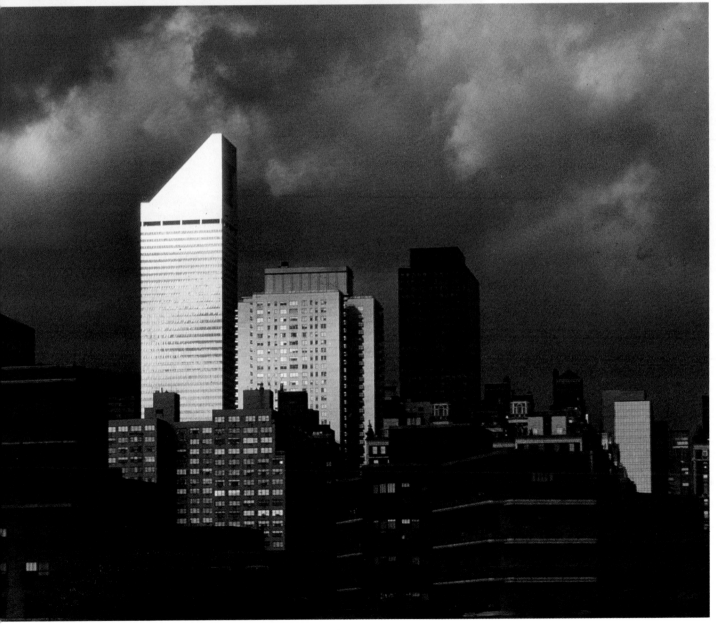

Using the Foreground

It is too easy to think carefully about the background before taking a picture—and then leave the foreground to take care of itself. Often the result is that distracting foreground objects seem to appear from nowhere to upset the balance of the picture. You have to decide whether the foreground is important and, if so, how much of it should appear in the photograph. Many successful photographs have no foregrounds, but these are usually of subjects fairly close to the camera.

USING THE FOREGROUND

Constructive use of the foreground is an important compositional tool. It can add emphasis and balance, and tell more about the subject. If the perfect foreground is not immediately obvious, it may be simply a question of altering the viewpoint to include a wall, a hedge or some other object close to the camera.

You can also use foreground to give more information about the subject, especially when photographing people. This technique of *environmental portraiture* is done by including plants and flowers in a photograph of a florist or a stack of books with an author.

CREATING DEPTH

Proper use of foreground can also introduce an impression of depth and scale to photographs. This is especially important in landscape photography, where foreground makes the picture start right at your feet, rather than in the middle distance. If you include a ridge of grass at the front of a seascape with a distant fishing boat, the viewer subconsciously relates one to the other and perceives both distance and relative size.

▶ This photograph succeeds because of its composition. The sharp foreground tells a story and builds up the striking pattern of shapes and colors. Photo by Patrick Thurston.

▶ Far right: Notice how this use of foreground brings the viewer "into the picture." Jon Gardey included the foreground to emphasize the feeling of distance. The extreme depth of field also contributes to this impression. Cover the lower half of this photo with your hand and notice how the feeling changes.

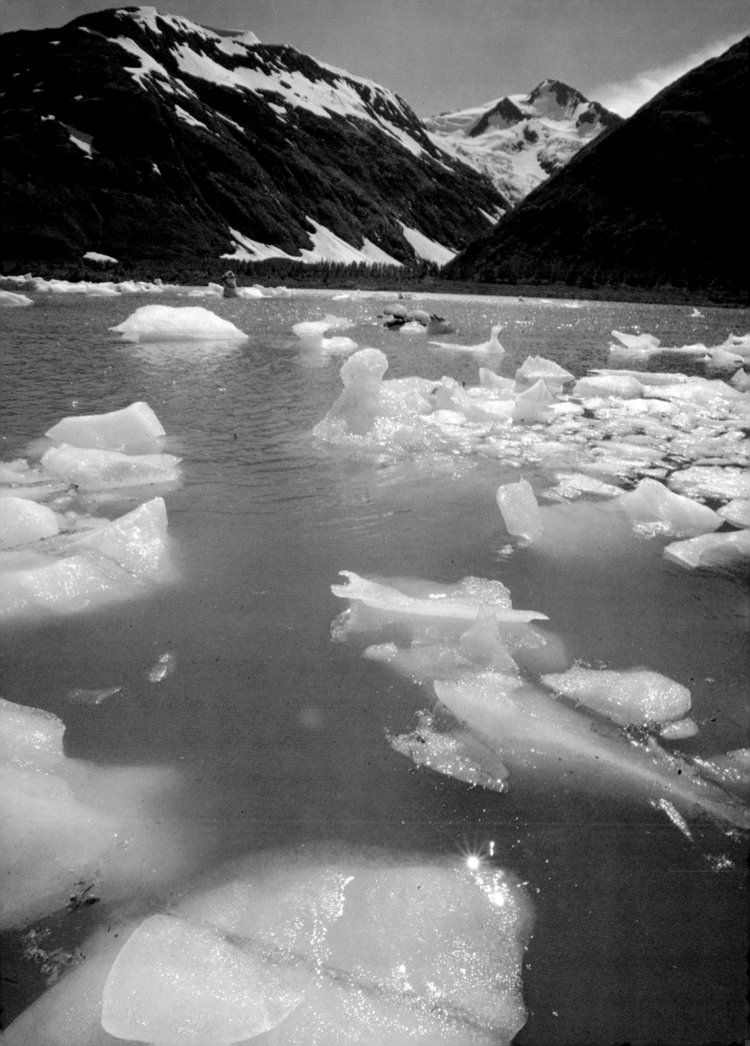

FRAMING WITH FOREGROUND

The foreground does not always have to be confined to the bottom of the picture. It can also create a complete or partial frame for the subject. Doorways, arches or windows are obvious foreground frames. Outdoors, a branch or a pattern of leaves at the top of a picture can be used to block large expanses of uninteresting sky and create a more intimate view. Often these are most effective as silhouettes, showing no detail or texture. This technique also works well with part of the foreground area out of focus, thus preventing the foreground from dominating the picture.

LOSING THE FOREGROUND

There is always the possibility that a prominent foreground will take over or dominate the picture and become distracting. In this case, objects close to the camera appear more defined and larger than distant objects. In the photograph of the ice-filled lake on the preceding page, if you include a boat in the foreground, it might take over and become the main subject. Always be sure of what you want in the photograph.

There are three ways to "lose" the foreground:

1) Change camera position.

2) Use a lens of longer focal length that takes in less of the scene.

3) Reduce depth of field to put the foreground out of focus.

If something in the foreground threatens to become a distraction, you may choose to have it out of focus by using a larger aperture, rather than leave it out of the picture. However, be sure it does not turn into a distracting blur. With many SLR cameras you can use the depth-of-field preview button to see the how sharp the foreground will be.

▶ Out-of-focus foliage in the foreground acts as a frame and adds color. This technique can be effective when photographing people, houses and even landscapes, when the subject might otherwise look isolated. Photo by John Bulmer.

▶ Opposite: Imagine this scene without the arch. Take advantage of things like archways, doorways and foliage as simple but interesting frames to provide a reference point for the viewer. Photo by Robin Laurance.

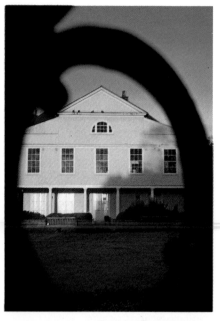

▲ Any clearly shaped object—a gate, window frame, rigging on a boat—can be used as a frame. Here, the house alone looks bare and boring. In the center picture, the gate is too distracting. In the photo at right, the simple, slightly out-of-focus shape does not interfere with the view of the house. Photo by Barry Lewis.

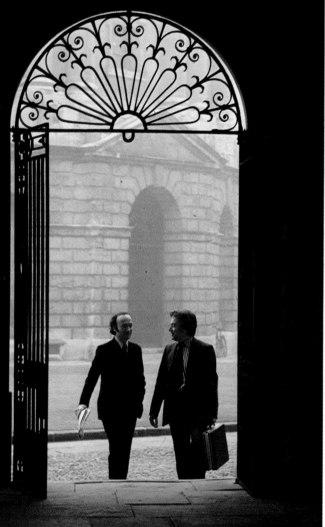

▼ If the wall had been left out of this picture, the stretch of grass in the foreground would have dominated the scene. Including the soft colors of the lichen-covered wall makes an effective "starting point" for the image without overwhelming the horse and the view. Photo by John Bulmer.

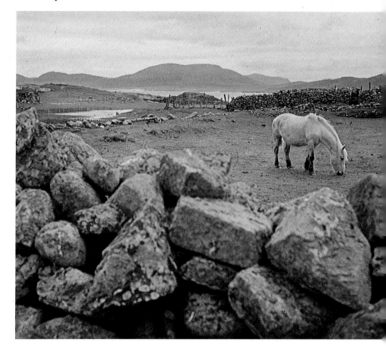

Where to Put the Subject

For many experienced photographers, deciding where to position the subject in the frame is instinctive. But for the beginner, this consideration needs as much attention as the horizon, background and foreground. Guidelines are useful for beginners, but you should soon let yourself react to the subject and not feel inhibited by rules.

The most obvious position for the subject is in the center of the frame, where there is no danger of cutting off the tops of heads or other parts of the subject.

However, a centrally placed subject often results in a dull image. It also means that you may not be filling the frame enough, with the result that the subject is too small in the final print or slide and is dominated by a background that adds little to the photograph.

Even so, a centrally placed subject can work particularly well when the picture has strong geometric lines. This is especially true when the geometric balance is important, such as when photographing architecture.

Most people find they prefer to look at a point just above the geometric center, so consider positioning the most important part of the subject in that area. Then compare the effects of placing it in the geometric center, and in the top or bottom half, to see which is most effective for the particular subject.

▼ The center of the frame is often the most satisfactory location for a round subject. With this much detail, the photo doesn't need any compositional device to hold interest. Photo by Eric Crichton.

▶ This is a strongly geometric composition—rectangular door, triangular ladder and the man centered. The facial expression and the position of the subject's hand add a touch of vitality. Photo by Martin Parr.

▲ Centering the subject tends to make a scene static. But if the subject is shown doing something active, the photo has a dynamic feeling. Photo by Robert Estall.

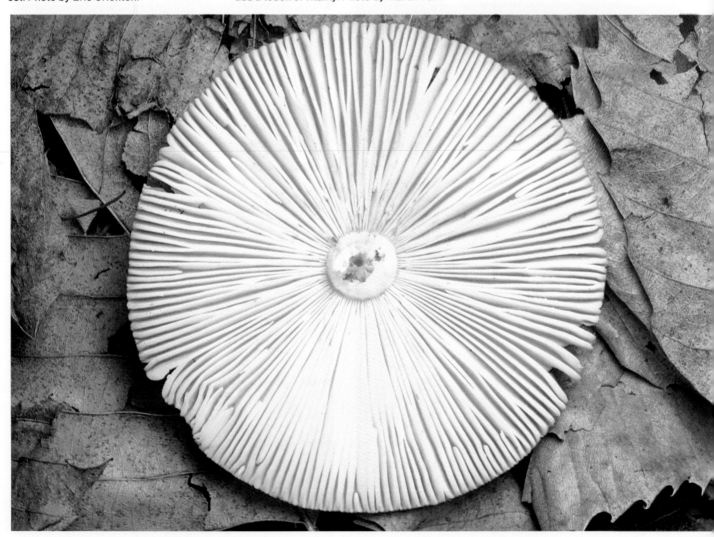

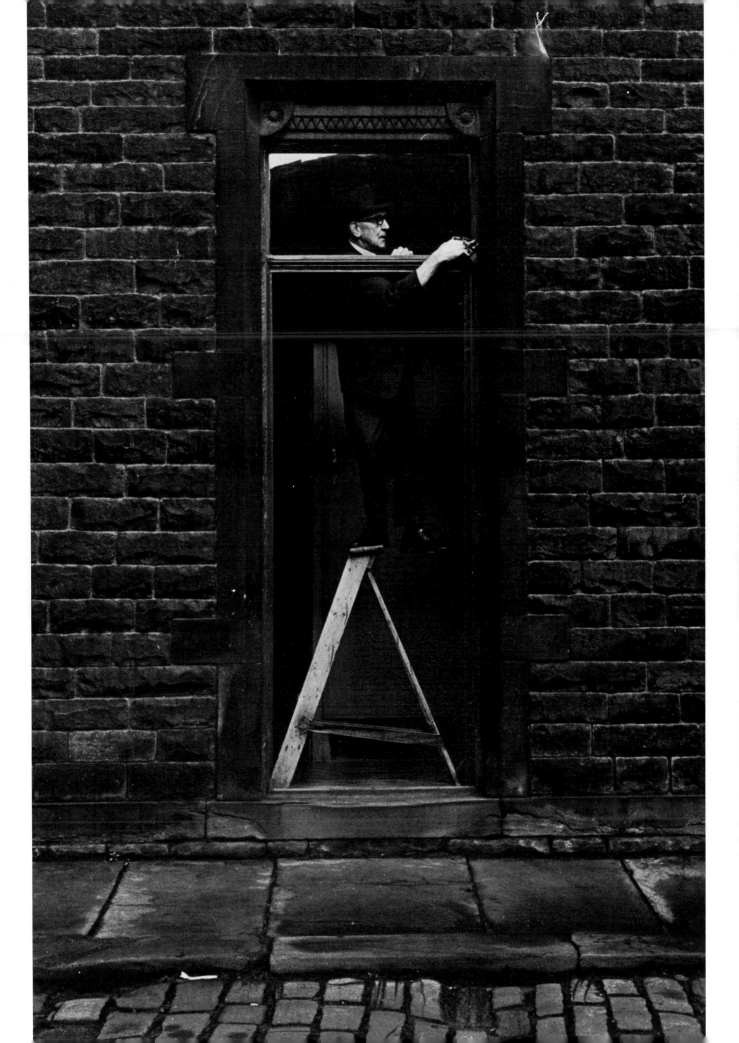

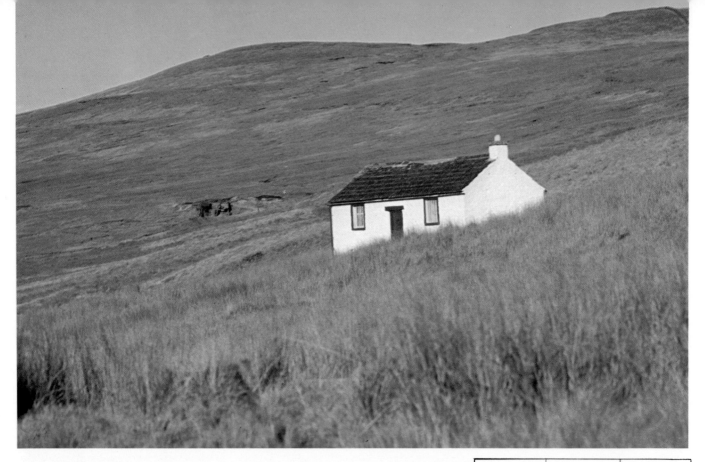

THE INTERSECTION OF THIRDS

The traditional way to produce a balanced, satisfying composition is to use the *intersection of thirds*. Painters have used this formula for centuries, and some photographers find it helpful too. See the accompanying drawings. Don't apply this to *every* picture or you will soon find the results boring and repetitive.

If you have a subject such as a tree, person or chair, start by positioning it on one of the two vertical grid lines. This location often results in a more satisfactory composition.

Next, imagine that the scene is divided into horizontal *and* vertical thirds. The intersection of the lines produces four *ideal* points on which to position the subject.

▲ The photographs on these two pages are balanced differently to suit either the shape or mood of the subject. Landscapes are easy to experiment with because they do not move. This house is positioned on a vertical third. Visualize how the picture would look with the house a little higher or lower, or positioned on a different intersection. Photo by John Bulmer.

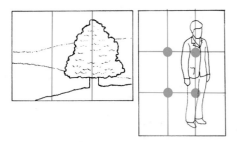

The diagrams above show the vertical thirds and the four intersections of thirds.

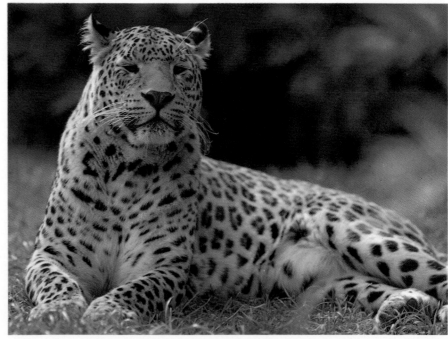

▶ When composing the picture in the viewfinder, try altering camera position. With a still subject, take more than one photograph and try arranging the composition differently. Here, Bryn Campbell used the strong rectangular shapes to dominate the image. But your attention is immediately drawn to the placement of the head.

◀ The position of this animal, combined with the rule of thirds, makes a photo with impact. The head and shoulders dominate the compositon. A lower placement of the head would have included distracting background, producing a weaker picture. Photo by Eric Stoye.

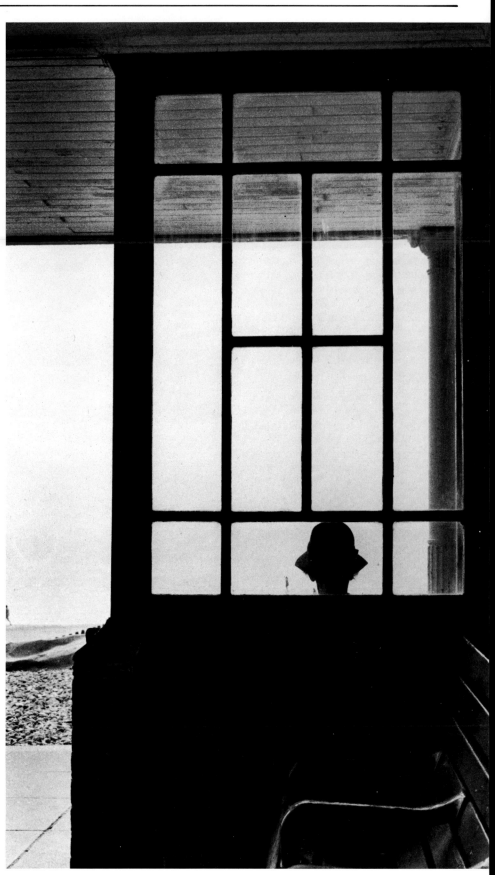

EMPHATIC ALTERNATIVES

Placing a subject off center in any direction is one of many ways to create emphasis in a photograph—to make the viewer look straight at the subject. At first glance, Tomas Sennett's photograph of the family group on the facing page might seem totally unbalanced, with the figures pushed to the side of the frame. But in fact, the group is carefully balanced by the expanse of sea, which also places them in natural surroundings.

Similarly, Roland Michaud's image of the Tibetan monk positioned on one side of the frame is a satisfying, well-balanced composition because the subject is looking *into* the picture. By closing in on the head, the photographer leaves no doubt where the center of interest lies.

If you place a subject off center, what happens to the "space" created? In many cases, like the two pictures just discussed, the space becomes a balancing factor in the composition. You can also use it to add information about the subject.

ROOM TO MOVE

There is another important reason for not composing some pictures too tightly. A moving subject seldom looks right if placed in the middle of the frame. Patrick Ward's photograph of the man on a bicycle needs the space on the right. It is not only a question of balance, but also that a moving subject needs space to "move into." This is especially worth remembering in sports photography, although it is often difficult to achieve because your attention is on the action.

Another effect of leaving plenty of space around the subject is to emphasize loneliness or isolation. In such cases, that space is as vital as the subject itself. The photograph of the tractor plowing would be less effective if it had been taken closer—the space emphasizes the scale of the open landscape.

TRY IT ANOTHER WAY

Not every subject should be placed off center. The important thing is to try several alternatives before taking the picture. If you can't move the subject, move the camera. If there is time, make more than one exposure, varying the camera viewpoint or changing the position of the subject. If you can't move yourself or the subject but you can change lenses, try using a lens of different focal length to alter the angle of view.

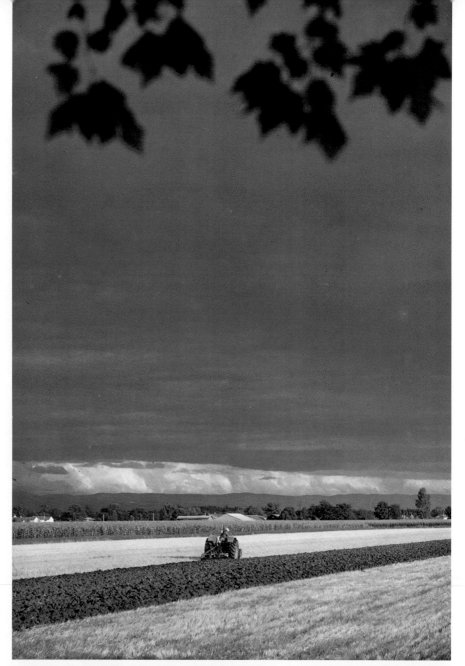

Emphasis is a way of making people notice a picture. This can be achieved by the way the picture is composed or by the way shapes, pattern and color are used. Placement of the subject is one of the most obvious ways of drawing attention. The photographs on these two pages seem to break rules—but all succeed in holding our attention.

◀ Emphasizing the sense of wide-open space with a vast sky.

◀ Emphasizing the monk's gaze by leaving space in front of him.

▶ Emphasizing the importance of the sea in these people's lives.

▼ Emphasizing movement by leaving space for the bicycle to "move into."

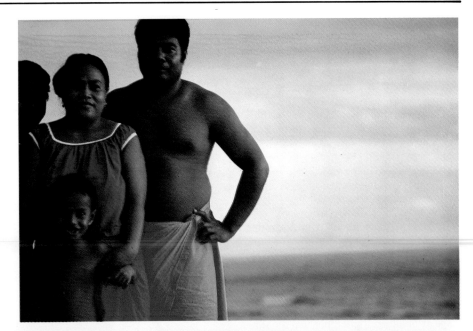

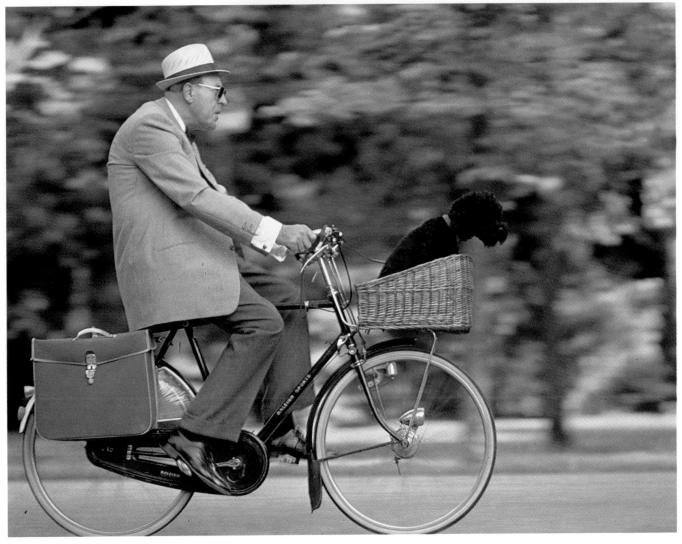

The Edges of the Picture

After you have decided where to place the subject, plan how the content of the picture will relate to the edges of the frame. This involves more than just glancing at the edges of the viewfinder to be sure the image is correctly framed. The common mistake of cutting off heads or feet often results from taking the picture too quickly or being too close to the subject. But apart from such elementary mistakes, how should you decide to crop or frame the picture in the viewfinder?

A good way to discover the different ways of framing is to use a pair of right-angled strips of cardboard when looking at photographs. Place them over the print and move them to vary the composition. To produce the same effect in the camera, move the camera closer to or farther from the subject and change the direction of view. The best way to test this method is to choose a static subject such as a landscape or building. Remember that the simpler the picture, the more likely it is to be strong and effective.

Another way of giving emphasis is by looking at the same subject several different ways. Very tight cropping around a portrait will draw the viewer's eye to the face, or even part of the face, and can strengthen a weak or uninteresting picture. It is a way of leading the viewer straight to the essential point you are trying to make, or of excluding confusing foreground or background detail to make the photograph more explicit.

USE THE EDGES

There is no hard and fast rule of composition that says the edge of the frame must not "cut" into the subject. Often a single detail of a subject or scene can be as strong a way of portraying it as showing the entire subject. Just as in placing the subject, it is a question of the emphasis you desire. There is nothing wrong with getting very close to some subjects.

On the other hand, a building may not look right if you are too close. Move back and allow a little more space around the edges and it looks better. If you move back even farther, the distracting elements on either side may begin to compete with the subject. The picture then ends up with no clear center of interest.

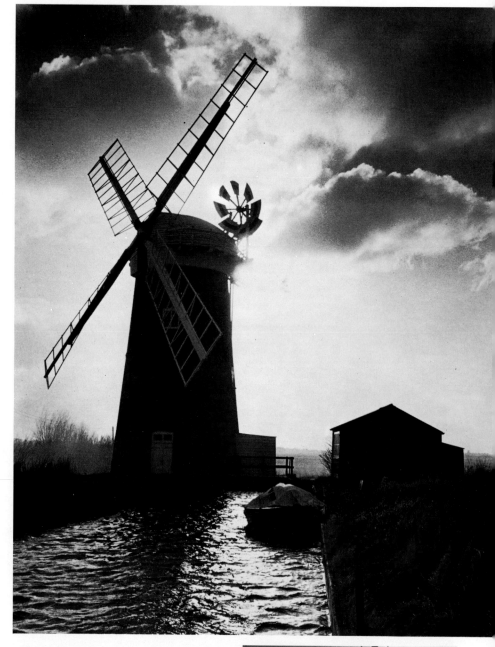

LOOK AT THE TOP
The photograph on the right shows the windmill with the top cut off. Compare it with the picture above that completes the shape, giving "breathing space" to the mill and including enough of the canal in front and the shed on the right to balance the weight of the windmill. Think of these points when photographing any building. Photo by Bill Coleman.

▲ If you are going to "cut off" part of a subject, it is often most effective to do it emphatically. Tomas Sennett used a telephoto lens to avoid distortion and yet get close enough to the subject to create the effect he wanted.

▲ Ask yourself *what* you really want to emphasize. Here, William Wise emphasizes the children. If he had included the father's face, the children would have become less significant and the photo would tell another story.

▼ Obviously, photographer Thomas Hopker was amused by the symmetry of these figures and the repetition of colors and poses. Cropping the heads accentuates the point.

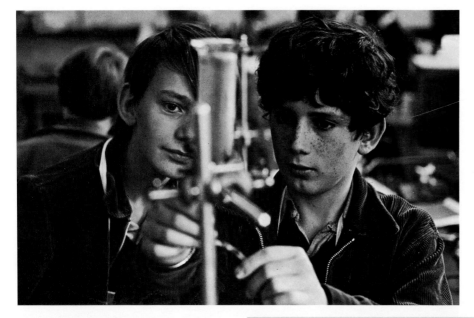

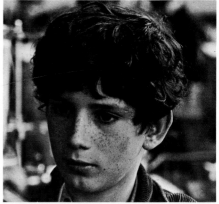

CHANGING THE MEANING
Cropping excludes distracting detail, but can also produce a misleading picture. The boy looks like he's daydreaming in the close-up. In the full frame, he is actually absorbed in an experiment.

MAKING A POINT

How you frame a photograph can establish its meaning or accentuate a specific point. A close crop on the face of the boy shows simply that—a boy's face, out of context. The longer view places the subject in appropriate surroundings, at work in a school laboratory, absorbed in an experiment. The emphasis is changed from a straightforward portrait to one that tells a story.

SIDES OF THE PICTURE
One of the hardest decisions to make is how much detail to leave in at the sides. The maxim, "when in doubt, leave it out," doesn't always apply, as in this photograph. The bank on the right tells you clearly that this is a river scene and not a sea view.

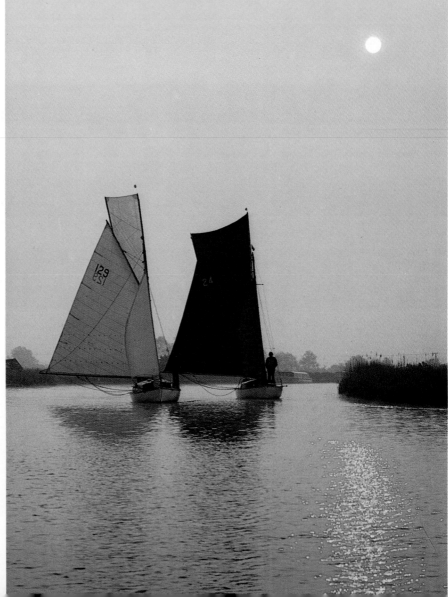

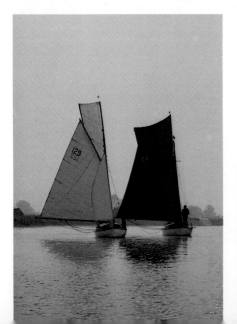

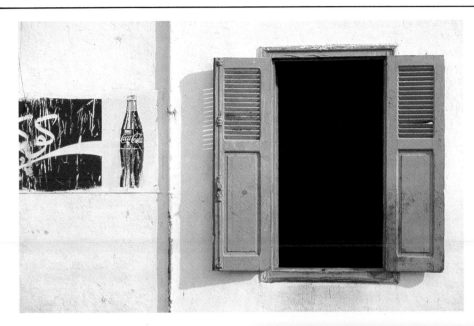

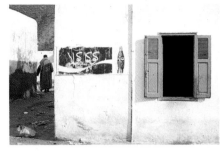

LOOK AT THE EDGES
Composition depends on what you want to emphasize. The small picture above shows a dusty street corner where the viewer hardly knows whether to focus on the poster, the window or the figure around the corner. At left, photographer Michael Busselle decided to leave out the figure and emphasize the pattern, color and "East-meets-West" theme.

EMPHASIS IN PRINTING

It takes practice, luck, experience, intuition or all of these to master the many possibilities of composition for a particular photograph. But if you get it wrong in the camera, you can sometimes adjust the balance or emphasis of a photograph during the enlarging process. Some photographers prefer not to alter the image at this stage, feeling that the way it was seen at the moment it was taken is all important. But for most of us, it is a good opportunity to vary the balance of a composition. This can be done before making the print by changing the framing of the image on the enlarger baseboard for the desired effect.

CROPPING THE FINISHED PRINT

Alternatively, the finished picture can be cropped by trimming. For example, an image of a long, thin subject benefits by being trimmed to this shape. Look at finished prints and see how you can improve them with more imaginative cropping—often by simply removing a disturbing background. A photograph does not have to fit the exact size of the paper any more than the subject must appear in the middle of the frame for good composition.

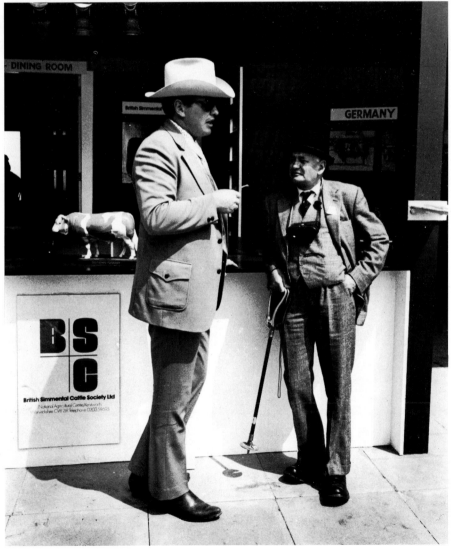

LOOK AT THE BOTTOM
Take a sheet of paper and move it around on this photograph of the two men. How do the figures look if they are cropped at the knees or if the poster is cropped out?

Frame Within a Frame

It is not always possible to fill the frame with the main subject of the photograph. Sometimes, using a longer lens will exclude intruding foreground elements if it is not practical for you to move closer. Or, if you do your own printing, you can enlarge the important part of the photograph and exclude, or *crop*, parts you don't want. If these options aren't available, the photo may lose some impact.

One solution is to find a viewpoint that uses the foreground as a frame around the main subject, as mentioned on page 32. The photo then has a "frame within a frame." The picture's foreground is no longer obtrusive. Instead, it helps the composition by focusing the viewer's attention on the center of interest.

FRAMING BUILDINGS

Uninteresting foregrounds are inherent problems in architectural photography. If you are far enough away from a big building to include all of it, the composition may also include surrounding areas that have little to do with the building. If you move close to the building and aim the camera upward, the building seems to lean backward and has converging verticals.

What to Do—Using an architectural structure as a frame is one way to solve the problem. Arches, doorways or windows are ideal. Their shapes contribute to the purpose of the photo—architectural representation. Converging verticals, when used properly, can even help the composition by pointing to the main subject.

▲Though the gold dome of the mosque is effective against the deep blue sky, the mosque alone did not make a strong picture. Photographer A. Evans solved the problem by moving back to include an arch in the foreground. The arch repeats the roundness of the dome.

◄Here the arch leads your eye to the shadowed foreground stairs, which then lead you to the brighter background. This helps create an impression of depth. Malcolm Aird used a 35mm wide-angle lens.

▶Patrick Thurston used a doorway to frame Exeter Cathedral, and exclude unwanted foreground detail. The apparent lean of the building is matched by the angle of the doorway.

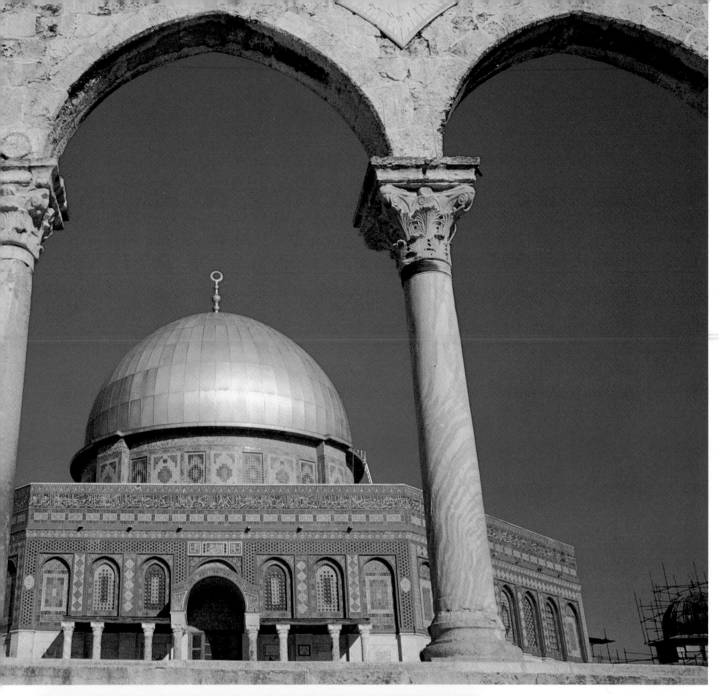

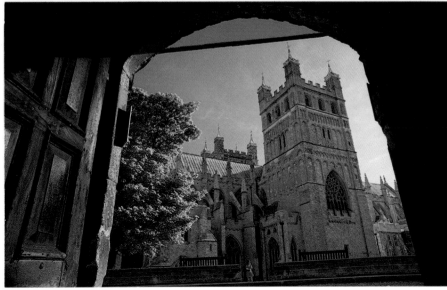

Exposure—If you are using a doorway or an arch to frame your subject, you will often be photographing from the inside looking out. If you expose for the outside light, the interior will be dark because the light is usually much dimmer indoors. This tends to silhouette the frame. On color film, these strong black foreground areas will make other colors seem brighter.

Unless you want a dramatic "keyhole" effect, a silhouetted frame should occupy only a small area of the picture. For best results, meter the main subject when outside. Then, when you move inside, set the camera manually to those settings. If you use an automatic camera, set the *Exposure-Compensation Dial* for one or two steps less exposure.

Otherwise, the dark areas tell the meter that the overall scene is darker than the outdoor light. The meter will recommend exposure settings that will overexpose the outdoor scene.

Other Frames—Trees, iron gates, statues and fountains can be used as frames for architectural subjects. Minimize detail and color in these framing elements. Otherwise, they can draw the viewer's attention away from the main subject. Single colors and simple, predictable shapes are best. If possible, choose a frame that complements the character of the building.

FRAMES FOR PEOPLE

The 35mm frame used horizontally is not always ideal for composing pictures of people. A square format is often worse if the subject is surrounded by empty areas. When faced with this kind of problem, consider using a frame within a frame. Many different kinds are possible.

Doors and Windows—Doors are designed for upright people, so they are natural frames. Windows are also helpful because they come in a variety of rectangular shapes, contrasting the rectangular shape of the photographic frame with another rectangle of different proportions.

If you compose so the window or door is parallel to the edges of the film frame, the framing area gives a "border" effect, emphasizing the subject. For best results, choose a frame that fits the mood of the picture. Have your subject use the frame as a prop if necessary.

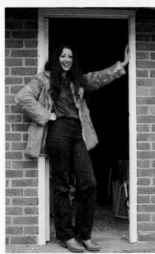

▲For this photo, Lawrence Lawry used two frames. One encloses a reflection and the other surrounds the woman.

◀Here are three good ways a standing subject can use a doorway as a frame within a frame. Photos by Anne Conway.

▶In this photo, man and cat each have a frame. Their close relationship is implied because the same fence is used for both frames. Photo by Wilf Woodhead.

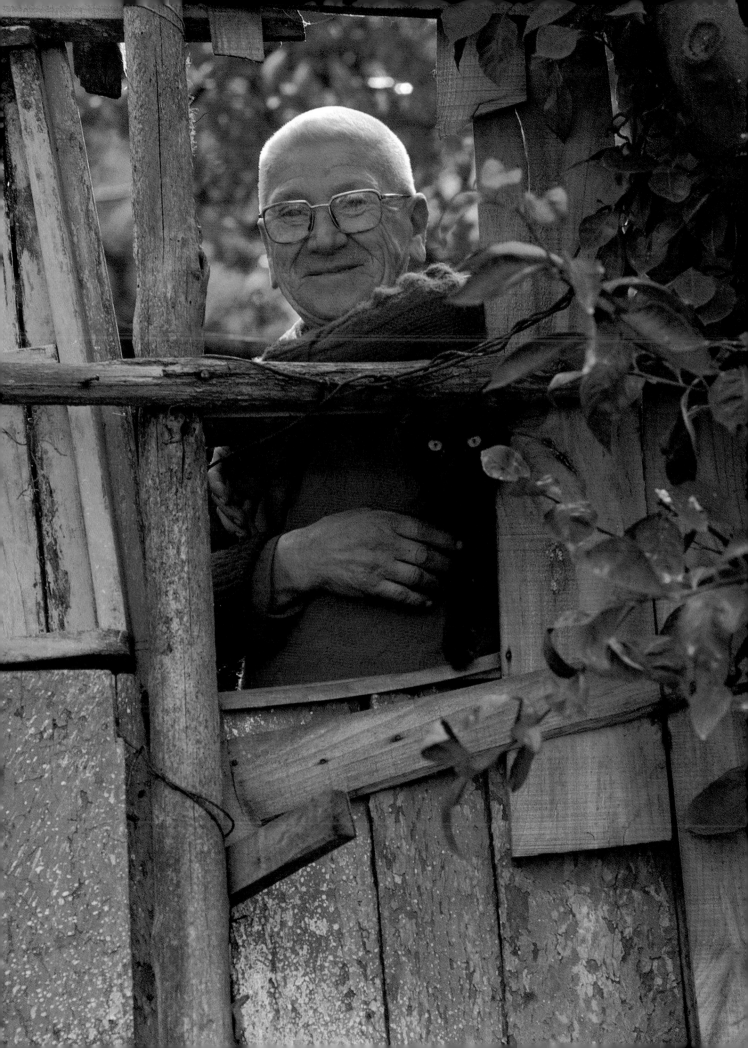

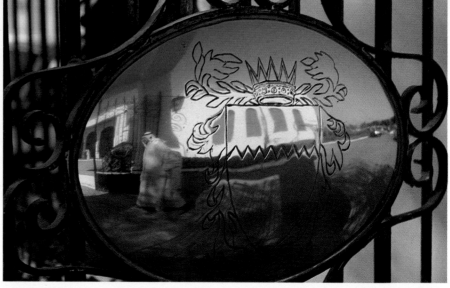

Matching Personality—Try to use a frame that accentuates or establishes something about the subject. For example, you can enhance a photo of a beautiful woman by using flowers as a framing element. This can work even if the flowers are slightly out of focus. If you photograph an auto mechanic at work, try using a tire as a frame. A portrait artist can be framed by a picture frame!

Using frames this way tells the viewer more about the subject than an uninteresting or totally unrelated foreground. When you determine the center of interest, make other things in the scene give additional information.

UNUSUAL FRAMES

You can create visual impact by finding a frame that *contrasts* with the subject. Some examples are old against new, rusty metal against shining steel, or a brand-new skyscraper viewed through the broken structure of a dilapidated building.

A wide-angle lens is useful with this approach. The idea of contrast will usually work best if the frame is recognizable and in sharp focus like the main subject. A wide-angle lens gives greater depth of field at a given aperture than a longer-focal-length lens. So if you use a small aperture like *f*-16, you can move in close and still keep both foreground and background in focus. See pages 58 to 63 for more information about using depth of field effectively.

Using Reflections—Mirrors make unusual frames within frames. In addition, you can use them to create an interesting contrast between the reflection and other things in the composition.

Try using a mirror with an interesting frame for a portrait of a person or even a curious animal. Or, find an angle that will give a surprising view of the subject— green fields reflected in a factory window, for example.

You can also play tricks with mirrors. A mirror without a frame appears to be an image within an image. Unless you want to take a picture of yourself, angle the mirror so your reflection is not in view.

The focused distance is the distance from the camera to mirror *plus* the distance from the mirror to the subject.

▶John Garrett could have shown more detail by moving in closer to these chickens. But by including the door above them, he added an interesting frame and created a stronger composition.

▲The gate around this shiny plaque acts as a frame for the scene reflected in the plaque. When you photograph reflective surfaces, you can include yourself in the photo if you wish. Photo by Ed Mullis.

▶Caroline Arber focused on the image in the mirror to frame her subject like a beautiful cameo. The out-of-focus foreground objects add to the scene's romantic mood.

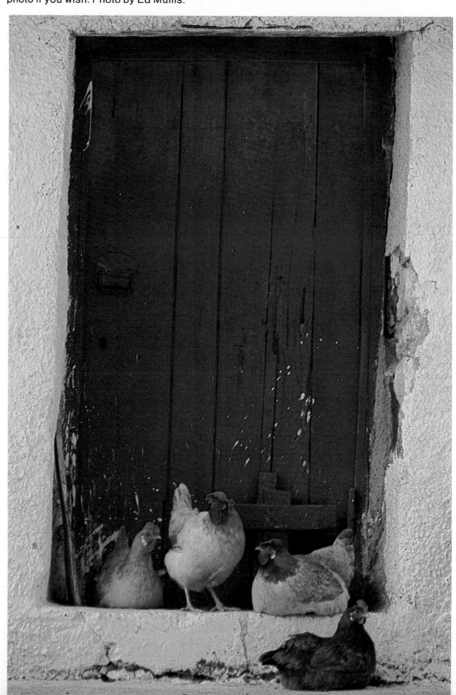

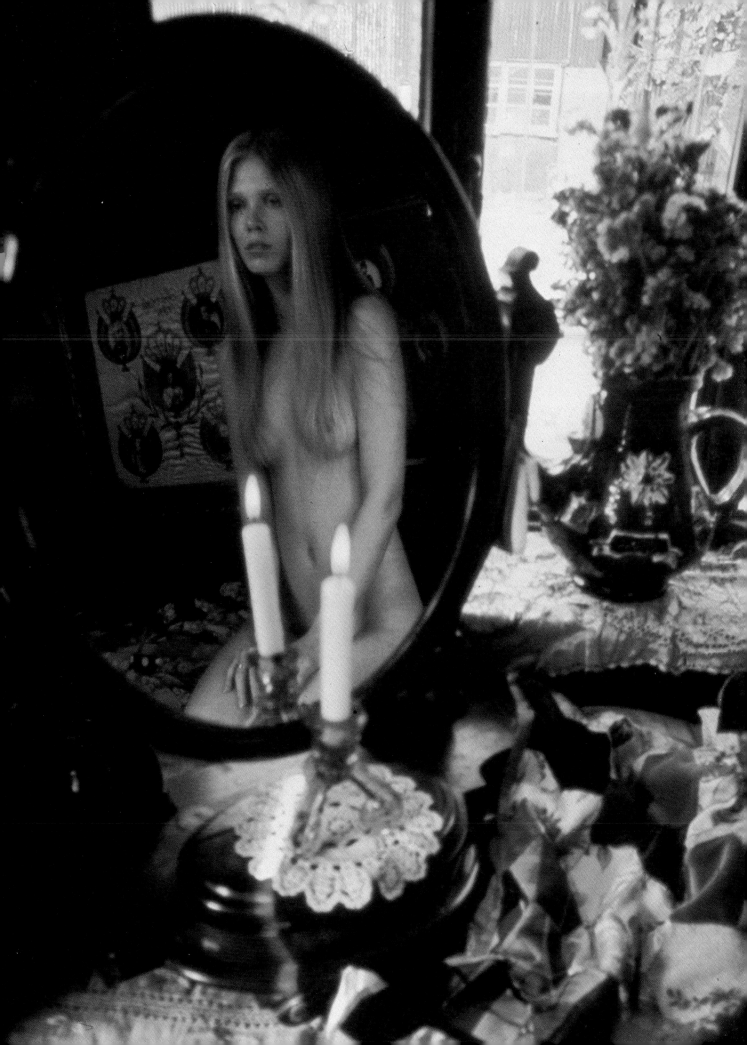

Perspective and Viewpoint 2

Contents

Scale and Depth

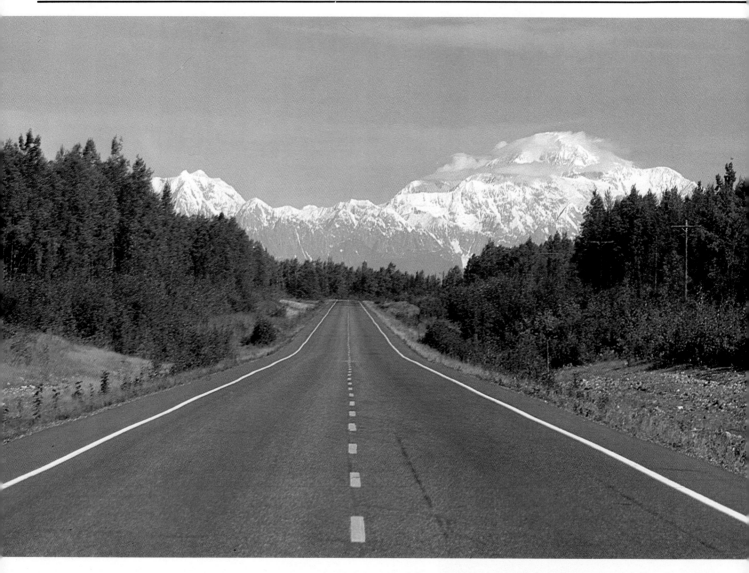

One of the greatest limitations of photography is that it has to show a three-dimensional subject by using a two-dimensional medium—a piece of photographic paper or film. However, when you look at a photograph, it's not difficult to assess the depth and form of the objects in the picture. This is because there are clues to help you. One of the most important of these is *perspective*. It is perspective that shows the shape and size of objects in relation to their distance from the viewpoint.

As a photographer, the more you learn about the tricks of perspective and how to use them, the more you can create a sense of dramatic three-dimensional depth to suit the subject of your photographs.

CONVERGING LINES

Everyone knows that if you look down a railroad track, the rails appear to converge.

They appear closer and closer together until, at a distance, they appear to touch. The ties also appear to get smaller and closer together. This apparent convergence is due to an effect of perspective—the fact that objects nearest to us always appear larger than identical objects placed farther away.

A railroad track is a simple and obvious example because we know that the lines are the same distance apart. But the effects of perspective are with us all the time. The buildings we see when looking down a street, even if they are not all identical, appear proportionally narrower and smaller the farther they are from us. Because your brain uses previous knowledge and experience, it modifies your eyes' accurate image and tells you that the buildings are the same relative size along the entire length of the street. You may *know* this to be true, but it is not the image actually re-

▲ Using converging lines, which the eye accepts as an indicator of distance, is one of the most simple and effective ways to give a photograph the feeling of depth. Photographer Steve Herr dramatized the effect by standing in the middle of the road to take this picture.

ceived. Your brain has translated the information and decided to ignore perspective.

Having established that your brain has been tricking you all your life, as a photographer you must now start trying to see what is actually there. Because the camera does not have a brain, it will not ignore perspective. Learn to rely more on your eyes and less on previous experience.

VANISHING POINTS

Vanishing points and the horizon are two essential elements of perspective.

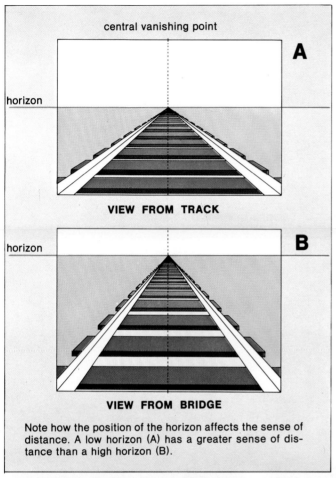

central vanishing point

horizon

A

VIEW FROM TRACK

horizon

B

VIEW FROM BRIDGE

Note how the position of the horizon affects the sense of distance. A low horizon (A) has a greater sense of distance than a high horizon (B).

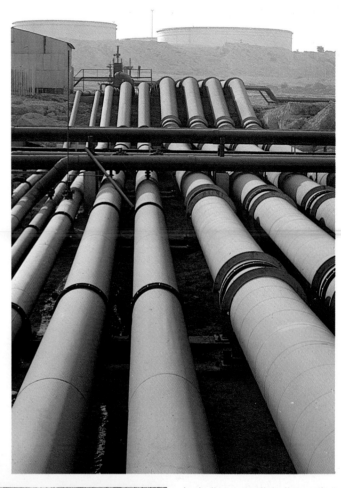

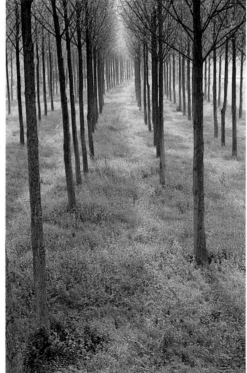

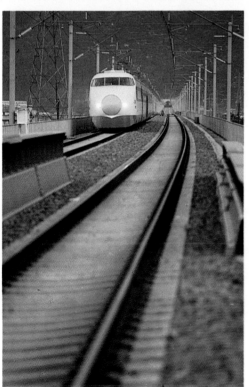

Including parallel lines that appear to meet in the distance is not in itself enough to make a good picture with good depth. You have to choose a viewpoint to best exploit the effect, thereby creating the mood you wish to convey.

Above: Paolo Koch's low, central viewpoint of oil pipes results in a feeling of power and order.

Lisa Mackson's high viewpoint at left draws the eye down into the quiet seclusion of the woodland scene.

Far left: John Bulmer stood slightly to one side to lead the viewer from the front of the photograph to the train, and then into the distance.

Taking the railroad track as an example, you can see that the lines appear to converge at a point as far as the eye can see, and then disappear. This is the *vanishing point.*

In any scene there may be more than one vanishing point. If you stand between the rails and look along the track, you will see that there is only one central vanishing point as you saw in Diagrams A and B on the preceding page. If you look at a building from one corner, as illustrated in Diagrams C, D, E and F, there are two vanishing points, one on either side. Whatever their number, and whichever direction you look, from the same viewpoint all vanishing points are on the same horizontal line. This line is the *horizon.*

VIEWPOINT

The position of the horizon, and of all the vanishing points along it, depends entirely on your viewpoint. By changing your viewpoint you change the position of the horizon, and alter the perspective.

The "normal" position of the horizon is at eye level, as in Diagram A. By moving higher up as in Diagram B, you extend your area of vision, and the horizon changes. The higher your viewpoint, the higher the horizon.

If you lower your viewpoint, objects appear to grow. A building appears larger because it towers above normal eye level, indicating that it is very tall in relation to your viewpoint.

Changing your viewpoint affects the position of the horizon and alters perspective, which, in turn, governs the visual impression of scale. With a very high viewpoint, such as from a helicopter, you could photograph a skyscraper so it would assume the scale of a cigarette pack in the resulting print. Your brain would adjust this image because it would recognize it as a building and because everything else would be in proportion. The building would still tower above its environment and stand out.

Similarly, you could photograph a cigarette pack from a very low viewpoint so it appears like a skyscraper.

This series of diagrams shows how the effect of perspective becomes exaggerated by moving from a high viewpoint to a low one. When there are two vanishing points, the sense of depth can be further increased by moving closer to one side than the other.

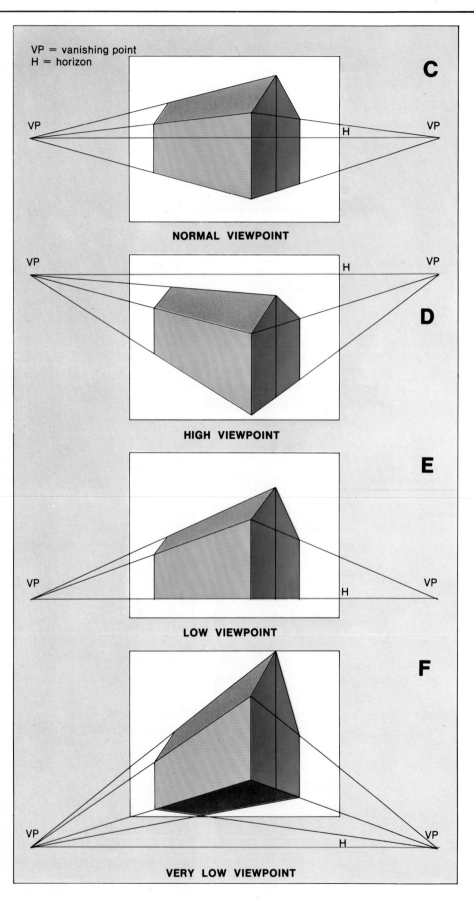

VP = vanishing point
H = horizon

C
NORMAL VIEWPOINT

D
HIGH VIEWPOINT

E
LOW VIEWPOINT

F
VERY LOW VIEWPOINT

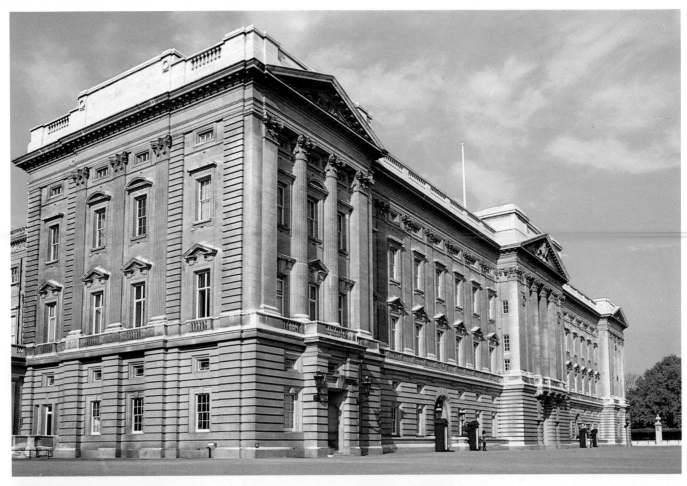

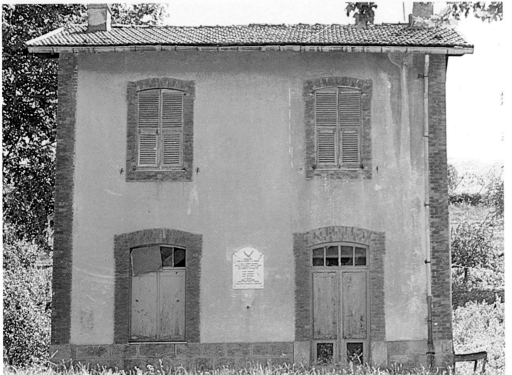

Two vanishing points are better than one, especially when you want to emphasize the subject's three-dimensional quality. For example, a building has two surfaces that meet at right angles to each other. This creates two vanishing points, one from each surface. You may not be able to include both, or even one, in the frame. But, by positioning yourself at the point where the walls meet, so both are seen at an angle (above), you can suggest vanishing points outside the edges of the picture. This will give a greater sense of depth than a shot made at a right angle to one surface, as illustrated at left.

USING PERSPECTIVE

Choose a photograph from a newspaper or magazine and draw a carefully measured grid over it. Better still, draw 1/4 inch or 1/2 inch (6mm or 12mm) squares on tracing paper. Overlay the grid on any picture. You can quickly see how perspective works with the aid of this grid.

You'll see how objects consistently appear smaller as they stretch into the distance because the grid has constant, equal squares. You should also find where the horizon is situated, and thus be able to plot vanishing points.

This will help you see the way three-dimensional scenes are depicted on the flat surface of a photograph or drawing. Try making better use of perspective as an element of design and composition in your pictures.

Incidentally, if you find yourself able to see the effect of perspective on the print but not through the camera viewfinder, consider using a focusing screen with a grid if your camera accepts interchangeable focusing screens. Such a screen may take a little time to get used to, but you should see a big improvement in your photographs. If you go back to using the original focusing screen later, this improvement should remain.

▶ For this picture, Adam Woolfitt found an unusual viewpoint that emphasizes the effect of perspective. The "flatness" of the head-on view coupled with the dynamic lines disappearing into the distance makes a striking contrast, emphasizing both elements.

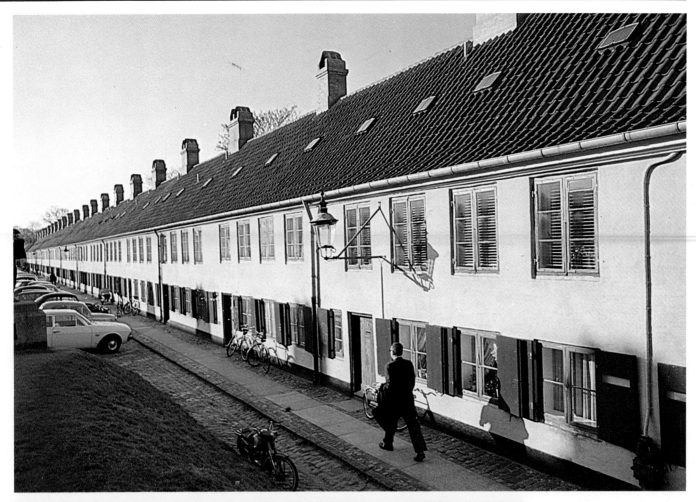

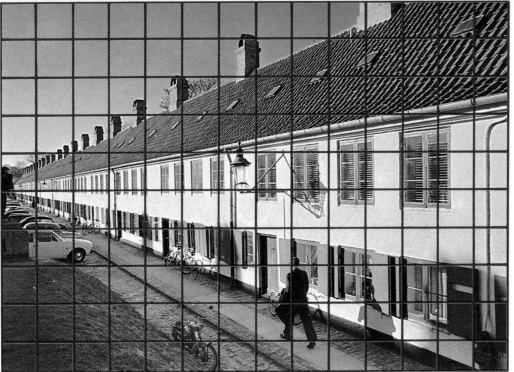

The essential part that perspective plays in showing depth and distance is obvious when you look at a print or transparency. It is not as easy to judge through the camera viewfinder. Placing a grid over printed photographs is one way of becoming more aware of the visual effect of perspective. This should help you think and "see" more carefully when perspective is an important part of a scene. Photo by Michael Busselle.

Creating Depth

A feeling of depth is not an essential requirement of every good photograph. A telephoto lens, for instance, compresses distance and can make an impressive two-dimensional picture that is arresting because of its flatness. The subject appears to be on the *surface* of the photograph like a flat, drawn design instead of a three-dimensional scene.

For many subjects, a flat image would be disappointing, and it is vital to create an impression of depth. Landscapes often appear to come to life only when the viewer's eye is drawn into and around the scenery, exploring the image. Look at successful photographs—still-lifes, landscapes or people—and observe how composition benefits from this strong three-dimensional effect.

Thus, one of the first decisions to consider every time you take a picture is, do you want to create a flat design or a three-dimensional effect?

There are many basic elements that can combine to give a sense of depth in a photograph. These are subject qualities such as scale, contour, tone and texture. In addition, you can use camera controls such as selective focusing. No matter what camera you have, you can exploit most of these. Start by looking for each element, described on the next few pages. Then see if you can make photos based on one or more of these elements. As with other areas of composition, the first step is to look carefully at the subject and recognize the opportunities.

▶ There are times when a flat, diagrammatic representation of a landscape can look very impressive. The strength of this image, however, lies in its tremendous feeling of depth. The countryside seems to stretch on and on into the distance. Kenneth Griffiths carefully composed the picture so the viewer is drawn from the foreground on the left to the main subject on the right. The lines of the road and walls then lead you into the middle distance, almost in the center of the scene, and then on to the horizon. Including the low layer of clouds as a ceiling further increases the sensation of depth.

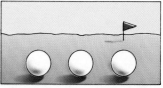
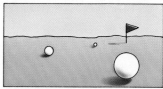

▶ DIMINISHING SIZE: Objects of the same or similar size appear to become smaller as they get farther away, as shown above. Using a wide-angle lens, Robert Estall emphasized this for a greater feeling of depth in the photo at right.

▲ FILLING THE MIDDLE AREA: Choosing a viewpoint that places the main subject in the middle area is an effective way of drawing you into a photograph, thus strengthening the feeling of depth. Photo by John Goldblatt.

▲ TEXTURE: Sharply focused texture in foreground objects combined with lack of detail in the distance is another way to add to the feeling of depth. Here, the converging lines of perspective give the greatest sense of depth. Emphasis of the foreground texture due to a low viewpoint has also added to the effect. Photo by Lisa Mackson.

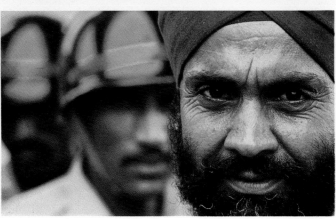

◀ SELECTIVE FOCUS: This technique is especially useful for producing good depth in close-up shots and in subjects with a confusing background. By throwing the background out of focus, you can make a sharply focused main subject stand out from the rest of the photograph. The lack of detail in the background makes it seem farther away from the main subject than it actually is, giving the illusion of depth.

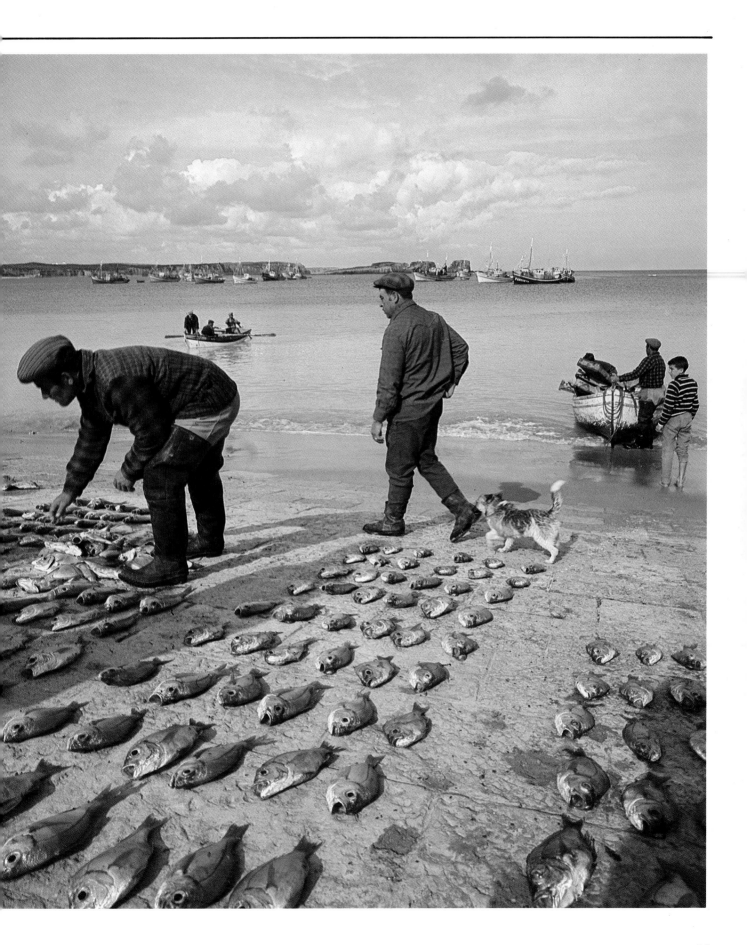

Choosing Your Viewpoint

Choice of viewpoint, or camera position, is important to a picture, yet many people hardly give it a thought. Viewpoint has the greatest single influence on a photograph. If you are going to hang a photograph on a wall, you examine the room carefully, looking for the position that is best for both the room and the picture. The same amount of consideration should be given to taking a photograph. The best viewpoint is unlikely to be the first place from which you saw the subject.

EXPLORE THE SUBJECT

Occasionally the immediately obvious viewpoint is the best possible place to take a picture. Usually this is not the case. The first thing you should do after deciding to take a photograph is to walk around the subject. See how it looks from the left and right, farther away and closer, higher and lower. Explore the subject to "see" the full range of picture possibilities.

It is a useful exercise to photograph a subject from every conceivable viewpoint.

You'll be surprised at how much variety of composition and emphasis you can obtain from even the simplest situation.

LIGHTING

Study the effect of light on your subject and see how it can be changed simply by moving the camera. Compare the difference between photographing a subject against the light as opposed to conventional "over your shoulder" lighting. Sometimes you may need to move the camera

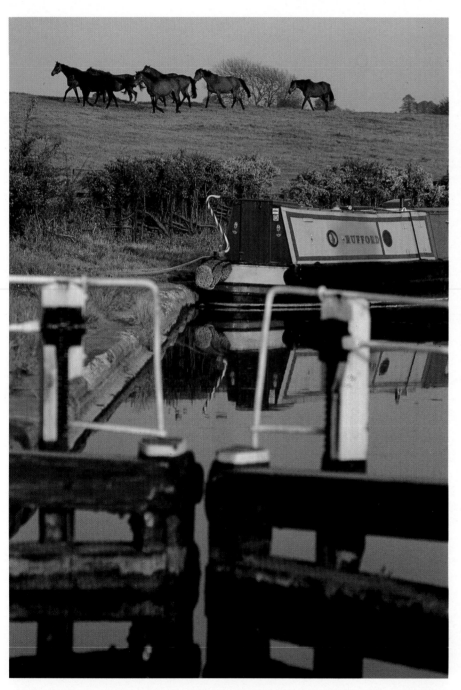

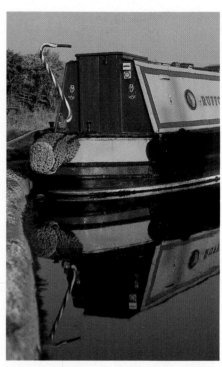

▲ The advantage of a close view is that the composition can be reduced to essentials, usually resulting in a simple, effective design. Because the design is simple, however, the smallest detail plays an important part in the photograph and must be carefully considered. For this image, Patrick Thurston positioned himself carefully so the tiller appears in the sky area, just above the bank, while the reflection just missed being cut into by the edge of the canal.

◄ Quite a different photograph is created by moving back to include more of the scene. You see the barge in its setting, with other points of interest. Camera height is important here because it controls the overlap between the foreground, subject and background. If it were any lower, the gates, barge and field would have been confusing.

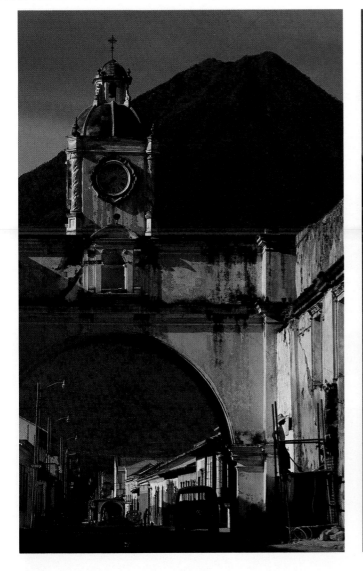

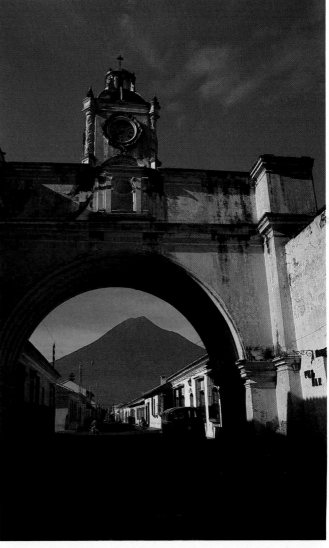

so part of the subject hides the sun to prevent flare.

Where the texture of a subject is important in a picture, the direction of the light is crucial. A head-on shot of the subject will rarely show the texture. Shooting into the light will destroy detail completely. It is important, therefore, to consider the effect of lighting when choosing your viewpoint. See pages 155 to 204 for more information about lighting.

PERSPECTIVE

Another aspect of photography that depends totally on viewpoint is perspective. By changing viewpoint you change the relationship between the size and proportion of objects in the picture area.

You can learn a great deal about perspective simply by observing what happens to the apparent sizes of objects as you move closer or farther away from the subject.

For example, from a distance, a person standing in front of a building is overshadowed by the prominence of the building. As you move closer, the figure becomes more dominant and the prominence of the building diminishes.

CHANGING LENSES

Having lenses with different focal lengths is a considerable advantage when choosing your viewpoint. In fact, lens interchangeability will often encourage you to change your viewpoint. For example, a longer lens enables you to use a more distant camera position but still obtain an image of adequate size. For a portrait, the perspective effect on a face is unflattering when a standard 50mm lens is used closer than about 5 feet (1.5m). A longer lens enables you to shoot at a greater distance and still get an image that fills the viewfinder, but without the apparent distortion.

▲ A new viewpoint combined with a change of lens can make a spectacular difference in perspective and scale. For the picture on the left, Anne Conway used a 135mm lens. Moving 100 feet closer and using a 28mm lens, the archway seems to grow and now dominates the volcano.

A wide-angle lens enables you to include more of a scene without having to move farther away. This is a particular advantage when taking pictures in a confined space, and it also allows objects quite close to the camera to be included in the foreground. This can be useful in landscape photography to produce an impression of depth and distance.

Changing lenses and viewpoints gives you the opportunity to make very dramatic changes in the appearance of a scene, as you can see in the accompanying photographs.

FRAMING

Having decided on a general position for your camera, you should consider *slight* changes of viewpoint. Perhaps one step to the left to exclude an intrusive color, or a fraction lower so you include an interesting piece of foreground will make a great difference in the final result.

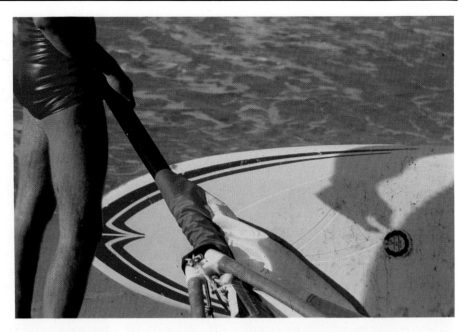

▲ Tessa Harris used a very close viewpoint to emphasize the graphic quality of the strong colors and shapes of this windsurfer as he dismantled his craft on the beach.

▼ When the figure moved, the shapes became much simpler, so Tessa lowered her viewpoint slightly to include waves rolling onto the beach. This created a more interesting background.

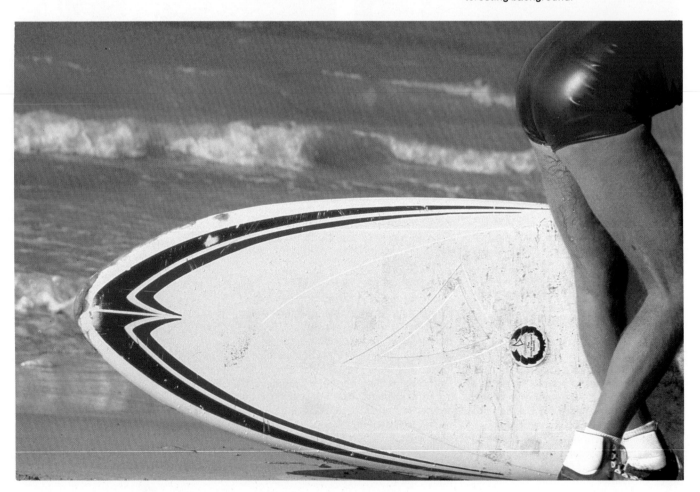

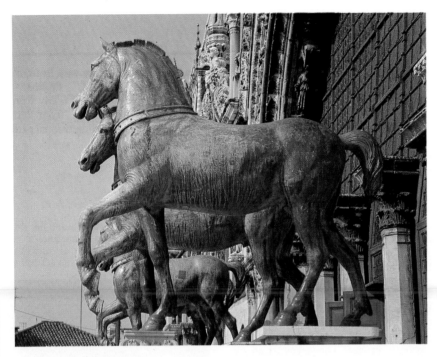

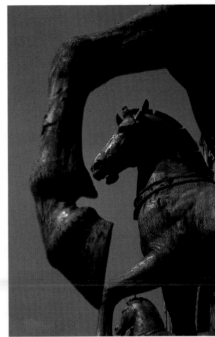

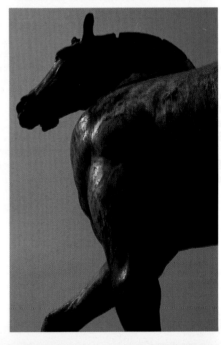

MAKE A CHECKLIST

Ask yourself these questions: When was the last time you took a picture from ground level? From the top of a building? From a chair? When was the last time you focused your camera at less than 10 feet (3m)? It's surprising how easily you can lapse into a routine without exploring the full possibilities of a subject.

Consider making a checklist of possible viewpoints and trying them next time:

- From left and right.
- From behind.
- From close up.
- From far away.
- Including foreground. See pages 30 to 33.
- From a high viewpoint. See pages 68 to 71.
- Lying on the ground. See pages 72 to 75.
- Shooting directly into the light. See pages 186 to 191.

These pictures were taken from the balcony of St. Mark's Basilica in Venice. They show how, by careful choice of viewpoint, you can control exactly what is in the picture to make a personal interpretation. For the picture above, Van Phillips chose a viewpoint that accurately reflects what the horses look like. In the other four shots, Malcolm Crowthers was trying to dramatize a quotation from Petrarch, for whom these horses seemed "to neigh and paw the ground with their hooves." Lower left: Crowthers lay on his back, hanging over the balcony slightly, to "capture" the descending hoof. The impression is helped by the viewpoint.

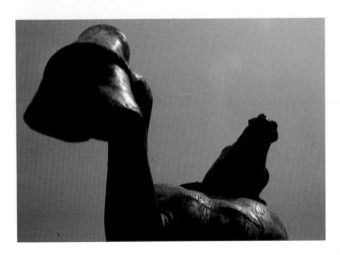

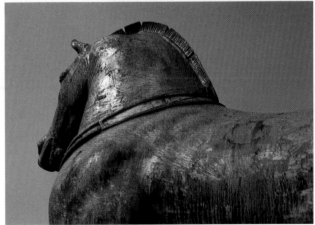

THE EFFECT OF LIGHTING

The way light strikes a scene viewed from overhead affects the flattened look of compressed perspective. The interplay of light and shadow is just as important as it is with an eye-level scene. For more information on lighting, see pages 155 to 204.

Time of Day—In the morning and evening, the sun will light the scene from the side. Objects will cast shadows that indicate their relative sizes. This gives the scene a more three-dimensional look than if shadows were not present. Shadows are longest early and late in the day, so for the most dramatic pictures from overhead, shoot in the early morning or late afternoon. The color of sunlight at these times of day is warm, and will reproduce with an orange cast on color film.

The sun is high in the sky between 10 a.m. and 3 p.m. Subjects on the ground are lit from overhead. Their shadows are nearly hidden from your view if you see the scene from overhead. This flattens the perspective of the scene, giving an effect similar to an overcast day, when shadows are nonexistent.

Haze—As the distance between you and the subject increases, so does the amount of haze in the atmosphere. The amount of ultraviolet (UV) radiation also increases as your viewpoint becomes higher—for example if you are on a mountain and are photographing a town below. This can lead to bluish color pictures or b&w prints that

Michael Busselle made the overview (A), with a 20mm wide-angle lens from the top of a tall building. He held the camera at eye level. This is an elevated, not overhead, view. He zoomed in on different parts of the overall scene with a 70-210mm zoom lens.

B) First he chose an area where an elevated view showed several vertical planes compressed together. The lens focal length was set at 70mm.

C) Then he shot the scene with the lens set at 180mm to exclude some buildings.

D) With the zoom lens set at 210mm, perspective is compressed most. These three photos show the usefulness of a zoom lens from a fixed elevated viewpoint. You are able to make a variety of compositions quickly.

E, F, G) Keeping the lens at 210mm, Busselle aimed at nearby details. Because he was more nearly above these scenes, the photos seem more two-dimensional than A, B and C. Notice how pattern and shape dominate composition.

B

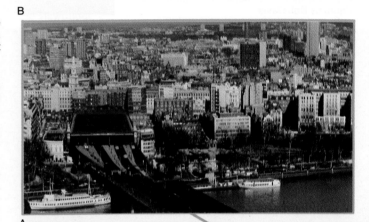

A

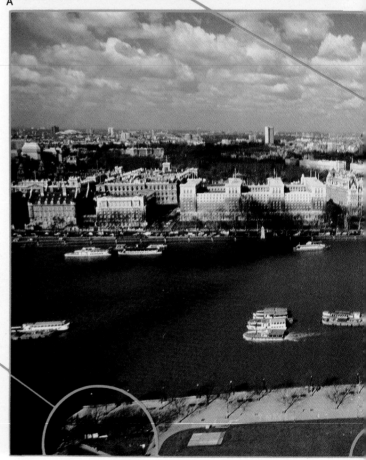

G

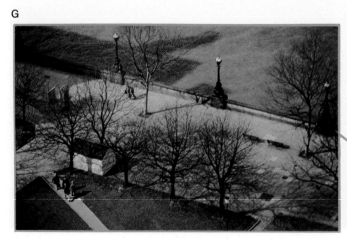

lack detail and good contrast. Even a slight amount of haze can affect the sharp details such pictures usually require.

Avoid this problem with color film by using a skylight, UV, haze, or 81A warming filter. A polarizing filter is effective in removing some of the reflected light scattered by the haze, thus producing greater clarity and color saturation.

If you are shooting b&w film, use a warm filter, such as a yellow, orange or red to penetrate haze by absorbing UV radiation and some blue light. An orange filter cuts more haze than a yellow filter. The red filter penetrates better than the orange filter.

LENS SELECTION

When you photograph from overhead, lens selection also affects the perspective of the scene. If you use a wide-angle lens aimed toward the ground, you can include part of whatever is supporting you, such as a balcony or airplane. This foreground element will greatly expand perspective by increasing the impression of height. Perhaps you can improve the composition of a dull picture this way.

A telephoto lens has the opposite effect. Pointed directly down so the subject is on a single plane, the foreshortening effect of the lens compresses perspective. It isolates small areas and seemingly brings together objects that are normally separate.

C
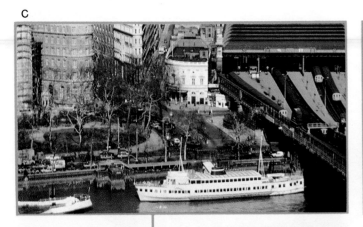

D
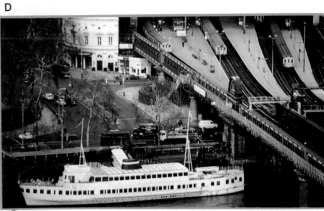

E
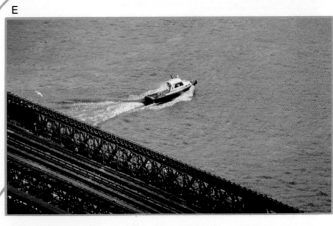

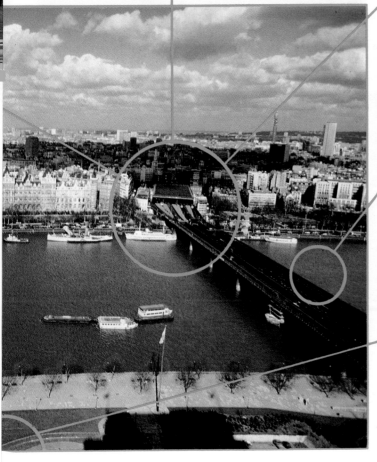

F

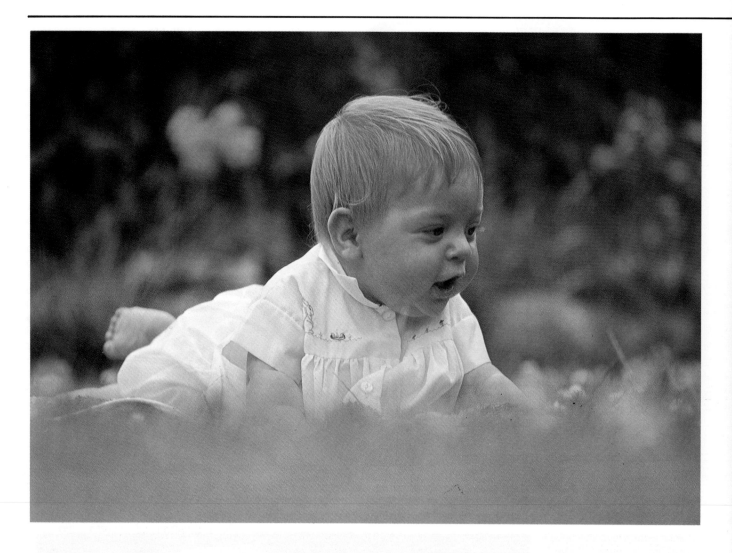

farther away. Lines seem to extend a great distance, giving a feeling of depth and convergence.

Depending on lens aperture, you can get extensive depth of field. For example, a 24mm lens with an aperture setting of ƒ-16 has depth of field from about 2.5 feet (.75m) to infinity. The shorter the lens focal length, the greater the depth of field for a given aperture. In addition, angle of view increases as focal length decreases. A fisheye lens has a focal length between 8mm and 18mm for a 35mm camera and sees a very wide angle of view.

CHOOSING SUBJECTS

Just as there are many different viewpoints, there are also many different subjects you can photograph.

Small Subjects—Toddlers, pets and other small subjects are most often photographed from the point of view of a "big person." By going down to or below that height, you can achieve a more intimate view that may also be more dramatic.

From ground level, a picture of a toddler or a cat towering above you is a reversal of normal, eye-level perspective. Use this to enhance the subject or shock the viewer.

With small subjects that do not move around too much, make your task easier by positioning the subject on a bench or a table. This lets you get your low viewpoint from a more comfortable position.

Action Photographs—For dramatic action photographs, such as sporting events, consider a low viewpoint. For example, this is used effectively by some sports photographers when photographing horses going over a jump. Their remote-controlled, motorized cameras are positioned directly under the jump, aimed at the sky.

You may not want to take such chances with your equipment, but you can use the same technique in more controlled situations. For example, have your child jump over you as you lie on the ground, or position yourself under the arc of a swing but at a safe distance.

▲A low viewpoint gives an intimate view of a small child. Photo by Michael Busselle.

FINDING YOUR VIEWPOINT

Any subject can be approached from a worm's-eye view for a novel perspective. You may want to be obvious about the unusual angle, making it the dominating factor in the shot. Or you may simply want to use the viewpoint as a subtle compositional element.

If you do not want a setting that looks contrived, consider locations that allow you to use this unusual angle without shocking the viewer. Examples would be a photo of a child climbing a tree or someone cleaning a window overhead.

An interesting photograph is often the result of the way you perceive your subject. An otherwise commonplace situation can become a dramatic picture when you use an unfamiliar viewpoint.

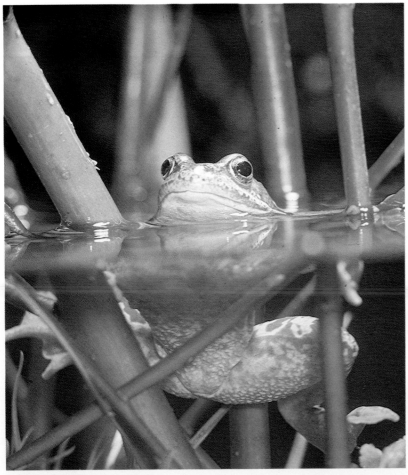

▲This photo was made with a low viewpoint, making it difficult to determine the subject of this abstract. It's a wet street at night reflecting light from neon signs. Photo by Robin Bath.

◄A low viewpoint is helpful for many photographs of small animals and nature subjects. Jane Burton photographed this frog in an aquarium.

▼John Garrett was shoulder-deep in water for this action shot. He used a Nikonos, a special underwater camera.

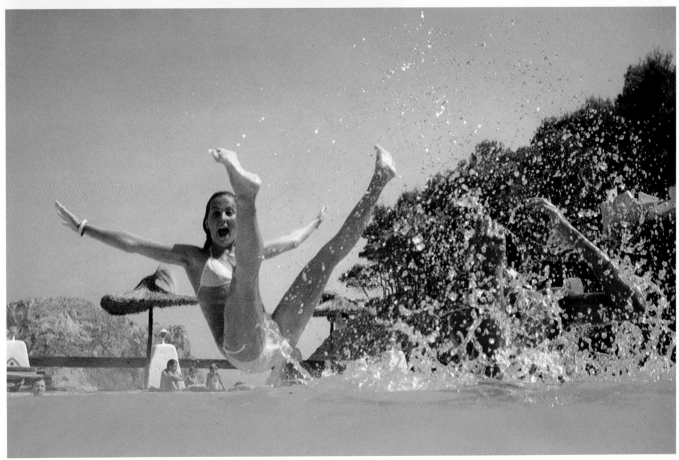

Diagonal Composition

Because cameras produce rectangular or square pictures, it is natural to first consider how the horizontal and vertical lines in the image work with the sides of the picture frame.

The position of the horizon is usually the first consideration because everyone knows how it looks in reality and where it should be. Common objects, such as trees, buildings and people, are normally expected to be vertical, at a 90° angle to the horizon. Most people compose scenes so the horizon is parallel to the top and bottom edges of the frame. Vertical subjects are usually made parallel to the sides of the frame. Typically, this divides the rectangular or square format into smaller rectangles.

In some scenes the strongest shapes and lines cut the frame diagonally. These require different compositional considerations. Whether or not the diagonal runs precisely from one corner of the picture to the other, the *impression* is that the image is divided into two triangles. This section describes many ways to take advantage of diagonal elements for more interesting compositions.

COMPOSITIONAL PRINCIPLES

With diagonals, principles of compositional balance apply. A strong color on one side of the dividing line can counteract a complicated shape on the other. Or, the silhouette of an individual will balance the strong attraction of a dramatic sunset on the other. With diagonal compositions, the problem is how to contain these visual "weights" within their opposing triangles.

The effect of a diagonal line is strongest if it runs from one corner of the frame to another. Incorrectly used, a diagonal can lead the viewer out of the picture. Avoid

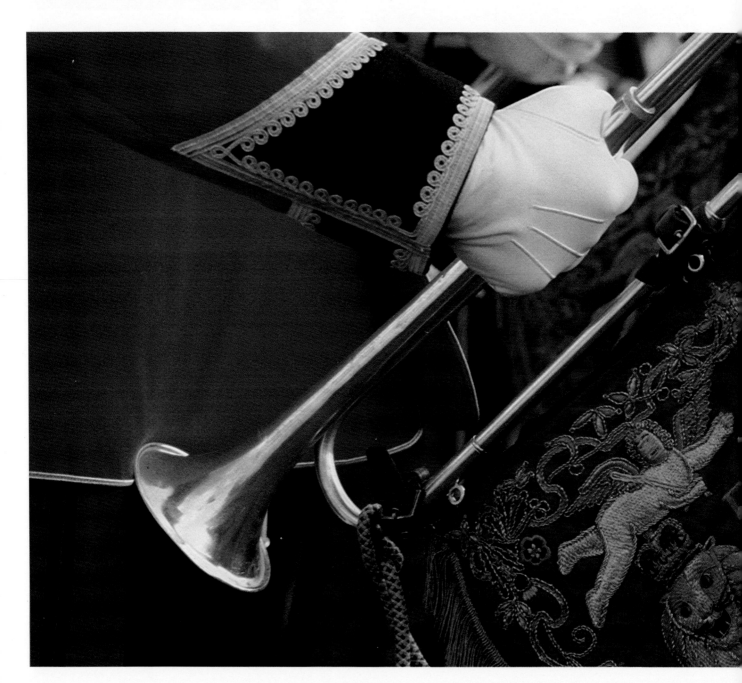

▼Graeme Harris chose to show the pageantry of a military parade with a detail view rather than an overall view. To do this, he picked an area dominated by a strong diagonal. The trumpet divides the frame into two balanced areas, one rich in color, the other in detail.

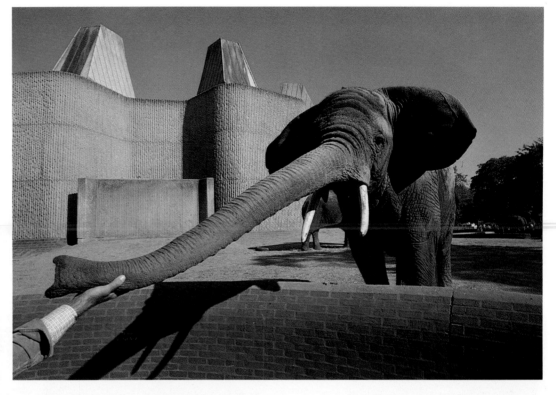

▲A 28mm wide-angle lens exaggerates the length of the elephant's trunk. Notice how your eye travels diagonally from the hand in the foreground to the elephant's head. Per Eide used a small aperture of ƒ-16 for extensive depth of field.

▼This view shows little depth. Instead, it relies on pattern for interest. To avoid a static feeling in the picture, Michael Busselle used a diagonal in the composition.

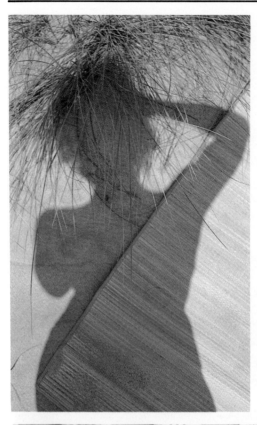

◀Far left: Tessa Harris's "self-portrait" is interesting because of the way the shadow outline and the details on the ground combine. Notice how the diagonal on the ground coincides with the diagonal of the figure.

◀Though the steps must lead down away from the camera, the flat viewpoint makes the scene appear two dimensional. It shows the abstract effect of color and texture along diagonal lines. Photo by Robin Bath.

▼This image falls into two sections, divided by a diagonal gap. The diagonal visually separates the buyer from the seller. There is also a division between the drab and colored parts of the scene. Photo by Bob Davis.

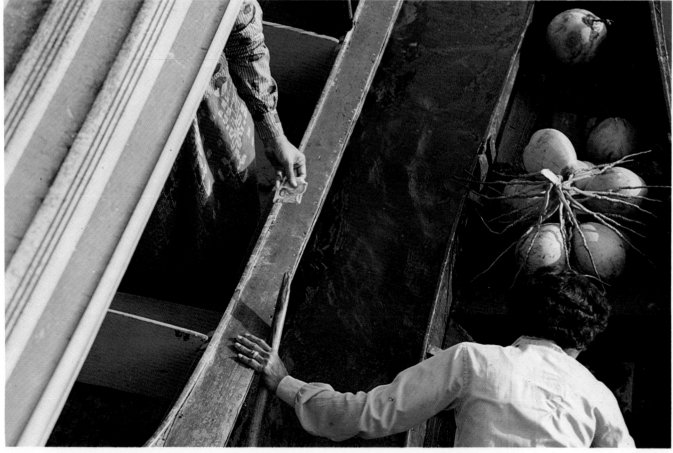

this by including a strong feature or color in the opposite corner to create a satisfying balance.

Diagonal compositions fall into two main categories:
● Pictures that lack depth. These rely on two-dimensional pattern, color and shape for their impact.
● Three-dimensional pictures in which the diagonal is a line of perspective that emphasizes depth in the scene.

TWO-DIMENSIONAL PICTURES

When photographing a flat surface, you usually need to accentuate some feature to compensate for the lack of depth. Perhaps you can emphasize pattern, add striking color combinations, or strong intricate shapes to hold the viewer's attention. A useful way is to include a diagonal line.

In this case, compose carefully so elements of equal interest are on either side for balance. For example, in a photograph of a delicate wrought-iron gate that occupies one of the triangular areas of the frame, a bright patch of colored flowers in the other will balance the picture with *contrasting* colors and shapes. This balance can also be with *similar* colors, shapes or elements.

▲Although the model was lying flat, Tino Tedaldi tilted his camera to give the impression that she was slipping down out of the frame.

High Viewpoint—One way to produce a picture that looks two-dimensional is to photograph a three-dimensional scene from overhead. From a high viewpoint looking down, there is no "right way up." You can frame the subject at any angle you choose.

79

◀This rectangular arrangement of Edam cheeses could have been photographed from the side. Instead, Mike Yamashita shot from one corner with a wide-angle lens to exploit diagonals for a much more dramatic composition. The resulting diamond shape contrasts with the rectangular shape of the picture frame.

In a picture of sunbathers on a beach taken from an elevated boardwalk, it would be just as logical to have heads at the bottom of the frame as at the top. This lets you put lines anywhere you want in the composition. Because there is no impression of depth, the balance of color and shape becomes most important.

DIAGONALS OF PERSPECTIVE

In a three-dimensional scene, a diagonal line that leads from the foreground to the background can have a very strong effect. In fact, the effect can sometimes be too strong. The line drawing the viewer into the picture can sometimes overwhelm the rest of the photo's contents. It is crucial to maintain a balanced composition.

Landscape photographs that include a road or river running from the foreground toward the horizon sometimes have a diagonal that dominates the composition. Uneven contours of the ground and the foliage may help to make the diagonal less dominant, but the picture may also need another strong center of interest for good balance. An interesting shape or object in the foreground will help. This could be a person or a splash of color. The viewer can use this foreground element as a focal

▲The height of this skyscraper is exaggerated because Ron Boardman tilted and turned the camera. He balanced the composition by including part of another building.

80

point for the foreground. The diagonal line will then lead the eye into the scene.

Wide-Angle Views—A wide-angle lens gives you the chance to exaggerate the distance between foreground and background. When you include a foreground element in the composition, its size relative to background elements makes it the dominant feature. The diagonal line leading to the background serves to remind the viewer about the background.

Another way to take advantage of diagonals is to use converging verticals creatively. For example, when you tilt your camera to photograph tall things like trees and buildings, the vertical lines seem to converge. They no longer look parallel, and the buildings or trees seem to lean backward. In this case, consider tilting the camera to exaggerate or abstract this effect even more.

▼David McAlpine wanted to show the contrast between the sunlit field in the foreground and the dark stormy sky beyond. He filled the frame with the foreground, so the path would lead your eyes across the picture into the distance.

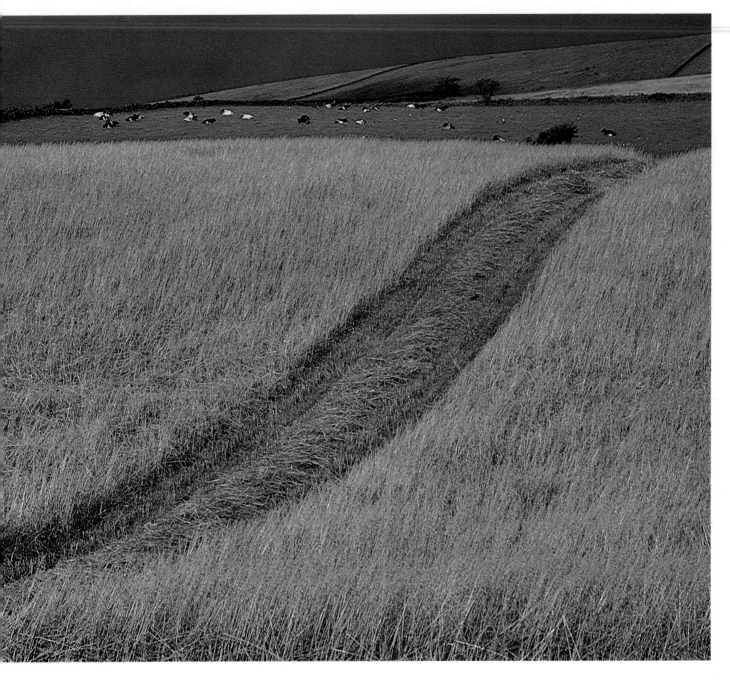

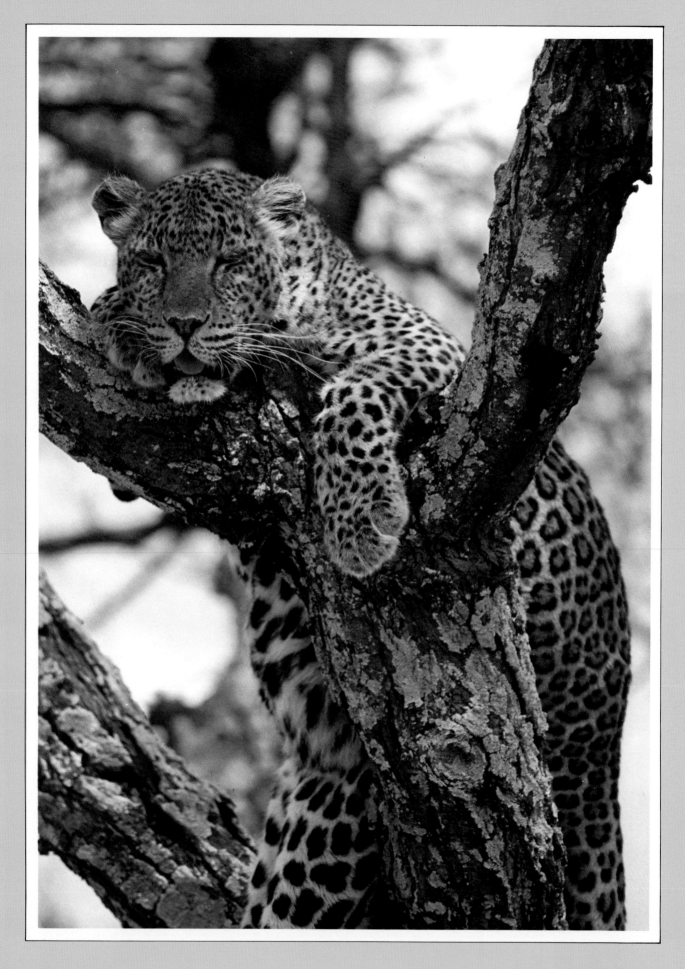

Important Details ___3

Contents___

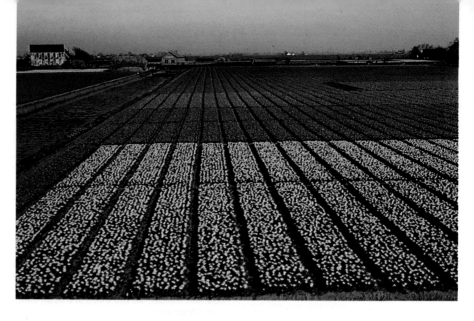

CONTRAST

Shapes and the way they react with each other is also important. Contrast is one way to make sure the subject draws the attention of the viewer. An effective way of achieving this is with a contrasting shape or line.

In a portrait, for example, you can enhance the roundness of face and eyes by using the model's arms and shoulders to create an angular contrast. You can also achieve contrast with even a small vertical line such as a human figure or a tree on an otherwise uncluttered horizon.

Contrast in shape alone is not always enough to achieve the desired impact; sometimes contrasting tone or color is needed. For instance, a red triangular sail on a blue sea is much more striking than a blue sail.

ALTERING THE MOOD

Lines and shape can have a strong effect on the mood of a picture. Where horizontal lines predominate, as in many landscapes, a relaxed and passive quality is created. A strong diagonal line is much more vigorous and assertive. When several similar shapes exist in the image—curves in a still life of a bowl of fruit, for example—the effect is usually restful and harmonious. Contrasting shapes or lines at different angles create a busy and a more exciting impression.

CONTROLLING LINE AND SHAPE

With many subjects you have a limited degree of control over line and shape. In portraits and still lifes, you can create shapes at will—but with landscapes you can only control the viewpoint and the way the picture is framed. It is often possible to minimize the effect of undesirable lines in a picture by choosing a viewpoint that allows foreground details to interrupt or obscure those lines. To introduce diagonal lines, work from a different viewpoint or tilt the camera.

You can soften obtrusive shapes by hiding part of their outlines behind other details, or by cropping in the camera. A different viewpoint often alters the lighting effect and reduces the tonal contrast between a shape and the background.

When you see which of these elements contributes to the picture and which detracts, it is usually possible to find a way of stressing the former and subduing the latter. And if no solution is possible, your awareness will spare you from wasting film on a disappointing result.

▲ George Rodger climbed on top of a shed to gain a high viewpoint for this image. This was essential to capture the interplay of the repeated straight lines in the tulip field.

▼ The rhythm of curves and lines in the Sydney Opera House produces an exhilarating, almost abstract, composition. When photographing buildings, look for repeated lines and see how they echo or conflict with the shape of the subject. Photo by Gordon Ferguson.

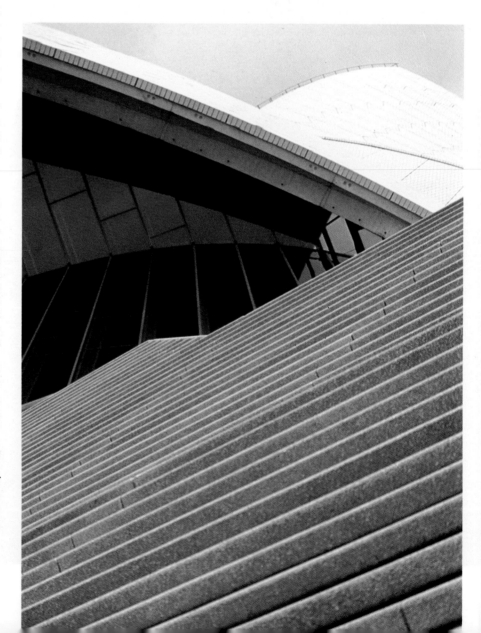

▲ Look for repeated curves or lines in hap-hazard arrangements.

▶ Contrast of color and shape prompted Michael Busselle to make this photograph. Try changing camera position to get the most effective contrast.

▼ Look at shapes from above. The strong diagonal of this pier is emphasized by bright directional sunlight and the dark shadow areas.

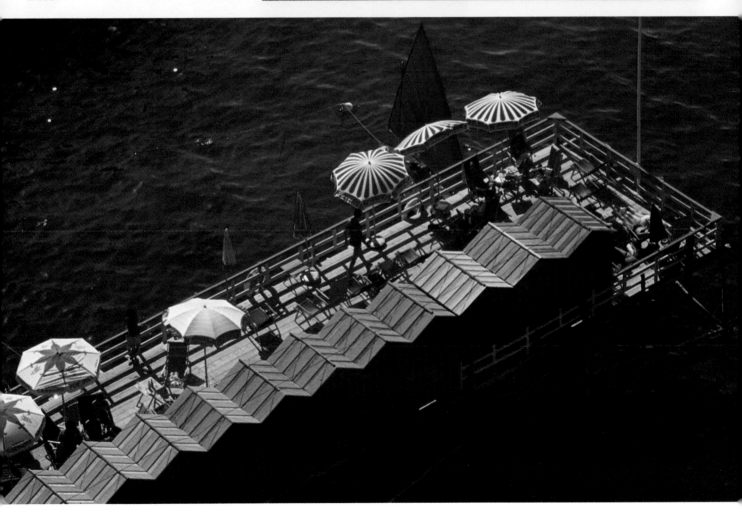

Discovering Patterns

In our lives, we are surrounded by patterns. In photography, these patterns can tease, amuse or stimulate the imagination. Skillfully used, the repetition of shapes or lines in a photograph helps create a rhythm and order that can make a particular picture memorable. The patterns the photographer uses need not always be exact geometric repetitions like the arches in a colonnade; they could be an impression of a pattern, such as expanding ripples of water, or branches traced against the sky.

WHERE TO FIND PATTERNS

Finding patterns is very much a question of being aware. To develop your "eye," look for locations with strong patterns and see how they are formed.

Patterns exist almost everywhere. Transient patterns exist only at a certain moment or from a particular viewpoint, such as faces in a crowd, a flock of flying birds or a parade of soldiers. There are also static patterns such as the windows in an office building or a row of houses, the bark of a tree or the ripples left in sand after the tide has gone out.

HOW TO USE PATTERNS

It is unlikely that a picture relying solely on patterns will have any lasting appeal, although it may have an initial impact. Therefore, patterns should be used only as a strong element of a photograph and not as the sole reason for taking it.

A strong pattern can create a reassuring, restful and ordered atmosphere in an image. But remember that patterns are usually busy and complex, so the main subject of the picture should be simple and bold, and placed in a dominating position within the frame. Otherwise, that subject may be completely overwhelmed.

▶ REPETITION
This diagonal pattern of soldiers creates a more dynamic effect than the usual straight rows. The buildup of repeated shapes, angles and details contributes to the overall result. The high viewpoint is important—at ground level the pattern would not have emerged as clearly. Photo by Bruno Barbey.

▲ This apparently disorganized mass of beach huts is visually held together by the strong repetition of the triangular roof shapes. Michael Busselle tried different viewpoints until he found the most effective combination of colors and perspective, with the interplay of light and shadow. If this photo had been composed to show the huts in straight lines, with each shape and angle identical, the image would lose the interest created by oddities in the pattern.

Sometimes a purely repetitious pattern can be boring—especially when the scale suppresses individual quirks and surprises, as in the photograph of a pile of logs at right. But as a background to the strongly diagonal ladder, the logs work well. They emphasize the simple structure of the ladder and do not compete with its lines. A more varied background, farm implements, for example, might have competed.

◄ When you notice the farm buildings at the bottom of this photograph, the image acquires a sense of scale. Then you no longer see the image as an abstract design. You see a pattern created by the contour of the land and plowed fields.

HOW LIGHT AFFECTS PATTERNS

A subject with inherent pattern, such as a pile of logs or a row of houses, may not be greatly affected by a change of light. But there are other images where the pattern is created or revealed by the nature of the light. A pattern of this sort may exist for only a short time. For example, consider the patterns caused by sunlight on the ripples of water. It is easy to photograph many frames on a subject like this, with each image different. In many instances, the shadows make a pattern but a slight shift in the angle of light causes the pattern to disappear.

PATTERNS AND COLOR

A pattern is made up of lines and shapes. In a b&w photograph, these are formed by highlights, shadows and contrasting shades of gray. In color photography, lines and shapes are often formed entirely of color.

◄ This reflection of a colorful boat on rippling water creates a transient pattern that will change with the movement of the water and the position of the sun.

▲ This is a view of an Italian village, taken in late afternoon when the sun was at a low angle. Very strong light created dense shadows and strong highlights, making a pattern that would be just as obvious in b&w.

The colors of the subjects become as important as highlights and shadows. Strong colors make a pattern obvious. It is possible for a pattern to be produced by color alone. The colors in landscapes and woodland scenes can make strong patterns. Close-up photography often reveals beautiful patterns in the colors of flowers and insects, or you can find beautiful rainbow patterns in soap bubbles and oily water.

Patterns exist everywhere but you must look for them. It's really only a question of "tuning in" visual awareness to uncover a limitless source of subject matter.

Patterns can be natural or man-made. They can be revealed by light, color or viewpoint. These pictures show strong patterns of one kind or another. Some are immediately obvious, such as the repeated shapes of the honeycomb, the sea urchins, the cars seen from above and the house fronts. Others, such as the umbrellas or the stone wall, depend on light and shadow to make the pattern obvious. Close-ups of details often show pattern more effectively than photographing the whole—such as the leaf patterns and the fir trees.

Emphasizing Texture

One of photography's special qualities is its ability to convey texture so realistically that you know what objects feel like just by looking at pictures.

The texture of a surface shows how it feels to the touch—whether it is rough or smooth, hard or soft. It is possible to take a picture of a group of objects—a piece of metal, an egg, some silk and an orange, for example—and give a really accurate impression of how each one would feel. In fact, wood grains can be printed on surfaces so convincingly that you have to touch them to tell genuine from fake.

TEXTURE FOR REALISM

The ability to convey texture is vital for photographs that are intended to look particularly realistic. You can see excellent examples in food and still-life photography, in which the photograph sometimes seems more real than the product. If you want an unreal quality, texture is the first thing to omit. For example, dream sequences in films are almost always shot with soft-focus attachments. To show texture, the image must be as sharp as you can get it.

Professionals specializing in still-life photographs often use large-format cameras to achieve a feeling of texture, but you can get good results with a smaller format. You must have the textured surface in precise focus, keep it very still, and set the lens aperture small enough for adequate depth of field. A fine-grain film is usually best for emphasizing texture.

▼ Michael Newton's use of soft, low-angled light works well with this range of textures, including fabric, paper and metal.

▶ Paul Forrester's skillful use of light emphasizes texture in this photograph. The combination of lighting angle and large depth of field gives good focus and defines textures very well in the foreground and middle area. Although this image was made on sheet film, similar quality is possible with 35mm color film.

Below right: Close camera position, precise focusing and shallow depth of field isolate the subject and emphasize its textural detail. Photo by Eric Crichton.

HOW LIGHT AFFECTS TEXTURE

The way you light an object to reveal texture depends on its surface. A subject with a coarse texture and wide range of tones, like the bark of a tree, can be photographed with a *large* front light. This gives *soft* light. However, a surface with a subtle texture that also has an even tone and color, such as an orange, should be lit so highlights and shadows are created within the tiny indentations of its surface. This means that the light source should be small and directed at the subject from an acute angle so the *hard* light literally skims across the surface.

With a subject with a more pronounced texture, such as a stone wall, slightly softer lighting at an acute angle is preferable. Otherwise shadows created by the indentations become too large and dense.

Shape is also important. With a flat surface such as a stone wall, light has the same effect over the whole surface, whereas the light on a rounded surface, such as an orange, varies.

As a general rule, subtle textures require harder and more directional lighting than surfaces with a more pronounced texture. But to achieve the best results, you have to be aware of the distribution of highlights and shadow tones, and the gradations between them, which the light creates on the surfaces of the subject. If you want textural quality above all else, you may find that your techniques create undesirable effects in other elements of the picture. In fashion photography, for example, the lighting used to bring out the texture of cloth may have an undesirable effect on the model's skin.

HOW TO ACCENT TEXTURE

One method of accentuating texture is to increase the contrast of the lighting, either by directing it from a sharper angle when it is controllable, like studio lighting, or by changing the camera position.

Aiming toward the sun is an effective way of doing this, especially when the sun is low in the sky. Don't point the camera directly at the sun, but position the camera

▶ A low sun will accentuate the texture of the sand, but also produces strong shadows. Bracketing exposures will result in a series of photos with the shadows lighter and darker, producing different renditions of the scene. Consider doing this when you have no control over the light. Photo by George Rodger.

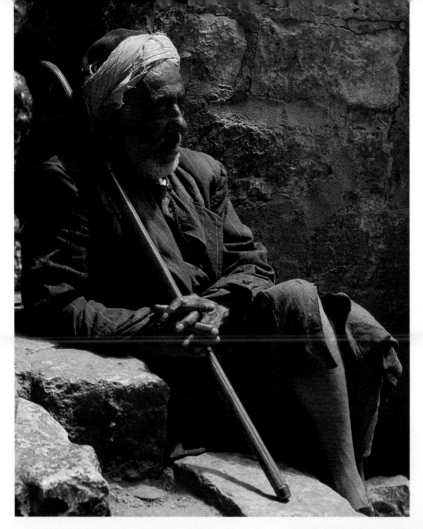

▲ Bark has a pronounced texture that is obvious in almost any light. Hard, directional light, which is good for emphasizing texture, often creates dense shadow and loss of shadow detail.

◀ Similarly, skin texture can be revealed by hard, directional light. This type of light is usually more effective on dark skin. On white skin, it tends to be unflattering. Photo by Michael Busselle.

▶ By moving in close, Eric Crichton emphasized the inherent texture of this cabbage. Here, soft light reveals delicate textures that would be lost in the shadows from a strong directional light.

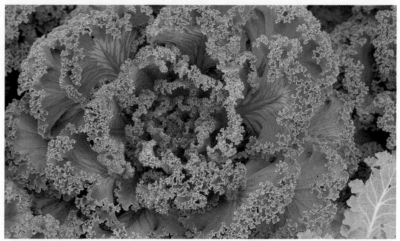

Below right: Texture like this peeling paint is emphasized by strong side lighting. The shadows imply a three-dimensional effect.

▼ In Colin Barker's picture of a leaf, the texture is made obvious by the extreme close-up view.

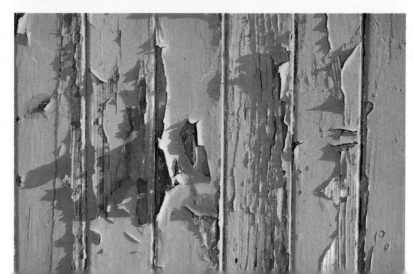

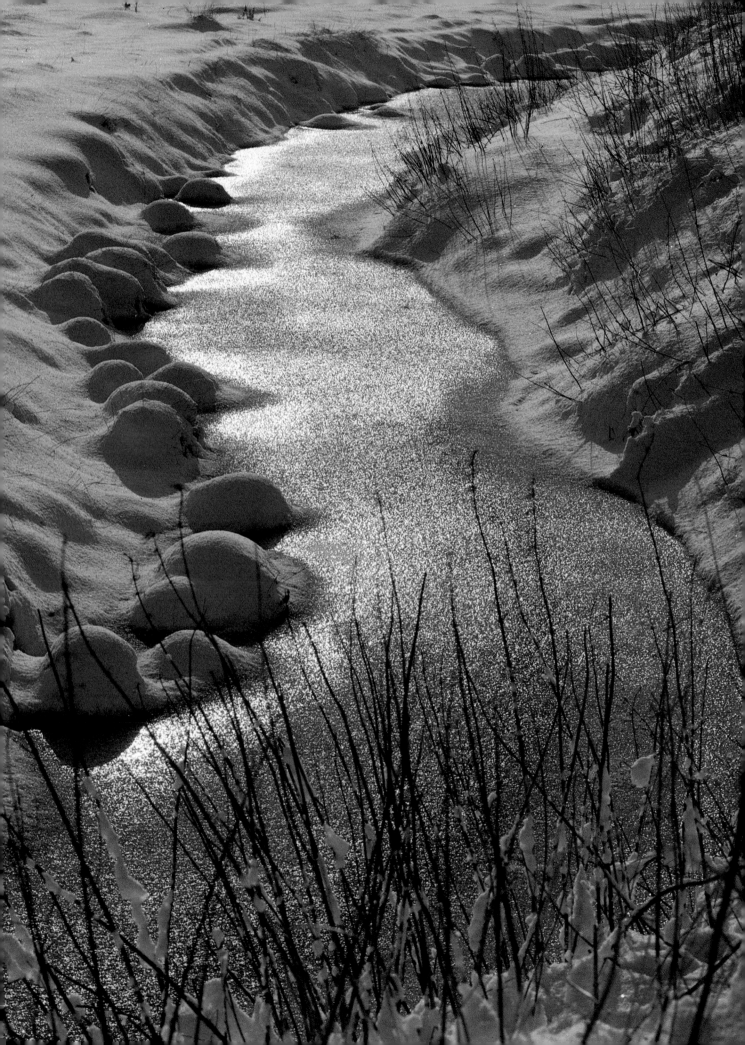

so its angle to the surface being photographed is roughly equal to the angle at which the sun strikes that surface.

Contrast can also be increased by choice of film—the slower the film the higher the contrast. In b&w photography, and with some color films, it is possible to increase the contrast by using special processing techniques. Although it is possible to create exaggerated effects this way, it reduces subtlety, and other elements of the picture may be sacrificed.

Exposure can often be used to accentuate texture, particularly if you use lighting with reasonably high contrast. In this situation, underexposure will often increase the textural quality of the subject. Skin tones in a portrait, for example, will have a stronger texture when they appear darker than usual—portraits of men often display this technique.

The opposite technique is used to minimize skin texture, as in fashion and beauty photography, where a soft, front light creating low contrast is often combined with overexposure for a more ethereal effect.

The key to a picture showing strong texture is a really sharp image. Although light, camera angle and exposure can all contribute, success ultimately depends on a sharp picture with good definition. Make sure you focus the camera accurately. Stop down to at least *f*-8. If this requires a slow shutter speed, use a tripod.

▲ Careful lighting and exposure control brings out skin texture in portraits, as in this one by Yousuf Karsh. Use this technique with care because it can also bring out unflattering blemishes.

◀ The picture at far left works as well in b&w as in color. Low back light creates strong highlights, shadow and sparkle. The strong highlights could cause a meter to suggest underexposure, so take a reading from a middle gray area or bracket exposures.

▶ Take away texture and you take away realism. Soft-focus effects result in a dreamy, romantic image.

TONE AND CONTRAST

Contrast is the relationship between the darkest and lightest tones. A photograph that has a full range of tones with detail in all but the brightest highlight is considered to be of normal contrast. One dominated by very light and very dark tones, with little tonal variation between them, is described as high contrast. When there is only a small difference between the brightest and darkest tones, you have a low-contrast image.

Contrast is partly controlled by lighting. A hard, directional light such as bright sunlight tends to create a high-contrast image. Very soft light—a heavily overcast day, for example—creates a low-contrast image.

COLOR AND CONTRAST

Light and dark colors within the subject give it contrast independent of that created by light. For example, a bride in a white wedding dress standing against a dark church door is a high-contrast subject, whereas the same bride standing against a white wall is a low-contrast subject. You can also control the contrast in photographs by the way you handle the lighting.

DEVELOPING AND PRINTING

In b&w photography, and to a lesser extent with some color films, it is possible to control contrast by varying development times; the longer the time, the greater the contrast. Conversely, less development means less contrast. Your choice of printing papers can also affect the contrast. A good book to get you started in the darkroom is HPBooks' *Do It in the Dark* by Tom Burk.

For a wide range of tones:
- Wait for—or create—softer, diffused lighting.
- Measure exposure carefully. If in doubt, make more than one exposure, using different settings.
- Develop and print according to manufacturer's instructions.

To increase contrast:
- Use harsh, direct light.
- Overexpose by about 1 step.
- Increase development and/or use a more contrasty printing paper.

To decrease contrast:
- Use soft, diffused light.
- Use soft-focus filters or accessories.
- Decrease development and/or use a less contrasty printing paper.

▲ Low-key pictures are usually found, not created. The somber, serious mood is helped by slight underexposure. Photo by Michael Busselle.

▼ A high-key picture has light tones with little contrast, but there are usually some areas of fine, bold detail in a darker tone, almost like a pencil sketch. Photo by Robin Laurance.

Top left: Back light, a slight haze and high contrast printing create a high-contrast image. Negative exposure needs to be enough to keep the light areas clean without unwanted detail in the foreground. Photo by Bob Kauders.

Above: This low-contrast image is the result of very soft light and a slight mist. If printing it yourself, use a soft grade of printing paper to accentuate this effect. Photo by Jonathan Bayer.

Left: The high contrast resulted from exposing for the very strong back light. Photo by Richard Tucker.

Below: This is an example of low contrast in color. The brightness range here is actually lower than it seems because there is so much color contrast. Photo by Michael Busselle.

Creating Silhouettes

A silhouette is the most elementary form an image can take. It is simply a dark shape on a light background. It is as interesting as the shape itself, yet silhouettes can tell a story in which the viewer mentally fills in the details. For example, the cut-out profiles of people often convey a strong likeness of the subject and reveal more than a little character.

Looking for silhouetted images is a good way to learn the basics of composition because the simple outlines show clearly how shapes within a frame relate to each other.

Shape alone is enough to identify some things, while others need more elements to be recognizable; the silhouette of a banana, for example, is enough to identify the subject, while the rounded outline of an orange is less easy to recognize.

HOW TO USE SILHOUETTES

A complete silhouette is rarely used in photography. A suggestion of color or tone, form or texture, or some background detail is usually included in the image.

The purpose of such an image is to concentrate the viewer's attention on the shape or outline of the subject. A silhouette showing subdued details, rather than one with the details completely blacked out, is an effective way of doing this. By using semi-silhouettes, something is left to the imagination, and this in itself can suggest mystery.

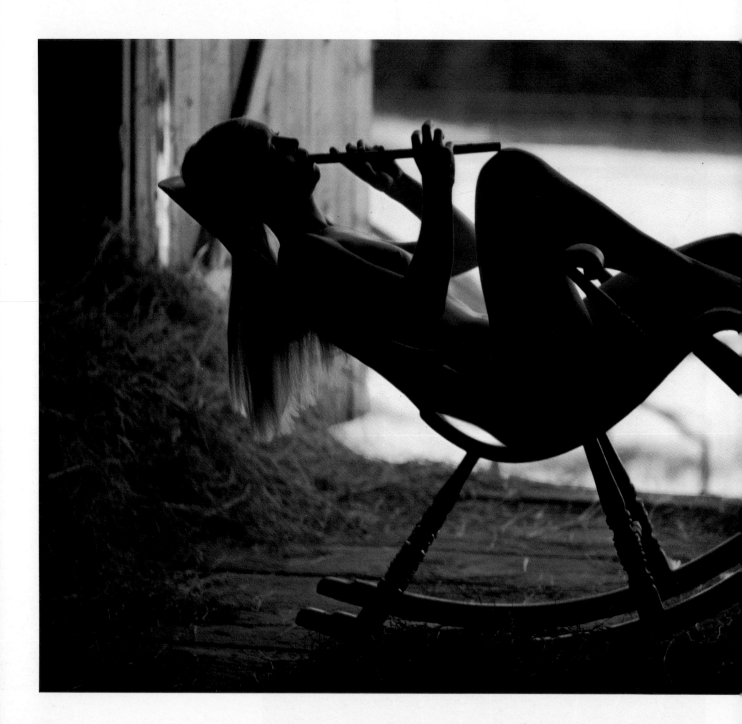

HOW TO CREATE SILHOUETTES

Silhouettes can be produced several ways: You can use natural or artificial light, shoot into the sun, or take advantage of foggy or misty conditions.

Natural Lighting—To create a silhouette, use a background that is brighter than the subject. A simple way to do this in natural light is to place the subject in front of a window or open doorway, with the light behind the subject. Outdoors, simply

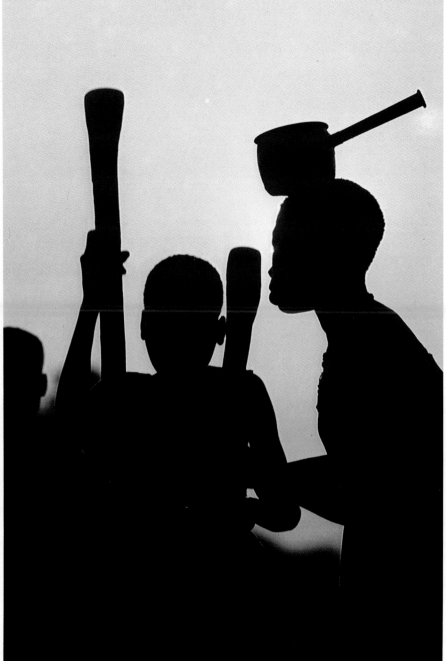

▲ This silhouette was created by shooting toward the sun. John Bulmer positioned himself so the sun was behind the figures. He determined exposure from the sky to underexpose foreground detail.

◄ The girl is carefully positioned in a doorway so both she and the rocking chair present a clear, explicit outline. Photo by Michael Boys.

► Silhouettes can frame a photograph too. They can provide foreground emphasis without competing with the main subject.

photograph the subject against the sky. Base exposure on the brightness of the background and the subject will appear in silhouette.

Studio Lighting—With studio lighting it is possible to control the light more precisely than with natural lighting. Limit the light falling on the subject and be sure it illuminates only the background.

In all cases, it is important that exposure readings be taken only from lit background areas to be sure that the subject itself remains as an underexposed dark tone.

The Sun—Shooting toward the sun is a convenient way of producing a silhouette, especially if the background has a light tone, such as water, sand or sky. Again, expose for the highlight areas. Shield the lens from direct sunlight because this can cause flare and lower image contrast that reduces the effect of the silhouette. Even a lens hood is not always adequate protection when pointing the camera toward the sun. A useful trick is to throw a shadow over the lens by holding your hand or an 18 to 20 inch (0.5m) piece of cardboard in front of the lens—out of the field of view of the lens, of course. *Never look directly at the sun through the viewfinder or any other optical instrument.*

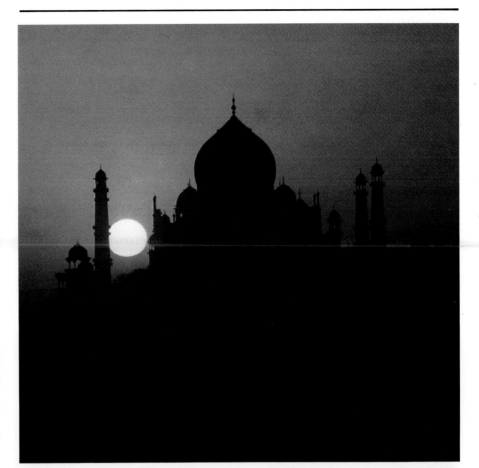

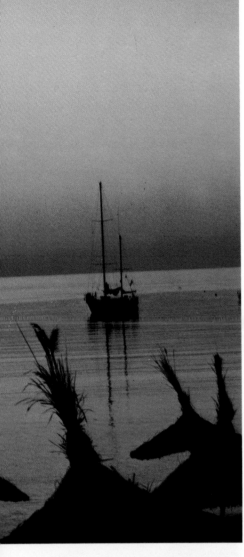

▲ Low back lighting can create interesting silhouettes with reflected highlights. Using a light reading taken from the sky darkens the silhouettes. Photo by Peter Myers.

▶ Right: When shooting toward the sun, consider how important its placement is. With the sun rising, the light is strong, resulting in high contrast and a black silhouette. Before dawn, the softer light reflected from the sky creates less contrast. The top picture was exposed for sky. The lower one was exposed for the building. Photos by George Rodger.

◀ Far left: You can find good silhouette subjects almost anywhere. A sunset framed by a pattern of leaves is more interesting than a sunset alone. Photo by George Rodger.

◀ Left: Look for unusual shapes. The dramatic diagonal was created by shooting from a low position, looking up. Placing the sun behind the subject increased contrast. Photo by Spike Powell.

◀ A background of mist, and a low camera position created this bold image. The mist stops flare from the sun by veiling it. Note how the silhouette emphasizes the tension of the fishing rod.

Below left: For this photograph, Chris Smith aimed into the sun, which is masked by one of the figures. He used a low camera position to be sure the cyclists made clean, clear shapes against the sky.

▼ Camera position here is important. Michael Busselle moved in slowly until the moment the deer were clearly on the horizon.

Fog and Night Lights—Fog or mist subdues background details so only the objects in the immediate foreground are seen clearly. This is another way of creating silhouetted images. A complex subject like a woodland scene can be reduced to an image of stark simplicity in mist or fog, especially when combined with back lighting. Street scenes at night can also result in bold silhouetted pictures under these conditions.

Exposure for subjects like these is fairly critical. Too little will produce muddy tones in the background and too much will weaken the silhouette effect. A useful method is to take an average from both the darker foreground and the brightest highlight in the background.

SILHOUETTE AND VIEWPOINT

Viewpoint is always one of the most vital decisions a photographer has to make. By finding a position that gives a silhouette effect to your subject, you achieve one of the main aims of good composition—separating the center of interest from the background. Of course there are other ways of doing this, such as using selective focus or color variation, but a viewpoint that results in a bold tonal contrast between the subject and its background is basic and often the most effective.

You may need to move to the right or left to place a highlight tone in the background behind the subject.

A low viewpoint allows the subject to be silhouetted against the sky. You can shoot from ground level to increase this effect. In addition to the silhouetting effect, a low viewpoint invariably adds impact to a picture. Conversely, a higher-than-normal viewpoint often removes unwanted background tone and detail—as little as 1 foot (30cm) can make a big difference. This is why many professional photographers prefer rigid camera cases they can stand on to give them a slightly higher viewpoint when nothing else is available.

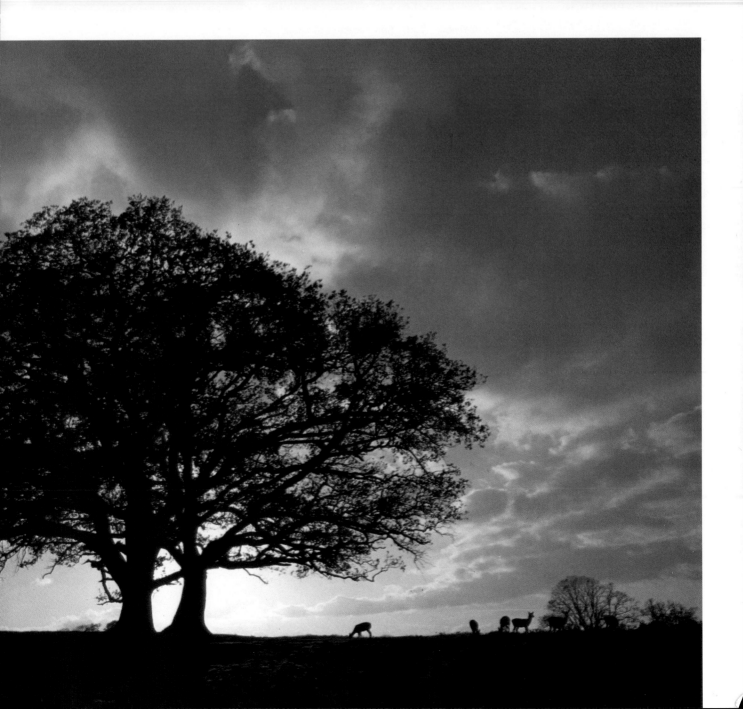

The Photo Essay

A photo essay is a series of individual photographs used together to tell a story or illustrate an idea. You can make an essay in many ways. Like a series of scenes in a motion picture, there must be a sense of continuity from one picture to the next.

A picture essay is a good way to give some direction to your photography. It is often frustrating to just "look" for scenes to photograph. By making an essay about something you find interesting, you can explore a subject in depth and have a reason for taking each picture. By making many pictures of a subject, you can tell the viewer more about your subject than you can in a single photo.

PLAN YOUR APPROACH

Before starting, it is important to plan the approach you want to take. Perhaps the final presentation will be a slide show. Or, you could have color or b&w prints made to put into an album in a magazine-type format. Some people make 8x10 or 11x14 inch enlargements and mount them for display. Each of these uses may demand different considerations of film, camera, and lens selection. When you know what you want to do, you are better able to organize. You waste less film and time.

This type of photography usually requires a lot of film. If you try to economize, you may end up with only half a story. It is better to take more pictures than you need and edit them later. This applies to all picture essays, even the most carefully planned ones.

Don't expect to take all of the pictures in the order of presentation. The first picture you make may be used last. Perhaps you'll want to make the most important pictures all at once and do detail shots later. You can arrange the order of the photos in any way you want. Make a list of photos to remind yourself of what you've shot and what else needs to be photographed. If you see something interesting that is not on your list, make a picture anyway! You may want to use it eventually.

CHOOSING A SUBJECT

Before planning a photo essay, you must first select a suitable subject. For your first essay, choose a simple, nearby subject you can photograph in a reasonably short time, such as a series of photos showing how to make bread or ride a bicycle. If you miss an essential shot the first time out, you don't want to have to travel a great distance for a reshoot!

When planning a photo essay, make a list of photographs that are essential to the story. For example, for an essay on glass blowing, Peter O'Rourke knew that he must include a picture of molten glass being worked with a tool (above), the furnace (below) and, most important, one of glass being blown (right). Photographs like these provide the basic information—the framework on which to build the rest of the story. Add more pictures to fill the gaps.

The most suitable subjects can be divided into four categories—people, events, places and themes. The main consideration is that they should be interesting enough to warrant more than one picture to tell a story.

PEOPLE

We are always interested in the lives of other people, no matter how ordinary or famous. Your subject doesn't have to be a public figure. In fact, you will find that photographing a local person or a member of your own family is more practical and more interesting to you than photographing somebody famous.

Planning—When you've chosen the subject, decide on the approach you want to take. You could choose a special occasion in the person's life, such as a birthday party. If your subject is a painter, you could use the progress of his work on a certain painting as the main focus.

Roughly plot out a story before you begin shooting. Decide how much of the person or events you want to cover. Make a list of what you think will be the most interesting moments.

Consider potential problems and schedules. Can you do all of the shooting in one day, or will it take many days? Can you reshoot if you make a mistake, or is it a one-chance opportunity?

Consider which lenses and types of film you'll need to make the pictures most interesting. A variety of photographic effects can make a story work. These ideas may change later as you become more involved in the project, but they give you some basic organization at the start.

Different Approaches—One approach is to follow your subject through a typical day. Create a chronological story. For example, start with him getting up in the morning, follow him through his day, and end with him getting back into bed. This treatment has a definite beginning and end, just like a satisfying story. The middle part of the essay contains the details.

The last picture of the essay does not have to be the most important, but if it is, you should record the significant moments and steps that lead up to it. Establish a continuity between each step and the eventual outcome.

Another idea is to make a series of portraits of one person. This can be a long-term project that has no definite beginning or end. Each picture can show a different viewpoint or interpretation of the person.

If you photograph a group, such as a football team or a choir, you can either treat the group as one unit or emphasize individual members. The choice is yours.

EVENTS

When you build your photo essay around an event rather than a person, you can have more variety in your pictures. Instead of concentrating on an individual, you can include relevant surroundings, such as buildings, plants, signs, cars and various people involved in the activity.

One of the most obvious and rewarding events to photograph is a wedding. You may also want to photograph a trip to the races, a parade or a special festival.

Setting the Scene—The first shot should set the scene, such as showing the location before anyone has arrived, or an overall view from a high vantage point. This gives the viewer a reference point for the pictures that follow.

The metal vats on the right are the modern way of storing wine before bottling it. Traditionally, wine was stored in wooden casks like those below. Details in the photo below include old wine labels on the wall and ancient tools of the trade on the table. This helps tell a comprehensive story about the subject. Comparison pictures like these are interesting in a picture essay, even if you hadn't planned for them.

◄Not only should all the photos work together, but each photo should be good when viewed alone. Control composition, lighting, and exposure carefully. The better each individual photograph is, the more impact the essay will have.

▼This is the final photo of the essay. It summarizes the story. For this shot, Sims left the vineyards and went into the town to find a shop selling the finished product.

Creative Color _____ 4

Contents

The Vocabulary of Color

It is useful and interesting to know why colors react with each other the way they do. Why, for example, does a green leaf look different when viewed against a white wall. A blue sky? A red flower?

HOW COLORS INTERACT

There are three basic ways colors interact. They *contrast, harmonize* or *clash.* These reactions are, to some extent, due to the relative location of colors in the *spectrum.* The spectrum is the range of colors that make white light, such as that from the sun. Colors of the spectrum are red, orange, yellow, green, cyan and blue. You see the spectrum in a rainbow.

The two small color wheels on the facing page show the *primary* and the *complementary* colors. The primary colors of light are red, blue and green. Artists working with pigments define the three primary colors differently. The complementary colors are cyan, magenta and yellow, formed as shown on the illustration.

Notice that the two small color wheels combine to make the color wheel in the center. Clockwise from the top the colors are yellow, green, cyan, blue, magenta, red. On the large wheel, *harmonizing* colors are adjacent. Contrasting colors are separated by another color. Red and green are contrasting colors. Colors that clash are opposite on the wheel—green and magenta, for example.

COLOR QUALITIES

The rules given here for harmony, contrast and clashing are generally true. You will find that sometimes—such as on a hazy day—colors that normally contrast seem to harmonize. This happens because the strength and brilliance of the colors are reduced.

The strength or impact of color depends upon three factors: *hue, saturation* and *brightness.*

The *hue* is the basic color that distinguishes one color from another—blue from red, for example.

Saturation is the purity of hue. A saturated green, for example, is composed only of pure green.

The *brightness* of a color is the characteristic we describe when we say a color is light or dark. A bright color seems to reflect more light than a dark one.

The hues shown in the color wheels are fully saturated, pure color. They become desaturated by the addition of either black (shadow) or white (light). Adding light makes the color more pale, producing a *tint.* Adding black, by covering the color with a shadow, gives a *shade.* See the diagram, center right.

A hazy day desaturates color because of the white haze between your eye and a distant color. This weakens a color's strength, making color harmony more likely. A very bright day can also have a similar effect. The strong light becomes glaring when reflected from some surfaces. This glare can desaturate colors.

▶ This range of blue colors shows the principle of *desaturation.* The fully saturated blue panel in the middle occurs in average lighting conditions. The desaturated areas on either side are created by adding white or black—or by illuminating the center panel with brighter and darker light. Bright light makes tints, and weak light or shadow makes shades.

The pictures along the bottom of these two pages show six basic ideas that can improve your color photos.

COLOR AS THE SUBJECT

COLOR CONTRAST

COLOR HARMONY

Red, blue and green are the *primary* colors of light. All three together make white light. Artists who use *pigment* colors consider the primary colors red, blue and yellow, but these are actually the three *complementary* colors shown at far right.

THE COLOR WHEEL
It shows the primary and complementary colors of light.

The *complementary colors* of light are formed by combining two primaries. Red and blue make magenta, blue and green make cyan, and red and green make yellow.

ACCENT COLOR

MONOCHROMATIC

POLYCHROMATIC

Color as the Subject

▲ The strength of this picture by Ed Buziak is due to the strong contrast between red and green. This impact has been emphasized by the exclusion of all other elements.

There may be times when the color of an object has greater impact on you than the object itself—a pile of fruit in a market, for example. In this case, you can compose the scene to make color, not form, the subject of your picture. In the example of the market, you may take an overall view of the scene conveying the mood of the place and then photograph some details—flowers or a pile of oranges—that have no special meaning other than the impact of bright colors.

LIMITING COLORS

To take a successful picture of just color, you will often find it most effective to move in close to the subject. This will eliminate distracting elements from the field of view. Or, use a neutral background or foreground for vivid color contrast.

In a scene of mixed colors, strong ones tend to dominate and flatten form. Although it *is* possible to produce a pleasing picture from a mass of mixed color, you will achieve a more dramatic and probably more satisfactory result by restricting the number of hues to one or two. Isolating a couple of cars, for example, emphasizes color more than a photo of the whole parking lot.

STRENGTHENING COLOR

When you want to record only a color's impact, there are several ways to strengthen the color without using special accessories.

Use Natural Contrast—Select a camera viewpoint so a very pale or very dark neutral area either frames your subject or acts

as the background. The lack of surrounding color emphasizes subject color.

Move In—The closer you are to the color, the more it fills the frame and the stronger it appears. Don't get so close that the subject loses contrast with the surroundings.

Use Soft Light—Strong, bold colors are most effectively illuminated by *soft lighting*. This is light produced by a source that is relatively large compared to the subject, such as light from an overcast sky. This eliminates strong highlight and shadow areas that desaturate color.

Colored objects do not necessarily have to be very interesting to make a good photograph. In all of these photographs, color, not the subject, captured the imagination of the photographer.

▲ The neighbors may not like this wall, but it makes a good picture! By limiting the number of colors in the composition, John Sims stressed the liveliness of the painted red bricks.

▼ Eliminate glare from shiny surfaces by carefully choosing viewpoint. Robin Laurance moved in on a detail of this car to control reflection.

▼ In this composition, your eye returns to the dark window as a focal point.

▶ Color contrast with the neutral background makes these colorful capes stand out brilliantly on an overcast day. Photo by Suzanne Hill.

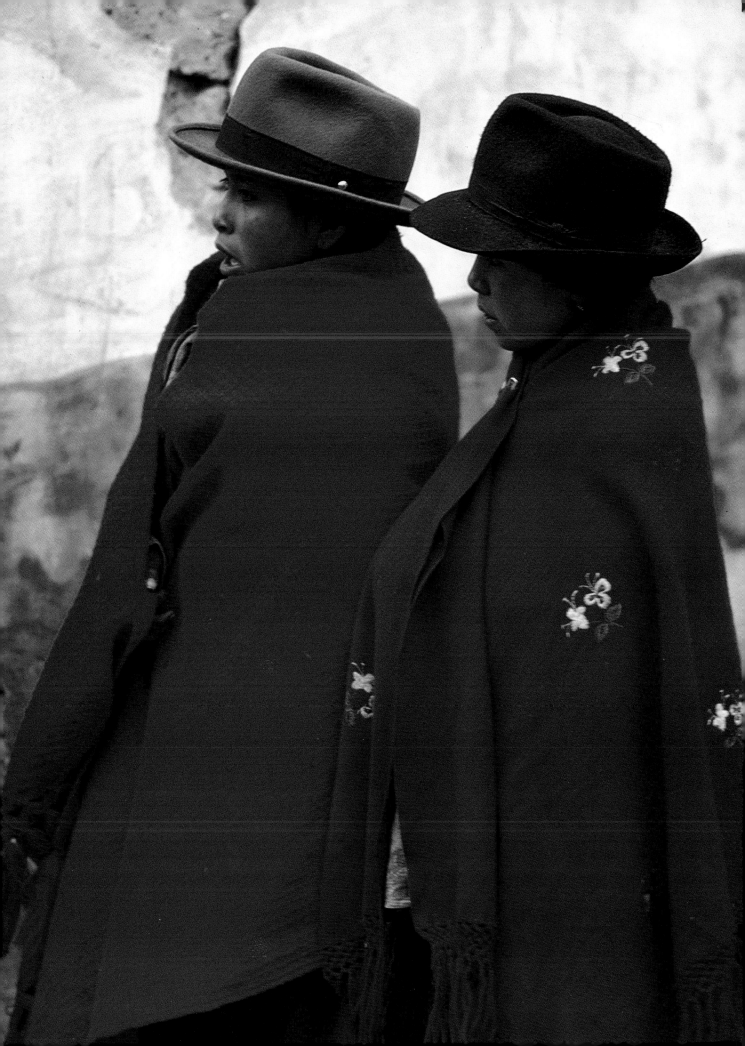

Eliminate Glare—Reflection or glare from subject surfaces weakens color. To bring out true colors, position the camera at an angle so it doesn't "see" reflected highlights.

Other Methods—To strengthen color photographically, use colored filters to boost a weak color. Polarizing filters help stop some glare and reflections. Underexposure by about a third or half step increases the saturation of color in a processed slide.

KEEP DESIGN SIMPLE

A mass of complex elements within the scene is as destructive to a color composition as too many hues. Each element will compete with others for the viewer's attention. Therefore, when using color as the subject, it is essential to strive for simple design.

Sometimes you can achieve this by selecting scenes with one overall color and introducing visual variety with a range of brightnesses, such as in a sunlit woodland landscape. Moving in on the subject helps eliminate unwanted surroundings and keeps the composition as simple as possible.

With practice you will become a good judge of effective balance between color and design. If the color scheme is complex, make the design simple. If the color scheme is simple, then the design can be more complex.

EXPERIMENTING WITH COLOR

Start with an uncomplicated subject with an attractive color—a painted mailbox, for example. Photograph the whole subject from different distances and angles, in various lighting conditions, and with different exposures. Color slide film is best for this experiment.

The results should give you a good idea of how best to capture color with your camera. You can draw on this experience to solve more challenging problems.

Facing page: Michael Busselle found this abstract picture after carefully observing a group of overturned boats. He chose his viewpoint carefully to use the small area of bright color and keep the design as simple as possible.

◄ When photographing a detailed subject, you may find that the subject dominates the color. Photo by Michael Busselle.

▼ You can strengthen a weak color by using a filter on the front of the lens. For this photo an orange filter exaggerated the effect of evening sunlight on water.

▼ For this simple composition, Ron Boardman used a polarizing filter to darken blue sky and slightly underexposed slide film by a half step to increase the saturation of blue and red.

Color Contrast

Your reaction to a color depends not only on the color itself, but also on other colors near it. Red, for example, looks brighter and warmer when near blue. Blue appears colder and more subdued when near red. This effect is called *color contrast.*

The impact of color contrast is considerable. By carefully controlling it in your pictures, you can achieve dramatic results.

HOW COLORS CONTRAST

Determining which colors contrast and which clash is largely a matter of personal taste. Generally, the more extreme the color qualities, the greater the contrast.

Strong primary colors contrast with each other. This is frequently seen in nature, as shown in the picture of the red poppy. Strong complementary colors also contrast with each other.

A bright color contrasts with a dark color. Primrose yellow will make navy blue appear even darker, and the yellow will seem to shine against the dark blue.

The contrast between warm and cold colors is strong, as shown by red and blue.

Bright colors contrast with the neutral colors—white, gray, and black. For example, green leaves are effectively contrasted against the gray background of an overcast sky.

Tones may contrast. A rich, dark red, for example, will contrast with a pale, pastel pink. The tonal difference provides the contrast, even though the colors appear to harmonize.

ARRANGING AND COMPOSING

Make color contrast work in your pictures by controlling it. When you arrange a still-life, you have maximum control. Introduce color contrast in a still-life by moving the objects around for the best effects between the objects or between the objects and the background. You can do similar things when photographing people. For example, if you are photographing a group of people dressed in similar clothing, choose a setting that contrasts with the clothes.

Although exploiting color contrasts in a natural or urban scene is more difficult, you should still exert some control. Find an area of color that contrasts with the surroundings. You can effectively contrast a

▲ For this photo, John McGovren carefully balanced the contrast between purple and bright chrome.

▲ The strong contrast of primary colors adds to the dramatic effect of this picture. To darken the blue sky, John Sims used a polarizing filter on his lens.

◄ Nature provides good examples of color contrast. Some plants have evolved this way to attract birds and insects for pollination. Photo by Bryn Campbell.

▶ Here, contrast of primary colors is combined with tonal contrast. Bright subjects are set off sharply against the dark background. Photo by Les Dyson.

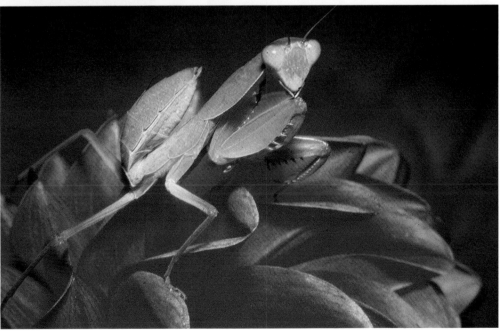

single wild flower with the tones and colors of a green meadow if you take the trouble to find a proper viewpoint. Or, you can use a low viewpoint to contrast the subject against the sky.

Standard rules of composition apply when you work with color contrast. It is important to remember that the area of greatest contrast will tend to dominate the picture. Make sure that the area of strong contrast is either part of the main subject or is related to it. It can then contribute to the composition without being distracting.

You will also find that more than one area of strong, contrasting colors in a photo may confuse the picture. Achieve a balance by varying the proportions of the colors that contrast. One red apple in a blue dish containing mostly green fruit, for example, will be more striking than the same dish holding half green apples and half red.

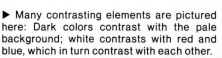
▶ Many contrasting elements are pictured here: Dark colors contrast with the pale background; white contrasts with red and blue, which in turn contrast with each other.

▲ Choice of viewpoint is an important element of composition. In this picture, Colin Barker emphasized the warmth and purity of orange by choosing a low viewpoint, bringing in blue sky as a background. A polarizing filter darkened the blue sky..

► Imagine a photo of this scene in summer when the snow has melted and color contrast has changed to color harmony. Natural scenes are constantly changing. Consider photographing their many moods. Photo by Michael Busselle.

▼ To emphasize color contrast of the main subject, put the background out of focus by selecting a large lens aperture, or move in close. Or both.

▲ The strongest color contrast is between a primary color and its complement—here, blue and its complement yellow. Contrast between dark and light is also a feature of this photo by Robin Laurance. Notice how the yellow appears to shine next to dark blue. The absence of excessive detail increases the impact.

Color Harmony

Harmony is possibly the most subtle and evocative of all the reactions among colors. Use it to establish the mood of your pictures. Contrast is dramatic and emphasizes the subject, often at the expense of mood. Pictures with clashing color are usually confusing.

Color harmony in your pictures can evoke feelings of romance and of peace, but it can also reflect the gloom of an industrial landscape, the anger of stormy weather, the heat of the desert, or the bleakness of bare mountains.

HOW COLORS HARMONIZE

Generally, harmony exists between adjacent hues of the color wheel, shown on page 119. For example, harmony occurs between yellow and green. Colors with the same warm and cold characteristics also harmonize. This frequently happens in nature—the reds and browns in an autumn scene or the yellows and greens in a spring landscape.

HARMONY AND VIEWPOINT

One of the easiest ways to make better pictures is to be selective when composing.

With most scenes, your choice of viewpoint is the most important control. This is particularly true with color harmony.

In a landscape of green fields and blue sky, for example, a foreground of red flowers is intrusive if you want to achieve color harmony. Exclude red from the photograph by choosing a suitable viewpoint or by changing lenses, and you will establish color harmony.

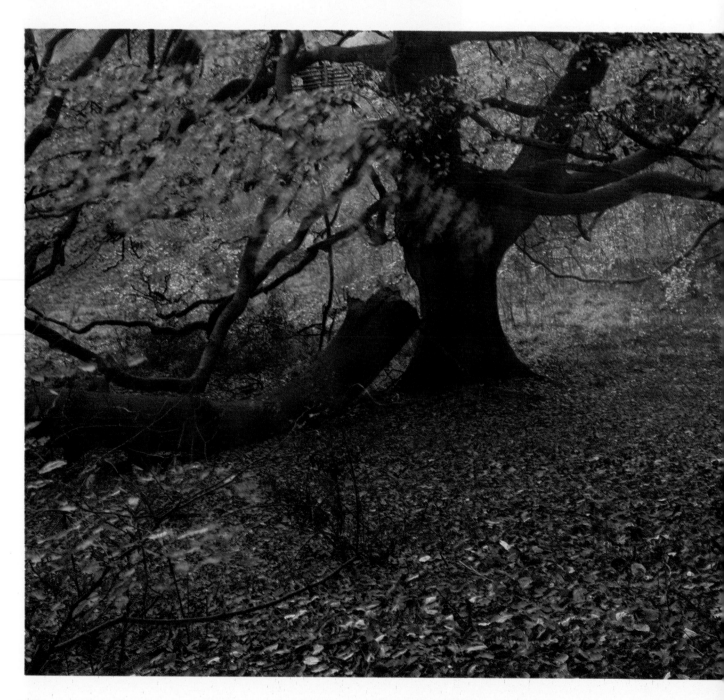

130

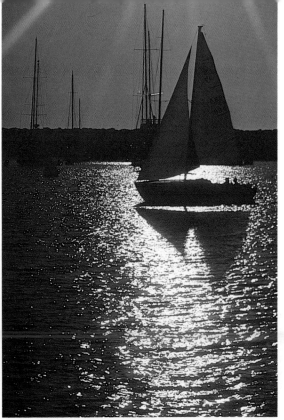

◄ Exposing for the light when shooting into the light creates silhouettes and underexposes areas in shadow. Colors become darker and are more likely to be in harmony. With normal exposure, the white sail would contrast with the surroundings. By controlling exposure, John McGovren silhouetted the boat and created a harmonious effect.

▼ Autumn provides spectacular examples of color harmony. Trees and dead leaves have a harmonious mixture of oranges, reds, yellows and browns. Mike Burgess used an amber filter to accentuate the warmth of autumn colors.

▼ This is an example of color harmony in nature—white and gray clouds, three colors of sand, blue sky, green trees and water. Photo by Clive Sawyer.

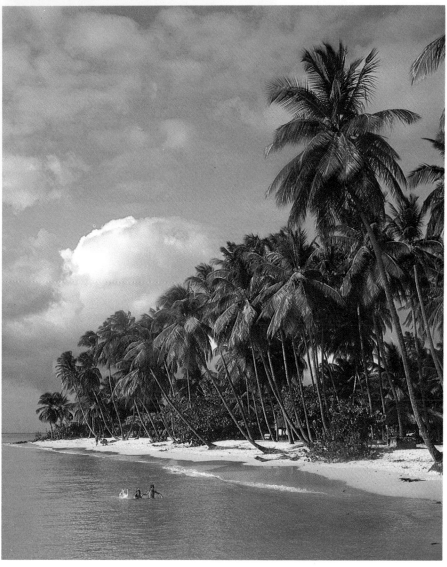

CREATING COLOR HARMONY

If harmony is important to a scene that has contrasting or clashing colors, try weakening the offending colors. You can do this photographically so colors blend together more. One way to do this when using slide film is with exposure control. Overexposure lightens colors, and underexposure darkens them.

In either case, contrast is weakened, and the desaturated colors give a more harmonious effect. Slight overexposure is more suitable for dreamy, quiet pictures. Underexposure is better for a more somber or gloomy effect. You can experiment by bracketing around the normal exposure by one or two steps in half-step increments. With color negatives, you can produce these effects during printing. If your negatives are printed by a commercial lab, the effect you created on the negative may be removed by automatic machine corrections.

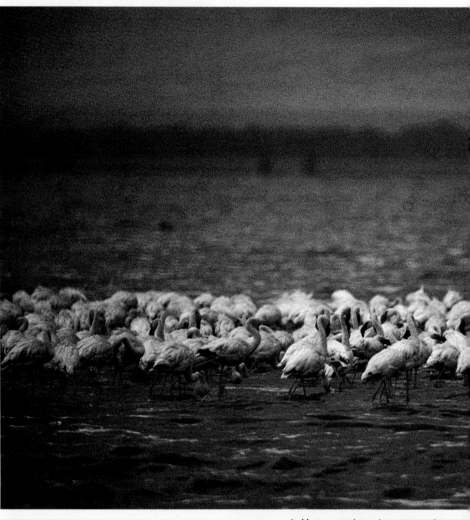

▲ Here, color harmony is emphasized at the expense of detail. A high-speed film and a 500mm telephoto lens were used. Most of the background is out of focus, softening colors. In addition, the whole scene has a pink cast, which harmonizes with the color of the flamingoes. Photo by John Garrett.

◄ Weather conditions have a great effect on color relationships. In this picture the early morning mist has created a blue cast over the whole scene, harmonizing colors. The photographer exaggerated the effect by using a pale blue filter over the lens.

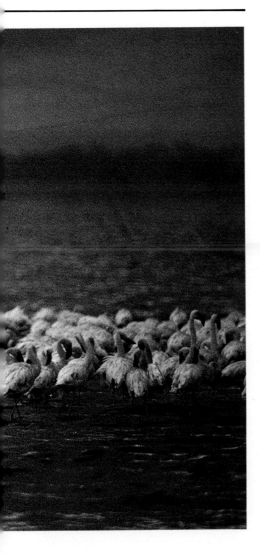

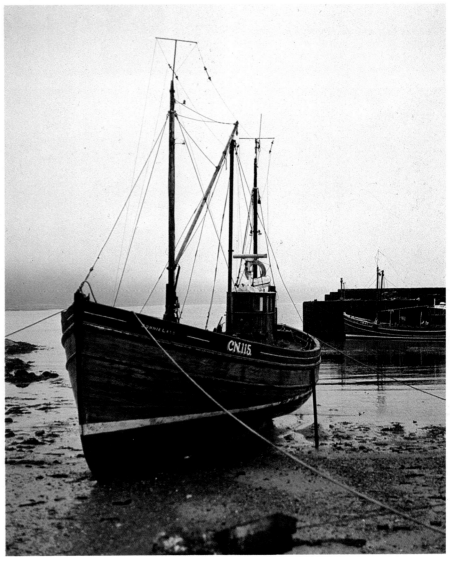

◄ A soft-focus lens attachment over the camera lens diffuses the image-forming light. This mixes and softens bright colors. Photo by Michael Busselle.

▼ Soft, misty light and dark brown colors combine to give bleak harmony. Photo by Gary Ede.

Another way to create harmony by reducing color saturation is by shooting into the light. This induces *flare* as the light shines into the lens. Flare is unfocused, non-image-forming light that exposes film. It tends to lighten shadow areas and make the focused image look less sharp. The effect is similar to overexposure but is more difficult to control.

You can also experiment with pale color filters to produce an overall harmonizing color cast. Do this by using a filter of the same color as the main color in the scene. For example, a scene may look predominantly bluish-green but have an offending patch of yellow. In this case a pale blue filter will be most effective. It will have a relatively small effect on blues and greens but will neutralize yellow.

Soft-focus lens accessories spread light around the image. This mixes and desaturates colors a bit. Sometimes this will tone down color and induce color harmony.

133

Accent Color

Unless the overall effect of a photo is particularly striking, most pictures need a *focal point* of main interest. This point attracts the viewer's attention first. Then his eyes scan the picture and periodically return to the focal point.

Create a focal point with careful framing and choice of viewpoint. Try to make the focal point a spot of contrasting color to provide the emphasis the picture needs for more impact.

For example, the red clothing of the small boy on the steps in the accompanying photo provides a focus for attention. It also gives depth and scale to the two-dimensional image. This is another advantage of accent color.

It is significant that the accent color in this example is red. As already mentioned, red is a lively color. It almost leaps at you

▼ Color accent can be highlighted by careful exposure. When you have an example like this, bracket exposures to be sure you get a good photo. Photo by Ernst Haas.

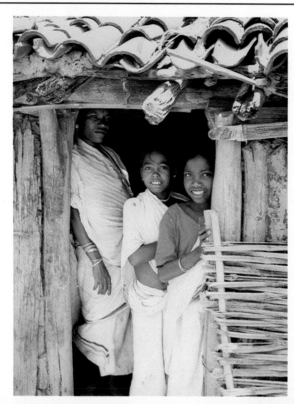

◄ One small splash of color in a monochromatic picture has a powerful effect. At first, it draws attention to itself. If the photograph is carefully composed with the accent off-center, the composition then leads you into the more subdued areas. Photo by Libuse Taylor.

▶ As this picture by Patrick Thurston shows, one small patch of bright color can often improve a photo by adding depth, scale and a focal point of interest.

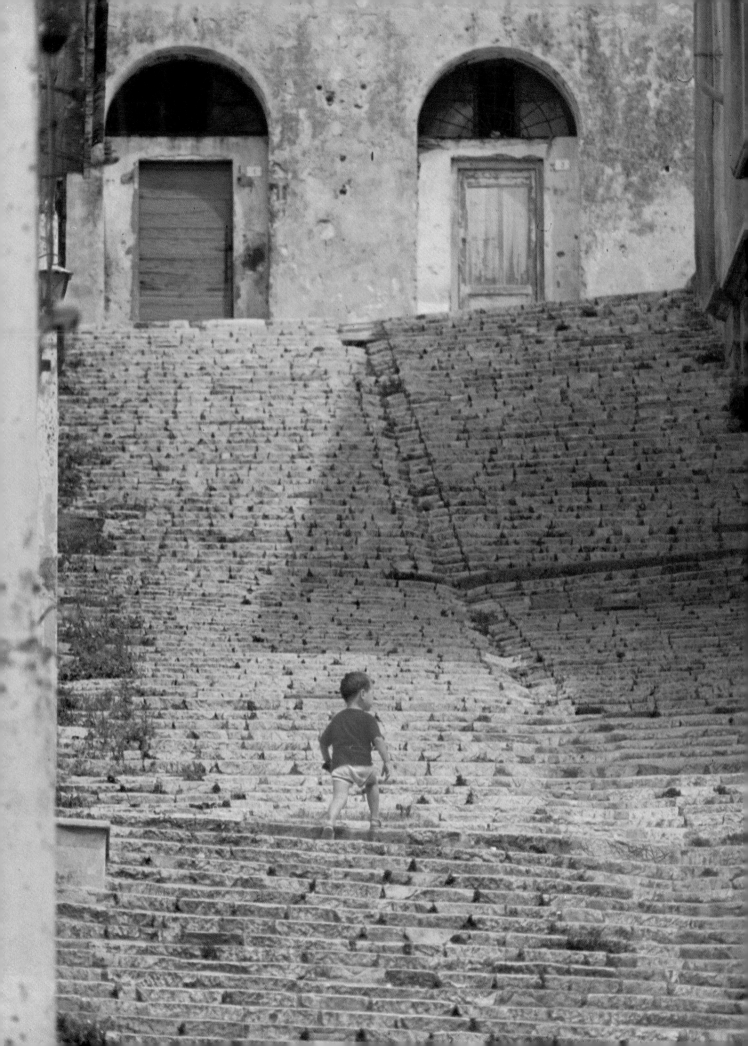

from its surroundings. You will generally find that the warm colors—red, yellow, and orange—are best for a focal point, especially if they are strong and bright.

In dull surroundings, however, any bright color will stand out. If there is sufficient tonal contrast, bright blue or green may serve equally well as an accent.

EXPOSURE AND COMPOSITION

An accent color is often useful for giving a monochromatic (single-color) setting more interest. For maximum color intensity of the accent, try slightly underexposing the main subject. This emphasizes the brightness of the spot of color.

Be careful to keep it small, and choose a viewpoint so the viewer's eyes are led from the focal point to the rest of the picture. If the accent color is too large or in the center of the picture, it assumes an importance out of proportion to its function as an accent. Look at the pictures reproduced here and see how your eyes are left free to explore the rest of the scene after the initial attraction of the accent color.

INTERIORS

Although you normally find accent color enhancing outdoor scenes, you can also use it to add interest to interior photos. Inside you have more control over the composition, so you can place an accent where it contributes most. A vase of roses strategically placed in the corner of a room, or a bowl of brightly colored fruit on a table, will draw attention not only to that point but also to other details around it.

After attracting your attention, the accent color interests you in the rest of the picture. Think of it this way and you will never underestimate its value.

▶ Photographing a landscape is more difficult than many photographers think. Without a focal point of interest, even a magnificent view seems to become insignificant in a print. John Bulmer solved the problem by including the huntsman. The red jacket attracts your attention and puts the scene in perspective.

▲ Photographs of interiors can be busier than exterior shots. Here, a strategically placed orange accent provides a focal point from which your eyes explore the scene. Photo by Valerie Conway.

▲ When composing with a color accent, try placing the area of bright color off center. This usually creates a more dynamic scene. Photo by Bryn Campbell.

▼ In this picture, the yellow accent balances the composition. Keep the accent small, so it doesn't dominate the picture and detract from the main subject. Photo by Robin Laurance.

Soft and Pale Colors

When taking photographs, you may overlook soft, pale colors and dismiss such a scene as dull. But if you look at successful color photographs, you will see that many are not bright and full of color. A photo with soft colors can be just as expressive as one with strong colors.

The weathered stonework of an old building, for example, is basically a single color with slightly different brightnesses. Its single color gives it a warmth and mellowness that can't be conveyed in a b&w print. You will also find that soft color is an advantage when you photograph a highly detailed or textured subject. The viewer can concentrate on the picture detail without being distracted by areas of strong color.

THE EFFECT OF LIGHT

A monochromatic photograph has only a single color. However, it is possible for a picture to appear monochromatic even if the subject is multicolored (polychromatic). This usually occurs when the light level is low, making colors desaturated. The whole picture then assumes the quality of the light, sometimes making a more interesting photograph than one made under more conventional conditions.

For example, the diffused light of a misty morning is ideal for dreamy, evocative pictures. The brighter light of day will strengthen colors and change the mood. Overexposure of about 1/2 step with slide film will exaggerate the effect by washing out the colors slightly.

▼ The weathered stonework of this old building beautifully illustrates the subtlety of muted color. The colors create a warm and gentle mood that neither strong color nor b&w tones can possibly convey. Photo by Eric Crichton.

The diffused light of a misty morning (far left), or the haze of a hot summer day (above) provides ideal conditions for photographing muted color. In the picture above Graeme Harris used a pink filter to increase the warm cast from the setting sun. For the forest photo, Michael Busselle focused on the foreground to increase the misty effect of the background.

◄ Without the distraction of bright colors, your eyes tend to concentrate on detail. In this picture slight overexposure muted the color, but still retained the cold, hard quality of the metal. Photo by J. P. Howe.

OTHER WAYS

You can experiment with soft, pale colors by photographing a normally bright subject through material that diffuses the light. Try photographing a person through a lacy curtain, or a landscape through a rain-drenched window. Focus on the subject so the diffusing material is out of focus.

Soft-focus lens accessories also accentuate soft color. The conventional way to do this is with a screw-in, soft-focus lens accessory. Several types are available from your camera dealer. They give various degrees of soft focus.

You can smear petroleum jelly on a UV filter or stretch a nylon stocking over the lens to produce a similar effect.

▲ Shooting through a rain-drenched window is a good way to experiment with muted color. Focus on the glass.

▼ Some scenes of clouds and water produce a natural blue color cast in a photograph—perfect for taking moody monochromatic pictures. Photo by Robin Laurance.

▲ Nature often shows muted colors. Even though the subject lacks brightness, it has striking detail and texture.

▶ A mood was created by soft focus and a monochromatic scene. Slight overexposure adds to the softening effect. Photo by Martin Riedl.

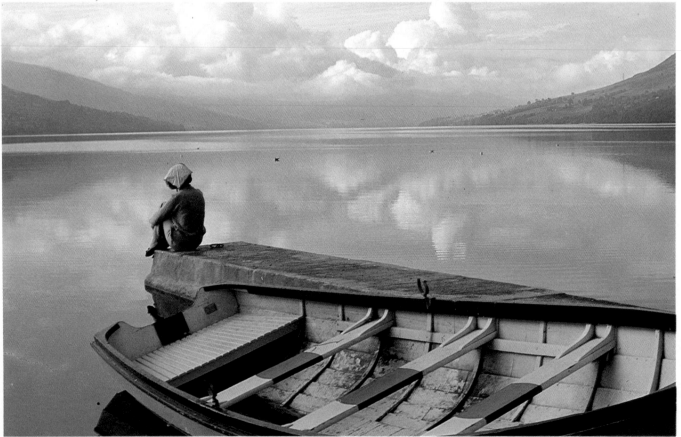

Multicolored Pictures

Do your prints or transparencies of beautiful multicolored scenes sometimes look unorganized and confusing? If so, you are not alone. A scene of mixed colors is one of the most difficult subjects to successfully photograph. Although it may look spectacular in its natural setting, it does not always work well within the confines of the picture frame. Several bright, saturated colors placed together compete with each other for the viewer's attention and a confusing picture results.

This does not mean that you should ignore multicolored scenes. With awareness and understanding you can solve the problem.

VIEWPOINT AND LENSES

There are two basic viewpoints to consider when you photograph a polychromatic scene—far away or close up.

Using Distance—The advantage of putting a long distance between you and a multicolored subject is that you don't remove it from its setting. Although at the time you may not be conscious of it, the background is tremendously important to a polychromatic subject.

Look at a multicolored scene in nature—a flower garden, for example. You will notice how important the green colors are and how they contribute to the overall effect. Green leaves and stalks are interspersed with the bright colors, separating them from each other and creating areas of contrast and harmony. Larger areas of green grass and leaves provide the background and an important restful quality to counterbalance the liveliness of bright flowers.

It's difficult to imagine a garden without the moderating influence of green, but to get some idea of what it would be like, pick a bunch of flowers of assorted bright colors and take off all the leaves. Then arrange the blooms so the stalks are not visible. Place your bouquet against a multicolored background.

The result is chromatic confusion. The value of a viewpoint that includes a subdued background becomes immediately obvious. If you can't change your viewpoint, a wide-angle lens with a greater field of view may enable you to get the composition you want.

▶ John Sims isolated these two people from the rest of the crowd by using a 200mm telephoto lens. This not only cuts out distracting detail, but also flattens the background so it does not conflict with the main subject.

▶ Try surrounding bright colors with subdued colors. Here the gentleness of natural green offsets the liveliness of the flowers. This makes the whole picture easier on the eye. Photo by Tsune Okuda.

▼ A close viewpoint isolates this area of mixed color from a busy market background. Photo by Alfred Gregory.

Getting Close—The alternative to including background with a polychromatic subject is to move in close. Choose one or two particularly striking colors—an area of contrasting colors, for example. Move in on them and exclude the others. A close-up lens accessory or macro lens is helpful. A long-focal-length lens may help you isolate a small area if you can't get in close enough.

STILL-LIFES AND PEOPLE

A still-life offers a broader range of subjects for polychromatic pictures than landscapes, but the same principles apply. For a successful still-life you must reduce the competition between the colors and between subject shapes and colors.

Use a monochromatic background to unite subject elements. You can use neutral-colored objects to separate contrasting and harmonizing areas. The table or other support can provide the unifying background. Create many small areas of color, unified by the setting.

For pictures of people in brightly colored clothing, remember these same points. Choose your viewpoint carefully so the background forms a cohesive setting. You can use shadow areas to separate the various color elements.

▲ The strength and brilliance of this colored fabric is accentuated by a low camera position close to the subject. In addition, light is shining through the material, giving an effect similar to a stained glass window. Photo by Colin Barker.

◄ Careful focusing with a large aperture put both the background and foreground out of focus so nothing interferes with the graphic image and strong colors. Photo by Michael Taylor.

▶ Multicolored still-lifes or posed people pictures are relatively easy to control. Arrange still-life objects so there are no areas of conflict between the colors. Position people in bright clothing in front of an uncluttered background.

SPECIAL TECHNIQUES

If you find that the difficulties presented by a particular polychromatic subject are difficult, you can use special techniques to reduce the saturation and brilliance of the colors. When you do this, the colors will conflict less, and the subject will be easier to photograph successfully. Some of these techniques have already been mentioned. They include image diffusion, overexposure, filtration and special lenses.

Seeing in Black and White

Many photographers prefer to use b&w. Although nothing beats color for realism, b&w is often more expressive. Color may be a distraction in certain circumstances, such as in documentary photography, or when the natural colors of the subject are not very pleasing. Without color, the image is simplified, allowing the shape, tones and texture to be emphasized.

COLOR AS B&W

To produce good b&w photographs, the world of color around us has to be seen as shades of gray. The change of approach is so marked that many experienced photographers find it difficult to shoot both b&w and color pictures at the same time.

One of the main problems is that colors of the same intensity, which may look very different in color, appear as the same tone of gray on b&w film. For example, a boat with a bright orange sail against a blue sea has strong contrast in color, but in b&w it may appear as gray on gray and look flat. When you start viewing the world in shades of gray, you will see that what makes a good color picture is very rarely as good in b&w.

If you have difficulty visualizing a scene in b&w, there are filters that will help you judge its tonal values. The Kodak Wratten No. 90 is a dark filter made specially for monochromatic viewing. You can place this gelatin filter in a transparency mount for protection and easier handling.

LIGHT AND B&W

Light changes tonal values and is of course vital to all photographic processes, but it has a special importance in b&w photography. The example of the orange-sailed boat on the blue sea, which looks flat and gray in b&w, can easily be converted into an exciting b&w image by a change of lighting. For example, if you aim into

Right and below: When shooting b&w, look carefully at a scene's tonal values without regard to color. These radishes show what can happen to colors when imaged on b&w panchromatic film. The red and green give a strong contrasting image in color, but in b&w, the contrast disappears. Photos by Michael Newton.

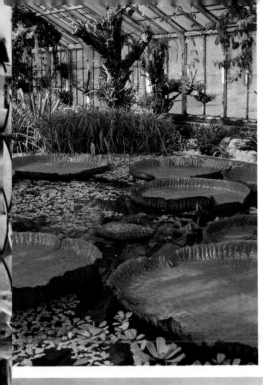

Left and far left: This garden is a busy scene that depends on color to separate the elements. These colors work well together but there is not much tonal contrast. In b&w the tonal values emerge as a rather distracting arrangement of details. Photo by Gunter Heil.

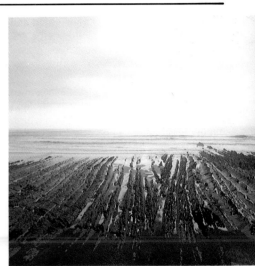

Right and below: This picture works better in b&w; in color it is flat. Increasing the contrast in the b&w print by using high-contrast paper and giving the sky extra exposure resulted in an image rich in contrast. Photo by Michael Busselle.

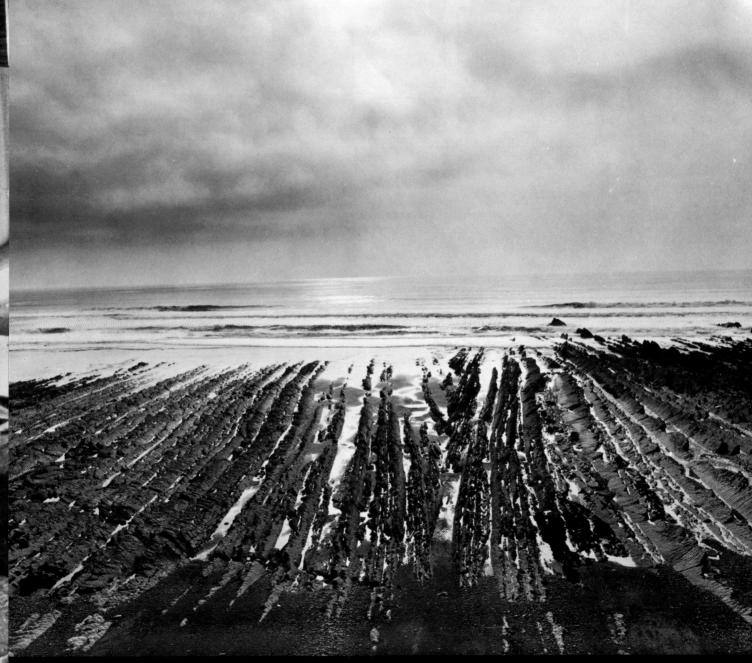

Using Light _____ 5

Contents

The Light Source

Lighting is one of the main ingredients of a successful photograph. By controlling the light source, you can make a subject look attractive or unattractive. Objects can be made to look either familiar or unrecognizable.

When away from controlled lighting in a studio, many photographers accept whatever lighting happens to exist. They think there is no alternative. How can you move the sun or roll back the clouds?

In fact, there is a lot you can do to gain control of existing light. This chapter will help you understand some basic principles of lighting so you can improve your photography.

Consider a family on a beach, where the sun is out. The sun is the *primary light source*. Every three-dimensional element in the scene, including eyebrows and noses, casts dark hard-edged shadows. On faces, these are unflattering. You can do

several things to solve the problem. Use a large beach umbrella or any other large object to cast a shadow over the group. Or, move the group into the shade of a building. This softens the hard-edged shadows. Base exposure on the subjects in shadow.

▼ You can use direct sunlight and dark shadows for dramatic effect. Clive Sawyer used it successfully here by composing the scene so the main subject seems spotlit against the dark background.

This is only one solution. The photographer who understands some of the basic ideas of photographic lighting can quickly improvise others, depending on the particular situation and the purpose of the picture.

WHAT IS GOOD LIGHTING?

Good lighting for a passport photograph, a "wanted" poster, or an actor's publicity shot is different in each case. What makes good lighting usually depends on the photo's particular purpose. When you think about good lighting, consider the following three functions.

The first function of lighting is to illuminate the subject so you can focus, meter, and expose film. Usually, but not always, the more light the better. Focusing is easier because the viewfinder image is bright. There will be enough light so you can use slow film for good image sharpness, small apertures for greater depth of field, or fast shutter speeds to freeze action.

The second function is to convey information about the subject's shape, size, color, and texture. A two-dimensional photograph must convey the impression of three dimensions.

We can move our heads from side to side to see the position of elements within the scene, enhancing the three-dimensional view of a subject. We can also concentrate on a small part of a scene and focus on it. Because a camera does not operate in the same way as our vision, controlling the light is important to communicate these elements to the picture's viewer.

The third function is to create a mood for the image. The lighting can imply the value of an object or suggest more indefinable qualities, such as honesty or purity, happiness or misery. It can also subdue some aspects and emphasize others. Look at advertising photographs to see how lighting causes you to attribute certain qualities to a subject or situation.

Any lighting that accomplishes the intended photographic purpose is good lighting.

TYPES OF LIGHT SOURCES

Many different words are used to describe lighting: *hard, harsh, soft, diffuse, flat*. These words are often used carelessly, which leads to confusion. For example, the term *flat lighting* is commonly used to describe three different forms of lighting—light from an overcast sky, light from a flash unit mounted on the camera, and light reflected into the shadows by white

A problem with a *small-source light,* such as direct sun (right), is that the subject casts dark, hard-edged shadows. These can complicate the composition and be unflattering to the subject.

When direct sunlight is blocked or diffused, shadows become lighter and edges softer (above). This lighting is more suited to this subject.

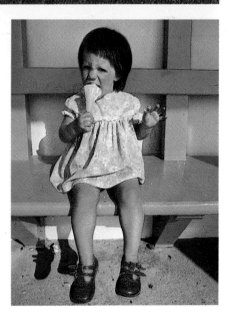

walls or other reflectors. None of the terms is very accurate.

A better way to talk about lighting is to refer to the nature of the *effective light source.* This is whatever lights the subject directly, with nothing between the effective source and subject except air. In the case of people on the beach on a clear day, the sun is both the primary and the effective light source. When the group is put in

shadow, direct sunlight no longer illuminates the scene. The *effective* light source becomes the sky, beach, and whatever reflective surfaces illuminate it. The sun is still the *primary* light source.

Knowing about the effective light source is important because *the nature of the effective light source determines qualities of the lighting.* The size of the effective light source is the most important factor.

Large Light Source—This is a source that is large compared to its distance from the subject. In this case, light strikes the subject from many directions, making it *nondirectional.* The subject casts weak shadows because light comes from all around. Examples are people under a beach umbrella, under an overcast sky, or beneath a series of fluorescent lights on a white ceiling. This kind of light is also called *soft light.*

EFFECT OF LARGE LIGHT SOURCE

Small Light Source—This is a source that is small compared to its distance from the subject. It is *directional*—you can tell what direction light comes from by observing the hard-edged shadows cast by the subject. Examples of small sources are bright sun in a clear sky, a flash mounted on camera, or a bare light bulb illuminating the subject.

A small source can be physically large but is so far away it appears small. This is why the sun on a clear day acts like a small

EFFECT OF SMALL LIGHT SOURCE

source. Light from a small source is also called *hard light.*

Medium Light Source—Between large and small is an infinite range of light sources. For simplicity, just one intermediate size is defined here. A medium source is defined as being about as large as its distance from the subject. For example, a window acts as a medium source if it is three feet square and the subject is within

three or four feet of the window. A medium light source gives directional light and causes shadows that are softer than those due to a small source.

Medium-source lighting occurs indoors and outdoors. When sunlight strikes any light-colored surface, such as a wall, the surface may be a medium light source. Sometimes, during heavily overcast weather, clouds part to reveal a brilliantly lit cloud. This is an unusual and dramatic example of medium-source lighting. You can produce a similar effect by reflecting or diffusing a small light source with material that is approximately as big as it is far away from the subject.

EFFECT OF MEDIUM LIGHT SOURCE

▼ An overcast sky is large-source lighting. Shadows are faint and colors stand out well. A complex composition is kept as simple as possible with this kind of light.

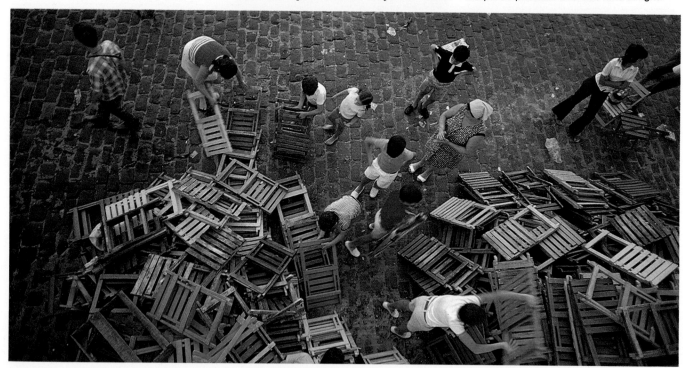

▲ A medium-source light illuminated the carving from behind. This results in better modeling and softer shadows than with a small-source light.

▶ This is another example of lighting from a medium source. For this photo, a sheet of white paper reflected light from a window onto the subject.

Lighting Different Surfaces

When directional light strikes an object, three areas are created on the object—the *highlight*, *lit* and *shadow* areas. A highlight is caused by a small area on the subject that appears very bright because it reflects light directly to your eye. Usually the reflected light is so bright that you cannot see surface details in that area. The lit area is bright and illuminated directly by the source, but you can see surface details. The shadow areas are shaded from the light source by another part of the subject or some nearby object.

▲ Sand is a typical matte surface. A minute highlight appears on each grain. Color is strongest in the lit area. The edge of the shadow shows texture and form.

The combination of these three areas tells the viewer about the dimensions, texture and color of the subject. There may also be a cast shadow.

To understand each area, place an orange or similar small object on a dark surface. Light it from one side with a single, small light source, such as a desk lamp.

Notice how the shadow and lit areas and the boundary between them show the object's shape. Color comes from the lit area. Texture appears at the edges of the lit

area. Texture is often most apparent at this area because the light strikes the surface irregularities from the side. The lit area may include a highlight.

TYPES OF SURFACES

If you replace the orange with a matte object, such as a peach or a tennis ball, you see that the highlight is practically invisible. Form and texture are now visible on the border of the shadow and lit areas.

If you substitute a shiny object made from glass or metal, you will notice the predominance of the highlight area and how sharply the lit area merges into the shadow.

The relative sizes of the three areas are determined by the nature of the surface. Depending on which subject area you want to emphasize, the type of surface you photograph influences how you should control the lighting.

For simplicity, surfaces are divided into three categories—*shiny, matte* and *semi-matte*. In reality, there are very few totally matte or shiny objects. These categories

▲ Lighting shows shape, color, and texture.

HIGHLIGHT: Shows color of light source.

HIGHLIGHT/LIT AREA BORDER: Shows shape and texture of shiny and semi-matte objects.

LIT AREA: Shows color of object.

SHADOW/LIT AREA BORDER: Shows shape and texture of matte and semi-matte objects.

SHADOW: Shows little, if any, detail.

▼ A medium-source studio light was used for the photo of fruit at the bottom of these two pages. The fruit surfaces range from the matte skin of a plum to a shiny, polished apple.

Now look at the fruit in terms of the diagram at left. Observe the differences between highlight, lit area and shadow on various surfaces. Notice which areas show texture and form, and which show color.

On the semi-matte orange, form and texture show best on the borders of the highlight/lit area and shadow/lit area. On the apple, only the edge of the highlight shows this kind of detail.

◄ Except for the artichoke and brushed aluminum pan, the objects in this photograph are shiny. Highlights indicate the shape and texture of shiny objects. The light used for this scene was a studio flash inside a rectangular reflector. You can see it reflected in the top of the glass decanter.

▶ The body of the dull clay crock is a good example of a matte object without an obvious highlight. Texture is clearest on the shadow/lit area border. Compare this with the semi-matte onion, which has a distinct highlight and visible texture in both borders.

represent objects that are *predominantly* shiny, matte or semi-matte.

SHINY OBJECTS

In the case of shiny surfaces, such as aluminum foil, polished steel or glass, highlights are very obvious. Lit and shadow areas tend to merge. For this reason, when lighting shiny objects, you should mostly consider the shape, size and position of the highlights.

These highlights are reflections of the light source and do not always show the color or texture of the object. Any texture of a shiny object appears in the lit area or its edges.

Lighting Suggestions—When you use small-source lighting, a small highlight is produced. This does little to show the shape of the object, so small light sources are not often used with shiny objects. In fact, for many years photographers have constructed the largest possible effective light source when photographing shiny objects. Recently there has been increasing use of medium-source lights, particularly a source with a rectangular shape.

MATTE OBJECTS

An object, such as a brick or tennis ball, appears matte because its surface is irregular and has many fine indentations. Therefore, when it is lit, there is not just one highlight but thousands or millions of minute ones reflected in all directions. In this case, the total effect of the highlights is not very strong. A comparison between the two still-lifes on this and the facing page clearly shows the difference between the highlights of shiny and matte objects.

On a matte object, the lit area shows the color of the object. The shadow does not have any modeling or texture. If there seems to be some, it is usually due to a second light source, such as a nearby reflecting surface, illuminating the shadow area. The edge of the shadow, where the lit area and shadow merge, shows most detail.

Lighting Suggestions—To emphasize texture, create a border between the lit and shadow areas. This means choosing a small or medium light source and positioning it so the border falls on a prominent part of the subject.

Top, bottom or side lighting puts this border between shadow and lit areas approximately in the center of the object. The next section discusses these positions.

SEMI-MATTE OBJECTS

Dulled copper and brass, semi-gloss or flat paint, most plastics, human skin, and oranges are examples of semi-matte surfaces.

With these, both the highlight and shadow areas are clearly distinguishable from the lit area. The highlight may show the color of the object in a lighter shade. The shadow is dark unless light from another direction reaches the shadow areas. The lit area shows the subject color strongest. Texture appears in both the highlight and the lit areas.

Lighting Suggestions—To emphasize subject color, arrange the lighting so the maximum amount of lit area is visible. Minimize the shadow area by using front or quarter lighting. The next section describes these positions in more detail. Minimize the size of the highlight by using a small light source.

POSITIONING THE HIGHLIGHT

The position of the highlight depends on the position of the light source. A rounded object will always show a highlight somewhere. A flat object may lose the highlight on an edge. Because most objects are a combination of flat and rounded surfaces, you can usually place the highlight on an area where it is most useful for the effect you want. For example, in portraiture you may want to emphasize furrows on the brow or wrinkles at the corners of the eyes with highlights.

You can emphasize the edges of dark objects photographed against dark backgrounds by placing the source so the highlight is at the edges. Of course, this technique can only work when the highlight is strong enough to stand out clearly, such as with a shiny object.

POSITIONING THE SHADOW

With matte objects, and to some extent with semi-matte objects, the merging of shadow and lit areas produces modeling of shape and texture. Just as you can position the edge of a highlight on a flat, shiny surface, you can also position the edge of the shadow.

For example, when photographing the front of a building, an architectural photographer will usually wait for the sun to cast light that cuts across the front of the building, accentuating fine details. A few minutes earlier, the front may have been in total shadow.

A few minutes later the front may be completely lit. This is good for color but unlikely to show fine detail in shape and texture. Between these times, *both* light and shadow exist on the building.

The portrait photographer may place the edge of the shadow down the wrinkles of the subject's face, as shown opposite.

FRONT LIGHTING

With front lighting there is virtually no shadow area as seen by the lens. The edge

▶ Here, side lighting emphasizes the man's wrinkles.

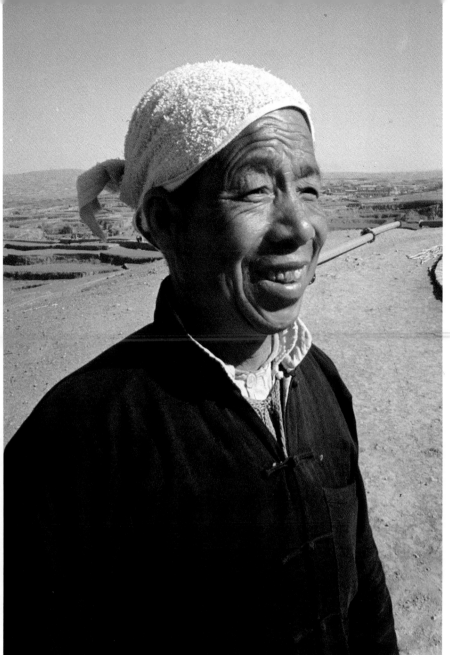

▼ Below right: This photo shows street lighting reflected by a car. You could change the position of the highlights by moving camera position.

▼ Below left: Side lighting accentuates surface details.

of the shadow is almost out of sight. Therefore, it creates very little texture or subject modeling. However, it does give good color rendition because the lit area is relatively large.

The highlight is practically in the center of each object. The resulting effect can be poor, especially with portraits. For example, a highlight in the center of the eyes is not very flattering. Usually, this is the lighting given by on-camera flash pointed straight at the subject.

Medical photographers use front lighting because the good color and absence of shadow on the subject ensure that skin color shows well and no detail is lost. Because of the way they use photos, they don't need to emphasize texture and shape. Press photographers often use front flash lighting because it is simple and quick.

SIDE LIGHTING

With side lighting, the edge of the shadow generally runs down the center of each object in full view. This is the most commonly used angle when texture must be emphasized.

QUARTER LIGHTING

Quarter lighting is halfway between front and side lighting. It keeps the edge of the shadow in view, while showing a little more of the lit area but less shadow than side lighting. Probably more pictures are taken with quarter lighting than any other directional lighting. It is also called *half-side lighting*.

 ▲ Made with quarter lighting.

◄ Far left: Made with front lighting.

◄ Left: Made with side lighting.

These three lighting angles are common. The front lit picture has best color, but looks two-dimensional. The picture lit from the side has less color but more shadow for a good three-dimensional effect. The photo above made with quarter lighting is good for both color and depth.

TOP LIGHTING

Top lighting is from above. The edge of the shadow usually runs horizontally across the center of each object in full view of the camera, leaving the lower half of the object in shadow.

Even though there is no objective difference between top and side lighting, there is a difference in the subjective effects. Top lighting does not flatter the human face. Eyes and jowls darken; the nose and forehead lighten. Most people find this unpleasant in a photo.

The best solution is to add or subtract light so the light is no longer exclusively from the top. For example, you can use a large white reflector or shiny object to bounce some light for a front-lit effect. Or, try something dark such as an umbrella above the subject's head to reduce the light from above.

BACK LIGHTING

With back lighting, most of the subject as seen by the lens is in shadow or silhouetted. Highlights surrounding the subject become dominant. This is because the subject becomes darker and less interesting than the light skimming around it. The effect is so powerful that this lighting angle is often used to make a subject look mysterious.

When a series of shapes recedes into the distance, one behind the other, such as a range of hills, back lighting is sometimes used to separate elements. A highlight rims each dark or silhouetted object. This creates a tonal gradation from lit area to highlight. The double effect of obscuring much unwanted detail while creating a large highlight has made back lighting a favorite among many photographers.

◄ Top lighting is not very flattering to a person's face. You can avoid it by reclining the subject so the top light becomes front light.

▶ Back lighting outlines heads with highlights, which separate the subjects from the background. The front of the subjects is illuminated by reflections from surrounding surfaces.

Small-Source Lighting

You can produce successful pictures if you control the size of the light source. The three basic sizes—small, medium and large—have been defined. This and the following two sections describe their advantages and disadvantages, and how to overcome problems that may occur.

WHAT IT IS

Small-source lighting, also called *hard lighting*, is directional and makes the subject cast dark hard-edged shadows. It is common because the sun in a bright, clear sky is a small source. In spite of its enormous size, it is so far away that it is small relative to subject distance.

Other small light sources are direct flash, household lamps, and studio lamps used in small reflector housings. The tests for a small source are: Can you see the direction of the light? Does the subject cast a hard-edged shadow? If the answer to both questions is *yes,* the source is small.

WHAT IT DOES

Because of the well defined shadows this type of lighting creates, small light sources make a picture seem more complicated.

Highlights are small and bright. The dividing line between lit area and shadow is distinct, with little space for the subtle tones that show the subject's shape.

ADVANTAGES

Though small-source lighting may present some problems, it is ideal for certain subjects. It works well with small simple objects when you want to complicate the way the subject looks. Hard-edged shadows and small highlights may add some compositional interest to a simple subject that might otherwise make a boring photo.

You can emphasize fine texture by placing the lit area/shadow border for best effect.

Small-source lighting can be projected considerable distances, and its distribution is easy to control. A spotlight is always a small source.

Water-spray or rain produces a rainbow when back lit by a small source—the sun. Ghost images in a lens are made by shooting into a small source.

DISADVANTAGES

Because subjects lit by a small source cast hard-edged shadows and show textural detail, small-source lighting is not always the most flattering for photographing people.

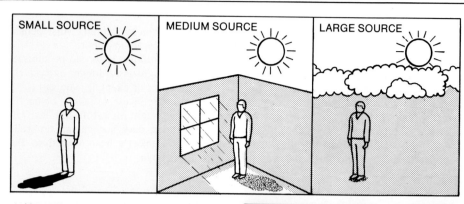

▲ You can usually determine the effective size of a light source by observing the shadows cast by a subject. A subject lit by a small-source light casts a hard-edged shadow. Medium-source light leads to a distinct but softer-edged shadow. A subject in large-source light produces faint and indistinct shadows.

▼ The jug was lit by a small-source light in the quarter position. Notice the small but distinct highlight, the hard shadow edge and good texture. Photo by Malkolm Warrington.

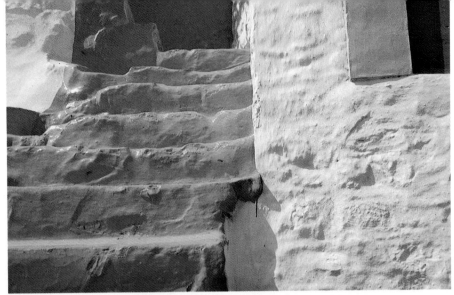

◀ Direct sunlight from the side makes the glossy green paint shine and emphasizes texture on all surfaces. Photo by Suzanne Hill.

▼ Direct sunlight results in many small highlights when reflected from choppy water. This makes the water look textured. Photo by Suzanne Hill.

If the scene is composed so the source gives side lighting, a dark shadow edge cuts across the subjects' faces. Facial lines are made obvious. If it is hot, any perspiration on faces becomes many tiny highlights.

Because of the excellent color in the lit area provided by a small source, a red nose appears even redder. There is a lack of modeling throughout the whole scene.

CHANGING THE LIGHTING

You can overcome this problem by changing a small source to a medium or large source. One way to do this is to find something to block direct sunlight. The best solution depends on the actual situation. Outdoors, you can use a beach umbrella or the shadow of an awning.

Or, you can wait until the sun is diffused by a cloud or haze. In each case, the principle is the same—use a large or medium source instead of a small one.

Back Lighting—Another way to change the lighting is to move around until the subject is backlit. Because the camera now faces the sun, you should use a lens hood to prevent stray light from striking the front lens element. This assumes that the sun is not so low as to actually be in the picture. If it is, it may cause severe flare, which lowers image quality. If necessary, move the subject in front of the sun to block it.

With direct sunlight lighting only the edges of the subject from behind, faces and bodies are lit by reflected light from the surrounding sand and sky. This front light is large-source lighting. It is certainly not as bright as sunlight. For best exposure, meter the area lit by reflected light.

▶ Strong shadows intensify the feeling of depth in this photo by Adam Woolfit.

▼ Placing the subject in shade on a bright sunny day is a good way to eliminate harsh, unflattering shadows. Photo by Tim Megarry.

▶ The subject has her back to direct sunlight. Her face is lit by softer light reflected from surrounding surfaces. Photo by John Garrett.

Exclude the back light from the metered area.

This combination of small-source back lighting and large-source front lighting is extremely flattering. It makes almost any subject look better. The highlight glow around the subject attracts the viewer's attention to the handsome effect of even, large-source lighting.

You can lighten the harsh shadows of side lighting by filling them with more light. This is called *lowering lighting contrast.* In this book *lighting contrast* is defined as the difference between the light in the brightest area and the light in the shadow area.

Use any white, silver, or pale-colored material to reflect some light back into the shadow areas. This will result in shadows

▶ Strong directional light from the side creates unflattering shadows under chin, eyes and nose. It accentuates every detail—even single strands of hair. Photo by Richard Greenhill.

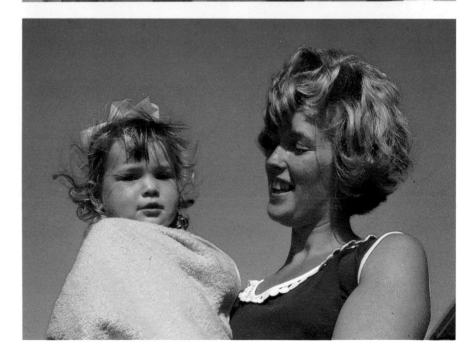

with more detail. You can make or buy reflectors. For example, use a white card, metal panel, or anything at hand to reflect light into a face.

CHANGING THE COMPOSITION

Instead of changing a small source to a larger source, you can change the composition to suit the lighting characteristics. For example, move so the sun is behind you. The subjects will then be lit from the front. Dark shadows are reduced. If you do this, be sure *your* shadow doesn't intrude into the picture area.

Faces are now entirely in the lit area and are not as shadowed as they would be with side lighting. Facial lines are less obvious. Any perspiration or redness of a nose will still show. One solution to these problems is to use a soft-focus lens attachment to smooth out the light on the faces.

Because small-source lighting tends to complicate a subject with shadow and reveals detail, you may wish to simplify the picture. Try a more formal arrangement of the subject. Watch for irritating flaws, such as unruly hair or creases in clothing.

A shadow problem can be solved if you

lower the camera angle and shoot up slightly. Shadows on the ground are no longer in the picture. Because the top half of most scenes is usually much simpler that the bottom half, this immediately simplifies the photograph.

Getting rid of shadows is not easy. You can use a second light to fill the shadows, but this sometimes leads to a second weaker shadow. Solve this problem by moving the second light to camera position so the subject casts the second shadow directly behind. This can produce a second set of highlights.

▲ Strong side lighting is good for landscape photography. Notice how it accentuates shallow ripples in the sand. Photo by Jack Taylor.

▶ Strong side lighting clearly defines the fluting on the columns. Shadows add interest to the right side of the composition.

USING SHADOWS CREATIVELY

Shadows can be very important in composition. Use them to form patterns, or to balance the subject matter.

The hard-edged shadows characteristic of small-source lighting can be used to show the shape of objects. For example, the shadow of a telegraph pole is bent if it is cast on the dips and rises of a ditch. The shadows cast by clouds on a hill often define the shape of the hill.

Shadows can also have symbolic effect and can be used to create images with emotion and mood. For example, they can give a menacing, sinister effect, such as when a long dark shadow follows a lone figure. A shadow all alone gives a mysterious mood.

SUMMARY

Small-source lighting will produce a:

Small Highlight—This results in good color but gives no modeling to a shiny object.

Hard Shadow Edge—This makes texture visible, but may give little modeling to matte objects.

Dark Shadow—This can be used creatively but can also cause problems by hiding detail.

◄ Without the strong shadow, this picture would be very dull. Try using shadows creatively. Photo by Jack Taylor.

MEASURING LIGHTING CONTRAST

You can measure the lighting contrast of a scene. What you do is meter the light on the lit side of the subject. Then meter the light in the shadow. Be sure to meter from similar subject tones, such as the skin. The difference between the two readings in exposure steps can be expressed as a ratio called the *light ratio.* High light ratios imply contrasty scenes; low light ratios imply the opposite. For most portraiture, low light ratios, such as 1:3 and smaller are used.

Difference in Exposure Steps	Light Ratio
0	1:1
1/3	1:1.3
1/2	1:1.4
2/3	1:1.6
1	1:2
1-1/3	1:2.5
1-1/2	1:2.8
1-2/3	1:3.2
2	1:4
2-1/3	1:5
2-1/2	1:5.7
2-2/3	1:6.3
3	1:8
n	$1:2^n$

Large-Source Lighting

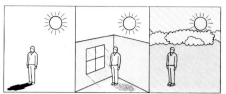

SMALL SOURCE MEDIUM SOURCE LARGE SOURCE

▶ Large-source lighting produces a spread-out highlight. Shadows are light and full of detail. Photo by Malkolm Warrington.

▼ A complex composition with many elements is ideal for large-source lighting. Photo by Richard Greenhill.

The opposite of small-source lighting is *large-source lighting.* In this case, the effective light source is so large or close to the subject that it practically surrounds the subject with light. Because light comes from many directions, there are few dark shadows.

The most common large light source is an overcast sky. White ceilings with rows of fluorescent tubes also act as a large light source. When flash is bounced from a light-colored surface such as a ceiling, the bounce surface becomes a large light source.

A large light source is not necessarily bright. The test of a large source is: Does the subject cast prominent shadows? With large-source lighting, shadows have soft edges.

WHAT IT DOES

Large-source lighting tends to simplify a subject. Highlights spread out—often until they are invisible. This tends to show color well.

Another advantage of large-source lighting is its simplicity and unifying effect. It emphasizes subject form and detail. Shadows are open and full of detail.

Shiny Objects—A large source is ideal for a shiny subject. Because the source is large, it reflects in the object as a large highlight that follows the contours of object. This effect tells the viewer that the object is shiny.

This is why photographers who photograph large shiny objects like cars and motorcycles like to photograph outdoors on overcast days. The sky acts as a large source. Its reflection in the object is not distracting. Instead, the contours of the object are emphasized.

Matte Objects—In the case of matte objects, it is the edge of the shadow that gives modeling and texture. With large-source lighting, this edge is soft and gradual; the lit area gradually changes into shadow area, which is open and shows detail.

For this reason, large-source lighting gives extremely subtle modeling—so subtle that it is sometimes ineffective. Texture, too, is reduced.

USING LARGE-SOURCE LIGHTING

Generally, you must work with large-source lighting when it occurs naturally. It is impractical to try to change its effective size.

Large-source lighting from an overcast sky is usually easier to handle than light from a small effective source, such as direct sunlight. You don't have to worry about exposure problems due to bright areas and dark shadows in the same scene. Instead, the large source fills shadows with light, making them almost as bright as other areas. When using color film, be sure there is something colorful in the scene to make the composition seem lively.

EXPOSURE FOR OVERCAST SKY

On a cloudy day, the whole sky is the effective light source. Though it may not look bright, there is unlikely to be anything around that is brighter. Like blue sky on a sunny day, too much cloudy sky at the top of the picture can fool a built-in camera meter.

Depending on the meter's sensitivity pattern, this bright area can make the camera think the subject is brighter than it really is. Exposure recommendations in this case tend to result in underexposure of the subject. A camera meter with a center-weighted pattern minimizes this problem. Check your camera's instruction book.

Usually, you'll get correct exposure by pointing the camera down to exclude much of the sky or moving closer to the subject. Make the meter reading, set the *f*-stop and shutter speed, recompose the scene, then take the photograph.

IMPROVING THE PICTURE

Consider these ways to improve photos made on an overcast day:

Color Contrast—Add a touch of very bright color. For example, if you are photographing people in an urban landscape, ask your subjects to wear bright clothes. They will probably be bright enough to improve an otherwise colorless picture.

Lighting Contrast—This is low in large-source lighting because shadows are not very dark and highlights are not extremely bright. There is little you can do to control lighting contrast when the sky is the large source.

If you use a large-source light indoors, however, you can use a reflector to make shadows brighter or you can block some light to darken shadows.

▼ Tonal contrast is high in this photo because the overcast sun is pictured. Exposure was based on the background sky. This makes the tree reproduce dark. Photo by Richard Tucker.

▼ Large-source lighting reduces the three-dimensional effect of a scene. It emphasizes shapes in the composition. Photo by John Garrett.

instead of absorbing light like a filter, they *diffract*, or bend, light.

The glass or plastic accessory has fine lines etched or molded in a geometric pattern. Depending on the design and pattern, the lines have various effects. Some exaggerate the radiating lines from lens flare. Others diffract the light into bright rainbow colors, which can produce beautiful and dramatic results on backlit subjects. Still others turn highlights into star- or cross-shaped patterns. When using these accessories, try to superimpose the optical effect over dark parts of the scene. Otherwise, bright subject areas may wash out the pattern.

DETERMINING EXPOSURE

One of the biggest problems with back lighting is exposure calculation. This is especially difficult if the subject is a landscape and the sun is low and visible in the viewfinder. The camera meter will see direct light from the sun and "think" the scene is much brighter than it really is. Therefore, it will recommend an exposure that reproduces the landscape too dark.

The landscape is lit by reflected light and skylight, which is of lower intensity than direct light from the sun. Therefore, to reproduce detail in the landscape, expose *more* than the meter recommends. This is a general guideline for photographing backlit subjects. How much more exposure to give depends on the camera meter's sensitivity pattern, how much direct light you are imaging, and how much detail you desire in the main subject.

To reproduce subject detail, exclude the effect of the direct light by metering closer to the subject, metering while pointing the camera down, or turn around with your back to the sun and meter from an average subject. When in doubt, bracket with more and less exposure.

INTERIORS

When you take pictures inside you can exercise a considerable degree of control over the light source. Consider creative techniques of shooting into the light.

If you use the back light as the main source of light, you may want to reflect some of the excess *spill light* back toward the front of the subject. Use colored reflectors to create various effects. Try locating the source behind the subject, but not directly behind.

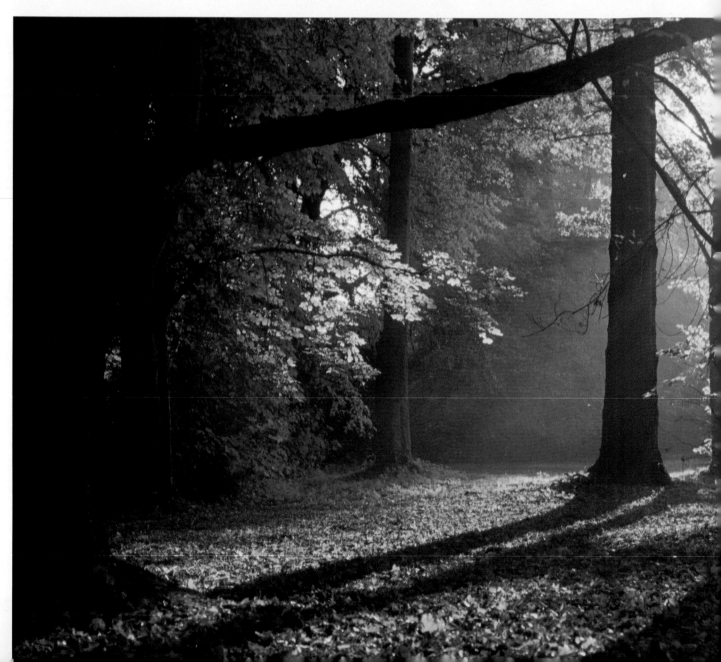

If you don't want light reflected on the subject, use black cards to limit spill light. Or, you can use special lighting accessories to limit spill light.

Exposure metering can be tricky. Remember, you must decide what part of the subject should be reproduced with detail. If you want a silhouette of the subject, meter the light and exclude the subject when metering. If you want the subject to be visible, meter the subject and exclude the effects of the light. For an in-between effect, use an in-between exposure. Bracket for best results.

Although back lighting provides a set of problems, some understanding and experience makes them solvable. Be willing to try new things; experiment; break conven-

▲ The sun was just outside the picture area in these photos. No flare is evident at top because a lens hood was used. Notice how flare reduced image contrast. Photos by Michael Busselle.

LENS FLARE

When light shines directly into a lens, surfaces of the lens elements reflect the light source numerous times. These multiple reflections become *ghost images* of the lens aperture or an overall *flare*. Ghost images are recognizable geometric shapes on the film. Flare is unfocused light that exposes film. It lowers image contrast by putting light into the shadow areas and obscuring image detail. These portions of the image reproduce with less density than you normally expect.

This problem is partially solved in *multicoated* lenses because reflections are greatly reduced. In addition, you can use a lens hood to prevent extraneous light from striking the front element. Even so, flare and ghosting may still occur. It happens most often with lenses with many lens elements, such as zooms.

To see the effect of flare, point an SLR toward, *but not at*, the setting sun. See how various shooting positions create different effects. View scenes at different lens apertures by using depth-of-field preview.

Sometimes, lens flare can improve a picture by giving a soft-focus effect or by lowering the contrast in a contrasty scene.

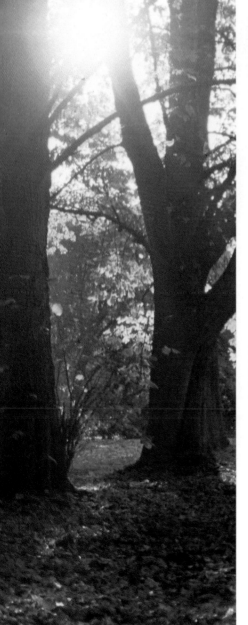

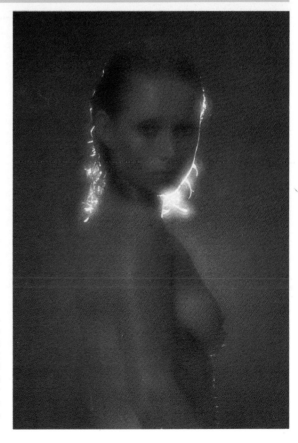

▶ Working in a studio gives you control over the lighting effect. John Garrett used strong back lighting to outline the girl's head. To bring out subject detail, he used front light from a large source.

◀ This type of lighting is naturally high in contrast, but the resulting flare in this case counteracted the effect. Light spreads into the shadow areas. This contributes to the soft-focus effect. Clive Sawyer determined exposure by excluding the sun from the metered area.

tional rules. You'll be rewarded with some outstanding pictures and effects.

SUNSETS

Sunsets are popular subjects. Here, *sunset* is defined as any time from two hours before the sun sinks below the horizon until about 30 minutes afterward. During this time, the light level decreases rapidly. This means you should check exposure often.

Metering sunsets is never easy. To reproduce the sky in middle tones, meter it. This will silhouette the foreground, and in many cases give good results. Recognizable objects, such as famous buildings, benefit from the simplification that a sunset silhouette gives, allowing you to concentrate on shape and pattern. Use exposure to *control* this effect. If you want the sky lighter, give more exposure. If you want it darker, less exposure. Bracketing is recommended when you want to be sure of getting the best picture.

When you look at sunsets, you'll notice that as the sun sinks lower, its light becomes redder and the sun appears to grow larger. A long-focal-length lens gives an ef-fective sunset photo by compressing perspective and making the sun look like a huge red ball dwarfing foreground subjects. A wide-angle lens makes the sun seem smaller relative to the foreground.

▼ Sometimes, the most spectacular moment of a sunset is seconds before the sun disappears below the horizon. Photo by Timothy Beddow.

▶ A dramatic silhouette and a reflection of the sun in the foreground turned an everyday sunset into an extraordinary photograph. Photo by David R. MacAlpine.

Below right: As the sun sets, it seems to become larger. One of the most effective ways to capture this in a photograph is to use a long-focal-length lens. If the sun is also slightly out of focus, as it is here, the unsharp outline will make it appear bigger still. Photo by Alexander Low.

Dawn-to-Dusk Photography

Sunlight mixed with blue light from the sky is called *daylight*. As mentioned earlier, daylight at midday has a *color temperature* of about 5500K. Color temperature expresses a certain balance of blue, green, and red light. The higher the color temperature, the bluer the light. The lower the color temperature, the redder the light.

COLOR AND TIME OF DAY

The color temperature of daylight changes with the time of day. This happens because the earth's atmosphere acts as a filter and absorbs and scatters different colors of light. As the earth rotates and the sun seemingly moves through the sky, the amount of atmosphere between the sun and you changes. It is greatest at sunrise and sunset. At midday, it is least.

Sunrise and Sunset—At sunrise and sunset, the amount of atmosphere between the sun and you is greatest because the light arrives from the side. The atmosphere absorbs and scatters blue light most, leaving relatively more red and green light. This gives a relatively low color temperature. It can range from 1000K to 3000K. You can see the orange color of the light during sunrise and sunset.

Before Dawn and After Sunset—Before sunrise and after sunset, the color temperature of the light is due mainly to light from the blue sky. This dim light is very blue, so it has a color temperature greater than 5500K. Typically, the color temperature of skylight is greater than 10,000K.

During the Day—After sunrise, the color temperature of daylight increases steadily as the sun moves higher in the sky. At midday on a clear day, the color temperature is about 5500K. Then the color temperature decreases as the sun begins sinking in the sky during the afternoon hours.

Rates of Change—The most dramatic change in color temperature occurs during sunrise and sunset. The sun rises in a matter of minutes, giving a change from cool blue colors to warm red colors very quickly. At sunset the change is from warm colors to cool colors. Because the change is rapid, this is when the color of the light is most noticeable to you.

The color temperature of daylight between 10 a.m. and 3 p.m. on a clear day is relatively constant, typically between 4500K and 5500K. It is difficult to visually detect this change.

USING COLOR FILM

As mentioned earlier, color film is designed to reproduce colors best when ex-

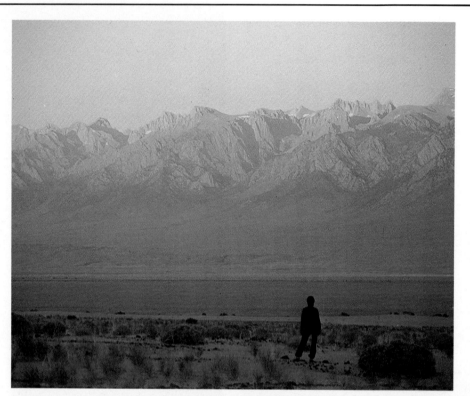

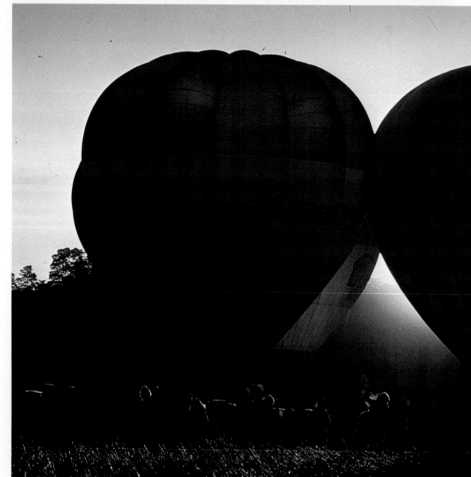

192

◀ As dawn arrives, sunlight adds a warmer color. Here, the sun is rising behind the photographer and colors the top of the mountains. Sunlight has not yet struck the valley. Photo by John Garrett.

▶ This tree looks delicate and fragile in silhouette just before sunrise. There is little color at this time of day. The light is cold and blue due to light from the sky. Photo by John Garrett.

▼ These hot air balloons are outlined clearly as the sun rises behind them. The warmth of the sun's light complements the orange balloons. Photo by Remy Poinot.

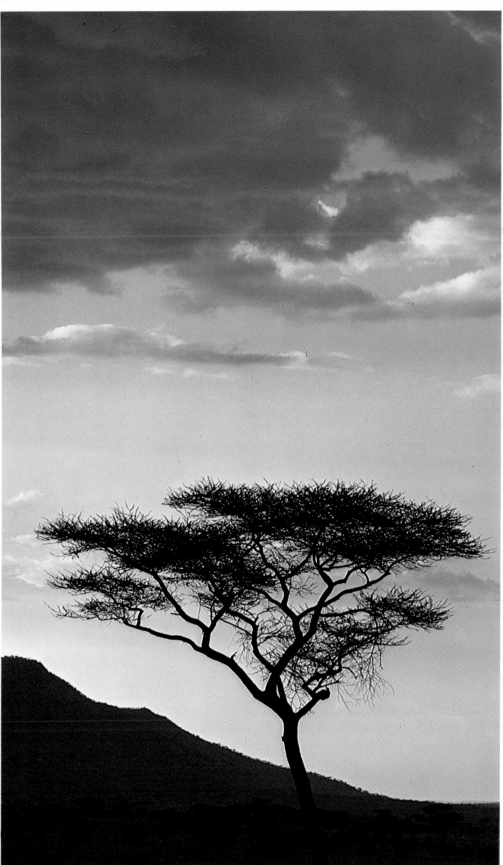

◀ Midday light on a clear day is a combination of direct sunlight and light from a blue sky. It has a color temperature of about 5500K, which balances with daylight color film for life-like color reproduction. Photo by Lisl Dennis.

▲ Raul Constancio took this picture at noon. Because the sun was overhead, cast shadows are below the subject and very dark. The sand shows little texture.

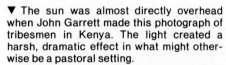

▼ The sun was almost directly overhead when John Garrett made this photograph of tribesmen in Kenya. The light created a harsh, dramatic effect in what might otherwise be a pastoral setting.

posed to light of a certain color temperature. Matching the film to light with the correct color temperature is called *balancing*. Daylight color film is designed for 5500K light. Two types of tungsten color film are available. They are made for 3200K and 3400K light, which are the color temperatures of common photographic tungsten lamps.

If the film is not balanced with the light source, an overall color cast results on film. If the color temperature of the source is higher than the film's standard, the image has a cool, blue cast. If the source has a color temperature lower than the film's standard, the image has a warm, orange cast.

▼ When you meter the clouds and sky after sunset, foreground objects become silhouettes. The light at this time of day is dim. Exposure time was two seconds for this photo. Photo by R. Bath.

Therefore, a scene photographed at different times of day will look different in each photo. In addition to the changing direction of light and length of shadow, the colors will be different. Test this effect by making a series of shots of a scene from before dawn to after sunrise.

Using Daylight Film—This film reproduces colors most lifelike when you use it between the hours of 10 a.m. and 3 p.m. on a clear day. At earlier and later times, daylight reproduces with a warm orange cast. Many photographers like this effect and will accentuate it by exposing film through an orange filter. In addition, the direction of morning and evening light gives interesting and dramatic shadows in the scene.

After sunset and before sunrise, the film reproduces the skylight with a cool blue cast.

Using Tungsten Film in Daylight—This film will reproduce lifelike colors when daylight has a color temperature of 3200K or 3400K. On a clear day, this happens sometime between sunrise and 10 a.m., and between 3 p.m. and sunset. If the color temperature is higher than 3200K or 3400K, the film will have a blue cast. If it is lower, the film has a warm cast.

Slide or Negative Film?—With slide film, you get the colors you photograph. With prints made from negative film, you may not. This happens because the processing lab's automatic printing machine may "correct" some of the color cast in the image.

The machine is designed to assume the scene's colors average to a midtone gray. This is helpful when a slight color cast is detrimental to the picture. However, the colors of a sunset or sunrise scene won't

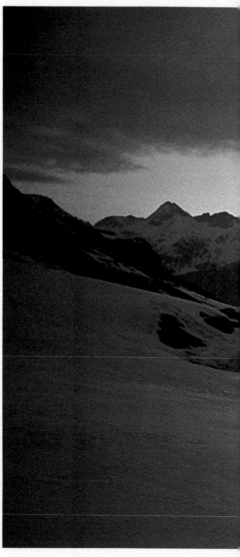

necessarily average to a gray, and the way the machine prints the negative may diminish the scene's impact.

If this happens, ask for a reprint and explain why. Avoid the problem completely by using slide film. Most processing labs can also make prints from slides. The printer will make the colors in the print match the colors in the slide.

▶ As the sun sinks toward the horizon, its light becomes warmer. Shadows lengthen and compositions become more dramatic. Photo by Colin Molyneux.

▼ After sunset, the light looks cold and blue as darkness approaches. The only light remaining is dim reflected light from the blue sky. In this photograph, the only impression of warmth comes from the lights in the cabin. The household tungsten lights have a color temperature of about 2800K. Daylight color film reproduces this light with a warm cast. Photo by Michael Freidel.

RECIPROCITY FAILURE

A characteristic of general-purpose b&w and color film is that when the correctly calculated or measured exposure time is longer than about 1/2 second, the film looks underexposed. For example, an exposure of 1/4 second at *f*-2.8 *should* give the same photographic effect as 1 second at *f*-5.6. However, due to long-exposure reciprocity failure, the second frame appears darker than the first. In addition, color film undergoes a color shift. With b&w film, contrast usually increases.

You can solve these problems by using a faster film or by giving the film more exposure than the meter recommends. Typically, this is one or two steps. When shooting color transparency film, filtration is also recommended, although for some scenes it isn't necessary. B&w film requires extra exposure and change in development time to adjust contrast.

Film manufacturers give exposure and filtration recommendations for exposure times that produce reciprocity failure. These too are guides. Extensive bracketing and careful record keeping are recommended. The long exposures in the exposure table in this section are adjusted for the effect of long-exposure reciprocity failure for a typical ASA 400 color film.

EQUIPMENT

Consider using this equipment when doing nighttime photography:

Tripod—This is handy when you photograph at night. With it you can hold the camera still for long exposures. Generally, you should use a tripod or other firm

camera support for exposures longer than 1/60 second.

Locking Cable Release—When the camera shutter-speed setting is set to **B**, the shutter stays open as long as the button is depressed. Releasing the button ends exposure. Using a locking cable release frees you from having to hold the shutter button for long exposures. After you depress the plunger of the cable release, lock the plunger. The shutter stays open until you unlock the plunger. This lets you leave the camera so you can fire a flash, if necessary.

Flashlight—When it is dark, seeing camera controls and focusing can be diffi-

▲ Eric Hayman determined exposure for this photo by metering the sky with his camera meter. This reproduced the sky as a middle tone and silhouetted the structure.

▶ Robert Estall made this photo of Piccadilly Circus with a shutter speed of 10 seconds. This was long enough for cars to pass through the scene, leaving trails of light.

◀ To achieve the correct lighting balance between the artificial lights and sky light, Dan Budnik bracketed exposures. This is the preferred result.

▼ Mixed artificial lights can give unpredictable results. Laurie Lewis used tungsten-balanced film to record this scene lit by floodlights and lasers.

cult. Bring along a flashlight to make focusing and camera operation easier.

Watch—When making long exposures with the **B** setting of the shutter-speed dial, an accurate way of measuring exposure time is useful. You can count, "One thousand one, one thousand two, one thousand three, etc.", but five minutes of this can be tedious. Instead, you'll find it easier to use a watch to time the exposure.

Auto-Focusing Cameras—Some non-SLR 35mm cameras can focus on a subject automatically—even at night. If you have one of these, try using it outside for night photography.

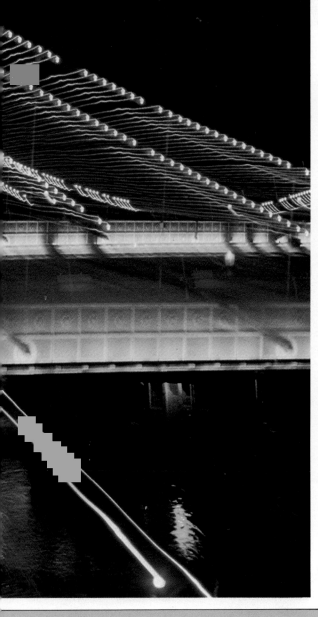

Movement 6
and Multiple
Exposures

Contents

Recording Movement

One of the many creative uses of photography is capturing the impression of movement in a still picture. This can be an indistinct blur or a picture of a flash-frozen athlete during peak action.

The subject can move relative to the camera, the camera can move relative to the subject, or they can both move during exposure. You can use short or long exposure times for dynamic images.

WHAT IS BLUR?

Blur is the part of an image that is not sharp due to subject movement during exposure. The blur due to an image being out of focus is not discussed here.

The amount of blur in an image depends on many factors. This sometimes makes it difficult to get the right amount of blur for a certain effect. If there is too much blur, the image may be totally fuzzy and indistinct. If there is too little blur,

there may be no sensation of movement in the photo.

Because of this, you should vary exposure times when trying these creative techniques. Make a few exposures of the subject with a different shutter speed for each exposure.

This gives the best chance for getting a successful picture. If you make a careful record of your exposures, you'll quickly learn what settings work best under various conditions.

COLOR OR B&W FILM?

If you use b&w film to capture image blur, you'll get best results if the scene is contrasty. This way tonalities won't merge too much and become indistinct in the photo. This is less of a problem with color photos because different colors of the same tone are still distinct.

With either b&w or color film, a back-

ground darker than the moving subject will give best results. If the background is lighter than the subject, the dark blur may not be recorded on film. Background exposure will show through the blur.

THE MOVING SUBJECT

The simplest case to consider is when only the subject is moving. Hold the camera still or mount it on a tripod. The picture will show a stationary background and a moving subject. The amount of blur implies the speed of the subject. Even a slow-moving subject can be made to look as if it is moving quickly if the blur is pronounced.

Or, a fast-moving subject may look slow if the blur is slight or unapparent. The effect depends on the nature of the subject, subject distance, shutter speed, and subject motion in the direction 90° to the lens axis.

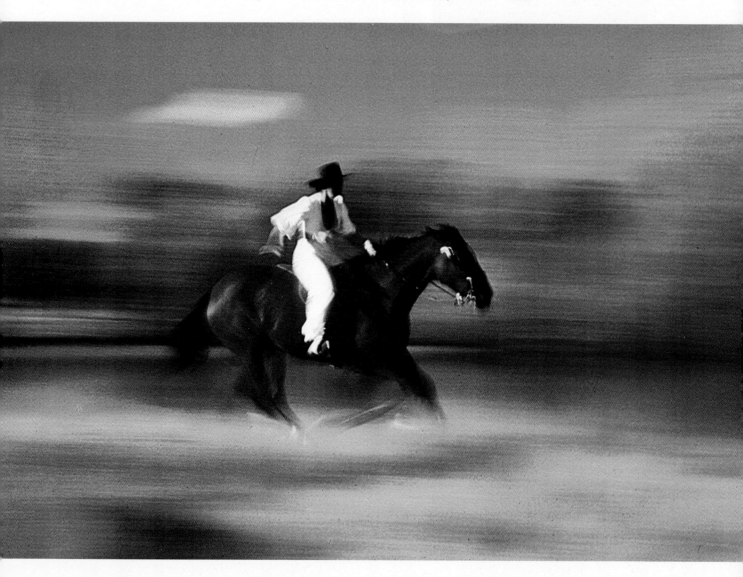

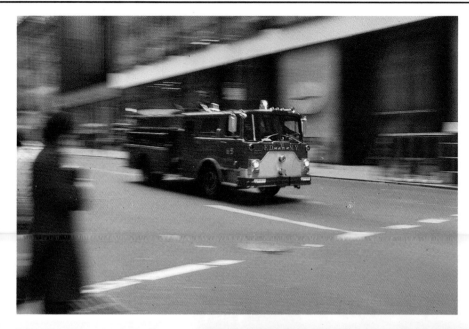

Stopping Motion—To *stop* subject motion on film, use the following formula when you use a 50mm lens on your 35mm SLR. If you double the lens focal length, use half the calculated time. If you use half the focal length, double the time.

$$T = D/(1000 \times S)$$

T is shutter speed in seconds.
D is distance between camera and subject in feet.
S is subject speed in miles per hour.

Example—Use typical subject speeds based on your experience for values of *S*. For example, if you photograph bicycle racers moving past you at 30 miles per hour on a road about 30 feet away:

$$T = 30/(1000 \times 30)$$
$$= 1/1000 \text{ second}$$

A shutter speed of 1/1000 second with a 50mm lens will freeze their motion. With

The pictures on these two pages were made with similar shutter speeds, about 1/30 second. Notice how the degree of blur is affected by camera operation and the angle at which the moving subject crosses the field of view.

Left: Panning with a subject traveling 90° to the lens axis created a blurred background and enhanced the impression of speed. Because the horse's legs and the rider's arms were not moving the same as the rest of the subject, they appear more blurred. Photo by M.P.L. Fogden.

Although actually moving faster than the horse in the photo on the facing page, the fire engine in the photo above, crossing at 45° to the lens axis, appears to be slower. The background is clearer, so the impression of speed is reduced. Photo by Norman Tomalin.

▶This go-cart is moving toward the lens, so it appears stationary. Only the driver's expression and the photographer's low viewpoint convey any sense of movement. Photo by Robert Estall.

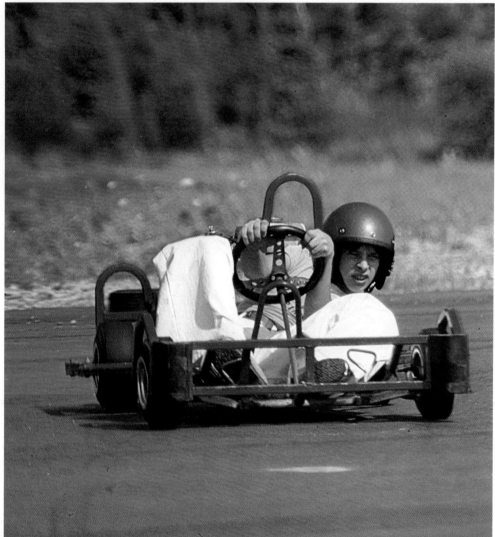

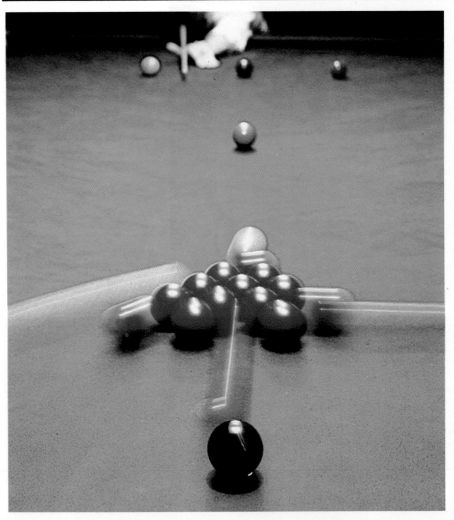

of 1/500 second. A shutter speed of 1/125 second will blur the subject more. If the shutter speed you selected is very long, such as 1/2 second, the racers will move out of the frame before exposure is finished. Their exposure will be slight or imperceptible. The picture may show only the road.

If the subject is not moving at a 90° angle to your line of sight, use a speed even slower than the calculated value for blur. If the subject crosses at a 45° angle, use a shutter speed one step slower than the value you would use for a subject moving 90° to you. If the subject is moving directly toward you or away from you, use a shutter speed two steps slower.

PANNING

This is the technique of moving the camera during exposure. The subject may or may not be moving. What happens is that the background blurs in the photo. A motionless subject will also blur.

If the subject is moving in the same direction as the swinging camera, it will have less blur than the background. In effect, the camera and subject are practically still relative to each other. It's nearly impossible for them to move so the image looks perfectly sharp on film. Typically, the moving image is partially sharp and partially blurred with all of the background blurred. The effect is similar to what you see when you follow a quickly moving subject with your eyes.

▲ ▶ Clive Sawyer used tungsten-balanced film for these two exposures. Exposure time was 1/4 second. Above: Notice that the streaking due to the moving balls is due to the highlight. The balls that moved most were not in one place long enough to reflect sufficient light to expose film. Right: For this photo, exposure settings were unchanged but the balls were moving slower. The blurred effect is different.

a 24mm lens, a speed of 1/500 second will stop motion. Depending on the composition and when you release the shutter, a photo that shows the racers sharp may also give the viewer the feeling of motion.

To Get Blur—If you want blur in the photo, select a *slower* speed than the calculated value. You may not have much of a choice anyway, depending on the lighting conditions and the speed of the film you are using.

The slower the shutter speed, the more blur in the image. In this example, to get slight blur with a 50mm lens, use a speed

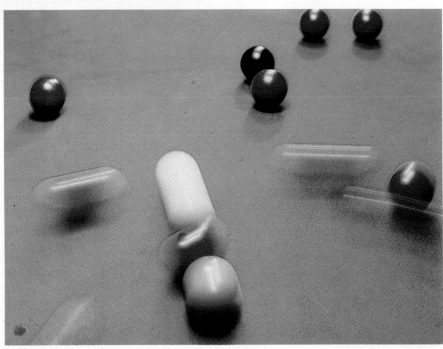

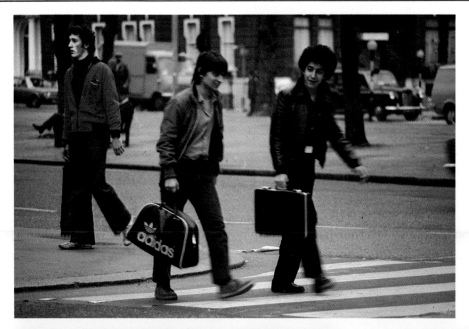

These four pictures were made with an ASA 25 film on an overcast day. The sequence illustrates the effect of different shutter speeds recording a moving subject. Aperture was closed more as shutter speed became slower.

At 1/60 second (left), only the fastest-moving parts of the people are blurred. At 1/15 second (below left), both subjects are blurred, but still recognizable. The fastest-moving areas have seemingly disappeared, making these girls seem one-legged. At 1/4 second (below right), more of the background shows through the blur. With a 1-second exposure (bottom), the subjects have almost totally disappeared. Only the brightest parts of the moving subject in front of the dark parts of the stationary subjects are recorded. Photos by Homer Sykes

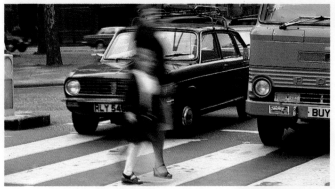

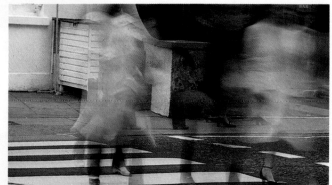

How To Pan—To make this technique work, you must follow the direction of the moving subject before and after exposure. If the subject is moving horizontally, follow the subject while moving the camera horizontally. Hold the camera at eye level and swing from your hips. Swing at a speed that makes the viewfinder image of the subject seem still. This will take some practice. If the subject is moving vertically, you can pan up or down.

Panning techniques will also work to photograph a moving subject from a moving vehicle, such as a car or train. What is most important is the motion of the camera relative to the motion of the moving subject.

Have the lens prefocused for the approximate subject distance at the time of exposure. Suppose you are photographing race cars and want to photograph the winner crossing the finish line. Focus on the finish line first, then follow the cars traveling down the track. Your total attention is

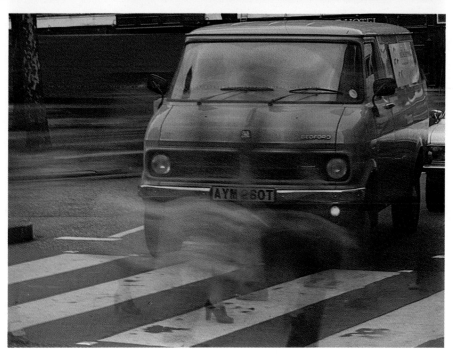

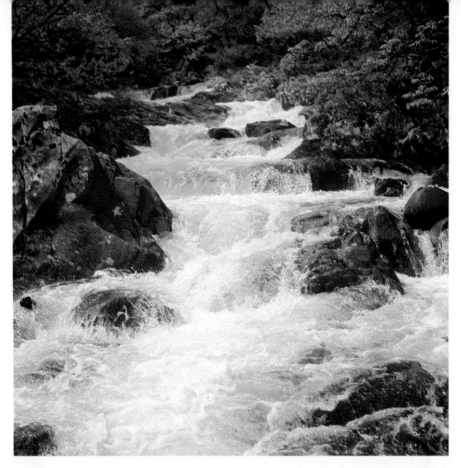

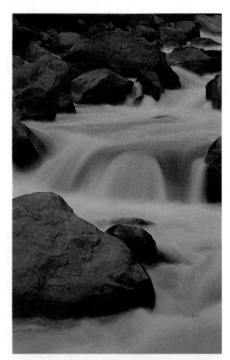

▲A fast shutter speed of 1/500 second makes the water seem frozen.

▼A longer exposure of 1/8 second in the photo below produced blurred water, which intensifies the feeling of rushing water. To compensate for the longer exposure, Eric Crichton stopped down the lens to f-22, which also gave extensive depth of field.

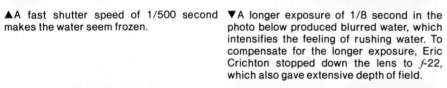

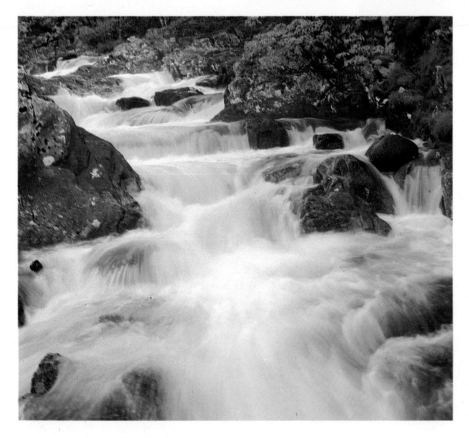

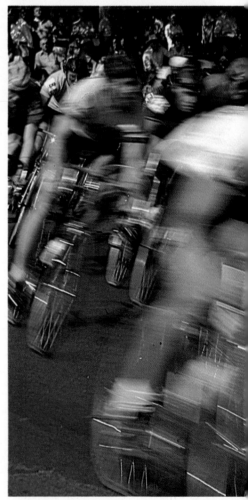

◄This water was photographed with a three-second exposure. Lens aperture was set to the minimum opening. A neutral-density filter was used to absorb light so the film would not be overexposed. As shutter speed lengthens, the water appears softer and smoother, until the impression of motion is gone and the water seems to be a soft blanket on rocks.

►Gerry Cranham panned a 200mm telephoto lens to convey the speed of this motorcycle. He used ASA 25 film and a 1/125-second shutter speed.

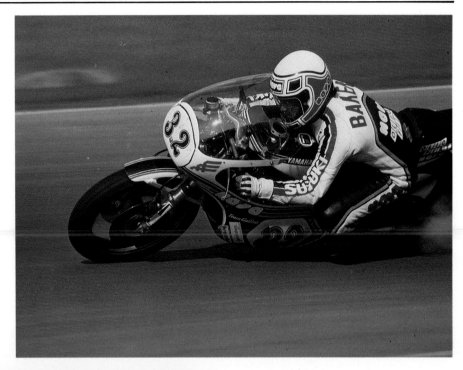

▼A moving subject with many highlights can become an effective picture when photographed in front of a dark background. Photo by David Overcash.

now on following the lead car and pushing the shutter button at the best time. You don't have to worry about focusing the camera. It is impractical to pan and focus at the same time.

As you swing the camera smoothly, push the shutter button to make the exposure. Do not stop swinging the camera after you push the shutter button. Continue following the action during exposure. The viewfinder image will black out in an SLR camera because the mirror is up, but if you are panning smoothly this won't matter. When the mirror swings back down, exposure is finished.

If you pan too slow or too fast, both the moving subject and the background will blur. This is OK if it is the effect you want.

Shutter Speed—Generally, you should use a shutter speed that would give a blurred image if you did not move the camera. Use the formula and information at the beginning of this section as a guide.

GETTING SLOW SHUTTER SPEEDS

For good exposure with some of these techniques, you may need to use slow shutter speeds, such as 1/15 second and slower. If you use a high-speed film on a sunny day, this may not be possible. For example, with ASA 400 film used outdoors on a sunny day, a typical camera setting is 1/500 second at f-16. Even if the lens can be stopped down to f-32, the slowest shutter speed will be 1/125 second. If you use slower speeds, the film will be

Unless your camera is mounted on a tripod during a slow exposure, some camera movement is inevitable. Use the resultant camera shake for creative motion effects. Victor Robertson made the top photo with an ASA 25 film and a 200mm lens. Exposure was 1/15 second at ƒ-16. The photo below by Tom Nebbia was made with similar equipment and settings.

Camera movement would have been inappropriate in the photo at right. The impression of the speed of the moving train depends on the stationary foreground sign. John Sims mounted his camera on a tripod and used an exposure time of 1/8 second.

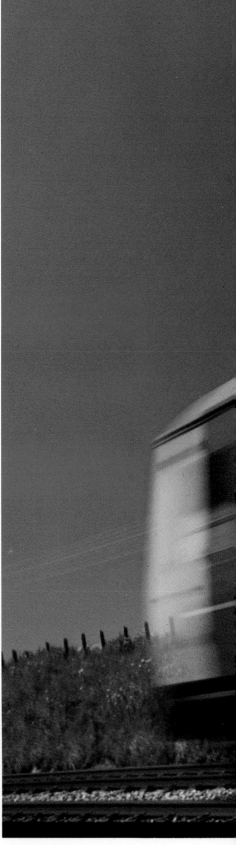

overexposed. There are two ways to avoid this kind of problem.

Slow Film—With slow film you can use slow shutter speeds and small lens apertures to get good exposure. For example, on a sunny day with ASA 32 film, a typical camera setting is 1/30 second at *f*-16. If you use a lens that stops down to *f*-32, shutter speed is 1/8 second. If the light is dimmer than that of a bright sunny day, you can use even slower speeds.

Neutral-Density Filter—When you can't stop down the lens any more, yet still need to lengthen exposure time, the problem is *absorbing* light you don't need. Filters absorb light, so you can use them to reduce the brightness of the light exposing film. *Neutral-density* (ND) filters are ideal for this, for two reasons.

Because they are colored gray, they don't affect the color balance of the light exposing film. If you shoot b&w film, there will not be any change in tonal contrast due to the filter. Nor will there be a color shift if you shoot color film. In addition, ND filters are available in different strengths, or *densities*. This lets you carefully control the amount of light absorbed by the filter.

Glass and plastic ND filters are typically available with one, two, or three steps of light-stopping ability. Gel ND filters are also available in increments of 0.10 density units from 0.10 to 0.90. Each 0.10 units of neutral density is one-third exposure step. Therefore, 0.30 density units is one exposure step of absorption, 0.60 is two steps of absorption, and 0.90 is three steps of absorption. Also available in gel form are 1.0, 2.0, 3.0 and 4.0 ND filters. These correspond to about 3, 7, 10, and 13 steps of absorption.

PEAK ACTION

Even though the fastest camera-controlled shutter speeds are often used to freeze movement of fast-moving subjects on film, it is not always necessary. This is because some motion is predictable and rythmic. There will be an instant of *peak action,* in which the motion reaches its limit in one direction, stops for an instant, and shifts to another direction.

For example, this happens when you throw a ball in the air. After it stops rising and before it starts falling, the ball is still. This is peak action. If you are using a relatively slow shutter speed that won't freeze the motion of the ball in motion, take the picture at the moment of peak action. Doing this well requires good timing and anticipation of the motion.

◀Duncan Laycock's split-second timing caught this rider at the top of the leap. He used ASA 64 film with an exposure of 1/125 second at ƒ-5.6 to effectively stop the motion. A 200mm lens gave shallow depth of field. By pre-focusing on the track before the rider arrived, Laycock was able to concentrate on exposing film at the proper time of the leap.

▶Electronic flash is effective for freezing all but the fastest movement. It is especially useful for some wildlife photos made at night. Photo by Hans Reinhard.

▶To stop the movement of this dancer with a 1/60-second exposure, the photographer exposed film during a pause in the movement. Careful framing and timing are most important for shots like this. Pre-set exposure or use a camera that sets exposure automatically.

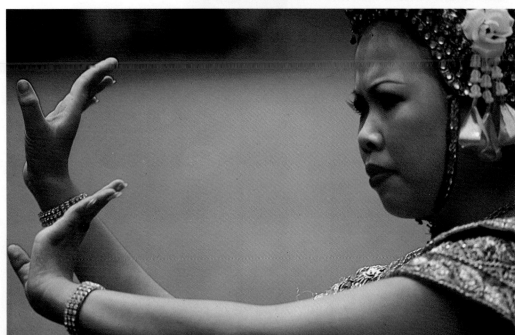

▼For this picture, Michael Busselle used a shutter speed of 1/1000 second to stop the motion of the water.

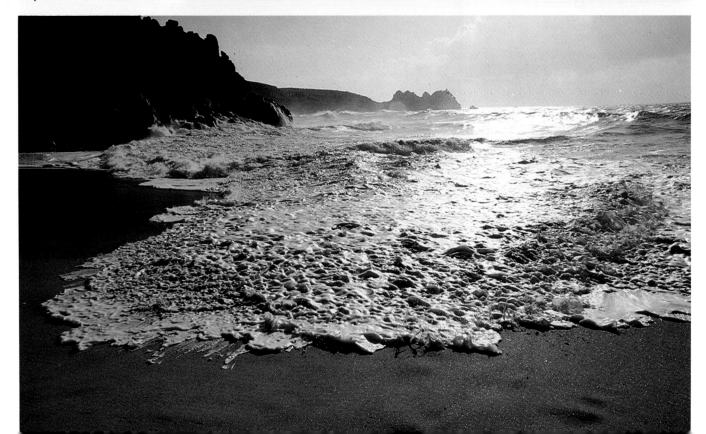

With many subjects photographed this way, motion is usually *implied* even though seemingly frozen on film. If something is up in the air, we know it got there because it was moving up. And, we know it's coming down because of gravity! The limbs of some subjects, such as athletes and dancers, are fully extended at times of peak action. This, too, can imply action and movement.

USING FLASH TO STOP MOTION

The flash duration of a small, camera-mounted electronic flash used manually is about 1/1000 second. This will stop many types of motion. For shorter flash durations, use an automatic flash on nearby subjects. The flash will turn itself off when the subject receives enough exposure. This can give flash durations as short as 1/20,000 second! Because the flash effectively stops motion, as recorded on film, you should push the shutter button at the right time to imply motion in the picture.

MOVING LIGHTS

The word *photography* literally means to write with light. By using moving lights, you can write with light, show motion, or make beautiful abstract color images, as shown on these pages.

Writing with Light—Photograph a person holding a flashlight or sparkler at night. Use the camera on a tripod and set the camera's shutter-speed dial to **B**. With this setting, the camera shutter stays open as long as you depress the shutter button.

Depress the shutter button to open the shutter. Have the person slowly move the light to write words, draw pictures or make abstract lines. To end exposure, release the button to close the shutter. To get a picture of the person during the long exposure, fire a flash before closing the shutter.

When doing this the first time, bracket exposures and make careful notes of exposure times and aperture settings. For subsequent photos with this technique, refer to your notes and you'll bracket less.

You don't have to manually depress the shutter button to keep the shutter open. Instead, use a locking cable release to open the shutter, then lock the release's plunger in the down position. The shutter stays open until you unlock the plunger.

Showing Motion—Record motion with lights moving relative to a camera mounted on a tripod, as shown in the photos on the opposite page. Or, you can move just the camera, as shown above. The possibilities are endless. Don't be afraid to experiment and expose lots of film.

◀Photographer Colin Barker made this abstract photo by shaking the camera during a one-second exposure of lights at night.

▼John Garrett lit this runner with two lights. A filtered tungsten light illuminated the subject during a one-second exposure. Then Garrett fired a handheld flash to freeze subject motion.

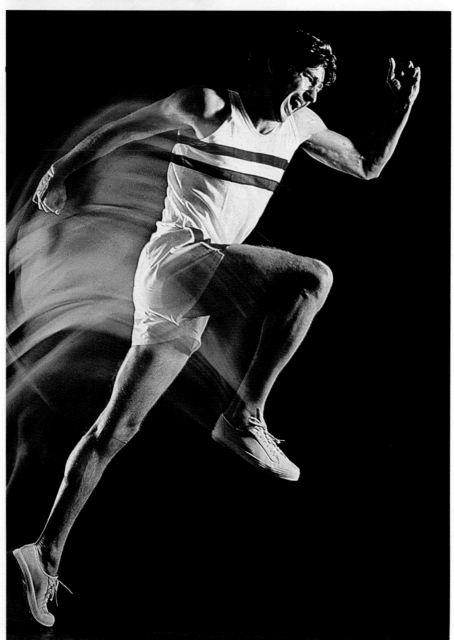

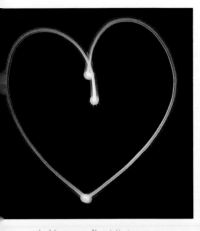

▲ Here, a flashlight was used to draw a heart. The camera was on a tripod, and the shutter held open on B during the motion of the light.

▼ Photograph car lights at night for unusual photos. Bracket exposures for best results.

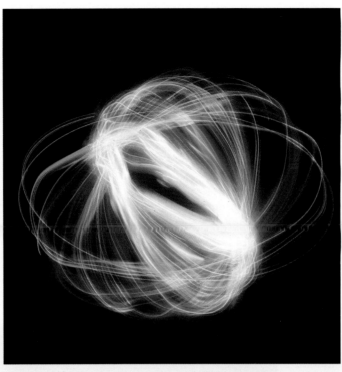

▲The drawing above shows one way to make photos of a moving flashlight. Focus the lens, turn on the flashlight, swing the cord, and open the camera shutter. Use colored filters over the camera lens for different exposures, as shown at left.

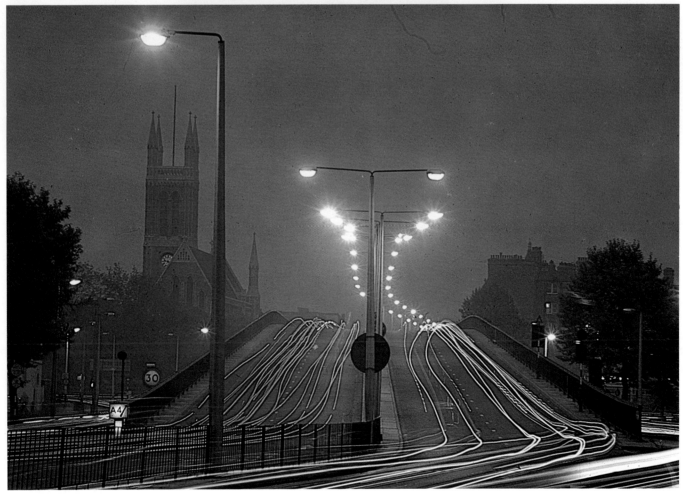

Zoom Effects

In addition to offering many focal lengths in one lens barrel, a zoom lens also gives you simple ways to get creative blur in your photos. By zooming during exposure, you can induce the feeling of movement in a stationary subject or make a moving subject even more interesting.

RECOMMENDED LENSES

The best zoom to use is one with a *zoom ratio* of 2.0 or more. Zoom ratio is maximum focal length divided by minimum focal length. Zooms of this sort are in the wide-angle, standard, and medium-telephoto focal-length ranges. They include 24-50mm, 35-70mm, 43-86mm, 75-150mm, 70-210mm, 80-200mm, 100-200mm and others.

These zooms offer a wide range of focal lengths and are light enough to handhold, if necessary. Some have one ring that controls both focus and lens focal length; some have separate rings.

ZOOMING TECHNIQUE

To create the characteristic streaking blur of the zoom effect, change lens focal length during a long exposure. When first trying this technique, use the camera mounted on a tripod. As you become more experienced, you may not need a tripod for all photos.

Meter the scene and set a relatively slow shutter speed such as 1/4, 1/8, or 1/15 second. You need this much time to smoothly adjust the zooming ring of the lens. If shutter speed is too fast, exposure will end before you use the full range of focal lengths.

Compose the image and focus the lens at its minimum focal length. After you begin the zoom by turning, pushing, or pulling the zooming ring, push the shutter button. Continue zooming during exposure.

Other Considerations—The method just described yields an image with streaking lines that seem to radiate from the center. Zooming from the maximum focal length to minimum focal length will give similar results if you operate the zoom for the total exposure.

However, some photographers prefer to use the zoom during only part of the total exposure. Part of the total exposure is made at minimum focal length to record the stationary subject. Then the lens is zoomed for the rest of the exposure. This way the image has a relatively sharp center with streaking lines emanating from it. This technique works best with scenes having very dark backgrounds. It was used for the large photo on pages 204 and 205.

Appropriate subjects for this technique should be contrasty. This way streaking bright areas will be recorded against dark areas of background. For example, with night scenes, streaks due to bright lights being zoomed become apparent against the darkness.

The effect of zooming is usually more interesting on color film than b&w film. With b&w film, tones merge during zooming, giving a print that has less tonal contrast than the original scene. If you must shoot in b&w, choose a very contrasty scene, such as one at night. With color film, the impact of blurred, streaking colors usually compensates for any decrease in image contrast.

Experiment and Bracket—The exact technique that works best with each scene is difficult to predict. When possible, try different exposures, shutter speeds and zooming rates.

Try handholding the camera and zoom while panning. Combine zooming effects with other creative camera work.

▼Leo Mason zoomed and panned to capture the cyclists' frantic energy on film. He used a 1/60-second shutter speed.

►A static subject, such as these flowers, can be made visually appealing with zooming technique. Photo by Suzanne Hill.

▼Below, right: Zooming during an exposure time of 1/30 second may yield an effective photo. The dark background and moving subject helped this picture. Photo by Leo Mason.

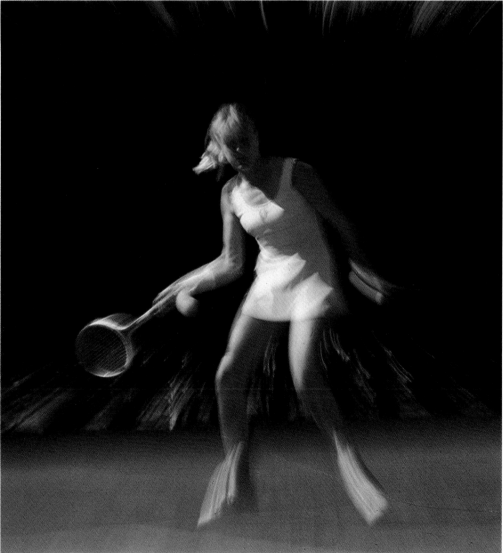

Making Multiple Exposures

Making more than one exposure on a single film frame is an exciting part of photography. It enables you to combine elements to make an image that would be impossible to make any other way, such as putting a full moon in a dark part of a landscape. It offers almost unlimited scope for your imagination and can give you some spectacular photographs.

CAMERA OPERATION

Modern cameras are designed to prevent accidental multiple exposures. Even so, you can make multiple exposures with most SLR cameras. After the first exposure, recock the camera shutter without advancing film as described in this section. Then push the shutter button to expose another image on the same frame. Repeat as often as desired.

Multiple-Exposure Control—Some SLR cameras have a multiple-exposure control that releases the film-advance mechanism from the camera's film-wind lever. On many cameras this control is a lever located near the film-wind lever. When the control is set for multiple exposures, you can cock and operate the shutter any number of times without moving the film.

The frame counter of some cameras advances every time you cock the shutter. In this case the counter indicates you've exposed more film than you really have. To keep an accurate count of the number of frames exposed, you'll have to write it down or use your memory.

With other cameras, using the multiple-exposure control also disengages the frame-counter mechanism. This gives an accurate count of the number of exposed frames.

Three-Finger Method—You can use most 35mm SLR cameras without a multiple-exposure control to make multiple exposures, but camera operation is a little trickier. Before making the first exposure, turn the film-rewind crank to take up the slack film in the film cassette. Turn the crank in the direction of the arrow engraved on the crank or camera top.

Make the first exposure.

With your left thumb, hold the film-rewind knob so it can't turn. At the same time, depress the film-rewind button, which is typically on the bottom of the camera. Depending on the size of your left hand, you can use either your index or little finger.

When both knob and button are secured, move the film-advance lever to cock the shutter. Film should not advance because depressing the film-rewind button at the bottom of the camera disengages the film-advance mechanism from the film-advance lever.

Make another exposure. Repeat the procedure for the next exposure.

After the last exposure on the frame, operate the film-advance lever to advance film as normal. Make a blank exposure by pushing the shutter button while covering the lens with its lens cap or the palm of your hand. This is helpful because the film sometimes slips a bit when you operate the film-advance lever normally after using the film-rewind button. If the film slips, the exposure on the next frame will overlap the multiply exposed image, possibly ruining the composition.

EXPOSURES

If you use normal settings for each image of a multiple exposure, you'll probably overexpose the film. Bright areas of each exposure will add up and reproduce white in the image. Avoid this problem by making each exposure a fractional part of the total.

For example, if normal exposure for two scenes of a double exposure is f-4 at 1/60 second, expose each at f-4 at 1/125 second. Each image is underexposed by one step, half the normal exposure. They add up to one normal exposure. For a triple exposure, give each image one-third the normal exposure.

This general guideline works if each scene or part of the multiple exposure has approximately equal amounts of light and dark areas in the scene and there will be overlap of light areas. Bright parts of one picture will be visible when overlapped with dark parts of another exposure. Overlapping dark parts stay dark. Overlapping bright areas become lighter and may be overexposed if you make too many exposures.

Using the Film-Speed Dial—A simple way to get good exposure settings for a multiple-exposure photo is to use the camera's film-speed dial as a multiple-exposure-control device. To do this, multiply the normal speed of the film in the camera by the number of exposures you plan to make. Set this number, or the closest standard film-speed number, on the film-speed dial. Meter each scene normally and use the recommended settings for each image of the multiple exposure.

For example, if you want to make four exposures on a frame of ASA 100 film, set **400** on the film-speed dial. The camera meter will then "underexpose" each image by two steps because the film-speed setting is set for a faster film speed. But total exposure is correct.

◄When image overlap is minimal and the scenes have large dark areas, use normal full exposure for each image of a multiple exposure. Michael Busselle moved the camera for the second exposure.

►Above right: The details of one image will always appear most strongly in the shadow areas of the other. Notice how the image of the bush is most apparent in the shadow under the hat. The exposure for each image was half the normal value. Photo by Brian Rybolt.

►To create the impression of leaves blowing in a storm, while keeping the whole image sharp, Ekhart Van Houten made four exposures, each underexposed by two steps. He moved the camera slightly between exposures.

With an Automatic Camera—You can do the same thing with the Exposure-Compensation Dial of an automatic camera. If you want to make a double exposure, set the dial for one step less exposure. If you want to make four exposures, set the dial for two steps less exposure. For three or five exposures, use the film-speed-dial method described.

Using Filters—If you want to use a colored filter on the lens for one or more of the images in a multiple-exposure photo, do it! Use the same exposure guidelines described. The camera's through-the-lens meter will automatically compensate for the added density of the filter.

▶The first exposure of this photo was of the waves. Chris Alan Wilton used a 105mm lens and shaded the sky area with a black card. The second exposure of the sun was greatly underexposed through a neutral-density (ND) filter. He blocked the bottom part of the picture with the black card during the second exposure.

▼For the first exposure of the statue, Sergio Dorantes used an 85mm lens to make the small dark image at the bottom. The second, more dramatic, exposure was made from the same spot with a 500mm lens and a red filter.

One of the most fascinating ways to use filters for multiple exposures is to make a triple exposure through a red, green, and blue filter. Kodak recommends the 25 red, 58 green, and 47B blue filters for this work.

The red, green, and blue exposures add to make white light. Therefore, a stationary subject photographed this way will reproduce with correct colors. Moving elements of the scene, such as white clouds or running water, are colored red, green, and blue. In addition, areas exposed by more than one exposure show mixed colors. Red and green combine to make yellow. Red and blue become magenta. Blue and green mix to give cyan.

Exposure Exceptions—The general guidelines described are good starting points for multiple exposures. However, it is sometimes difficult to make exact exposure predictions. Most times you'll get best results if you make more than one multiple-exposure photo of a certain idea.

Try varying exposure and image alignment. Change lenses between exposures. Use a variety of methods instead of just making one frame of double exposures. An experimental technique usually requires a lot of imagination *and* film to be a success.

If a large part of the scene in each image is a very dark area, you may not need to "underexpose" each image. If you arrange the placement of the images so bright areas do not overlap, but instead coincide with dark parts of another image, you can expose each normally. Use this technique when making photos at night or when making pictures of heavily shadowed areas.

If you want to, you can even mask part of the image area with a black card held in front of the lens. Make the second exposure in this area while holding the black card over the area exposed by the first exposure.

DOUBLE-EXPOSING THE WHOLE ROLL

One advantage of making double exposures is that you can combine images made many miles or days apart. You don't have to keep a roll of film in your camera while waiting to discover another scene for the second exposure. Instead, after the first series of exposures, you can rewind and remove the roll, reload it later, and shoot it again when the opportunity for the second scene occurs.

When To Do It—This technique is good to use when you want to make double

The most important step in exposing a roll of film twice is making the registration marks on the film and camera. After inserting the tongue of the film leader into the take-up spool, turn the film-rewind crank to take up slack in the film remaining in the cassette. Then mark the film and guide rail with a grease pencil. The dashed line in the above drawing indicates one place to do this. See the text for more information.

The photographer who made the pictures below didn't bother to make registration marks. The top strip shows the evening landscape pictures he made first. Then he rewound the film. He reloaded it and shot when the moon was full and the night sky clear. He relied on luck for registration of the landscape and the full moon images.

As you can see in the bottom film strip, the moon was not imaged where the photographer expected it to be. The border areas between frames do not line up, and the results are unusable.

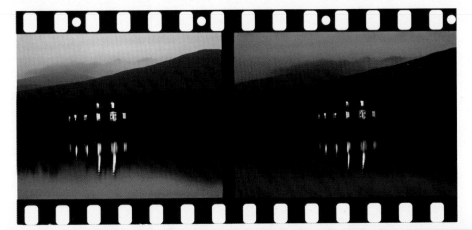

exposures on the whole roll. This is not unreasonable because you will want to bracket exposures anyway. For example, a 20-exposure roll may contain five different scenes, each bracketed four times.

Scenes appropriate for this method should have dark areas. Superimpose the bright parts of the second image over the dark areas of the first image. The dark parts of the second image are superimposed over the bright parts of the first exposure. This works well with night scenes or scenes in which you can cover parts of the frame with a black card held in front of the camera. Usually, each image receives full exposure.

For example, you may want to photograph an evening landscape when the moon is not out. Later, you can re-expose the roll of film when a full moon is high in the sky. If you wish, you can use a telephoto lens to make the moon appear relatively large on film.

How To Do It—Start with an unexposed roll of film. Load the roll into the camera and insert the tongue of the film leader into the take-up spool. Turn the film-rewind crank to take up the film slack in the roll.

Then make a registration mark on the back of the film and a guide rail. Use a grease pencil to make the mark. Close the camera back and advance the film two frames.

When you expose film to the first scene, make exposure notes and small drawings of each scene. This way you can remember where the dark parts of the first exposure are.

After exposing the whole roll to different scenes, rewind the film slowly. As soon as you feel rewinding tension slacken, stop rewinding. This prevents the tongue of the film leader from being wound into the film cassette.

Remove the roll, label it, and store it with the notes and drawings you made. Store the film in a cool dry place until you are ready to make the next series of exposures.

When this time arrives, reload the roll as described. Line up the registration marks on the film tongue and camera guide rails. Take up the slack in the film by

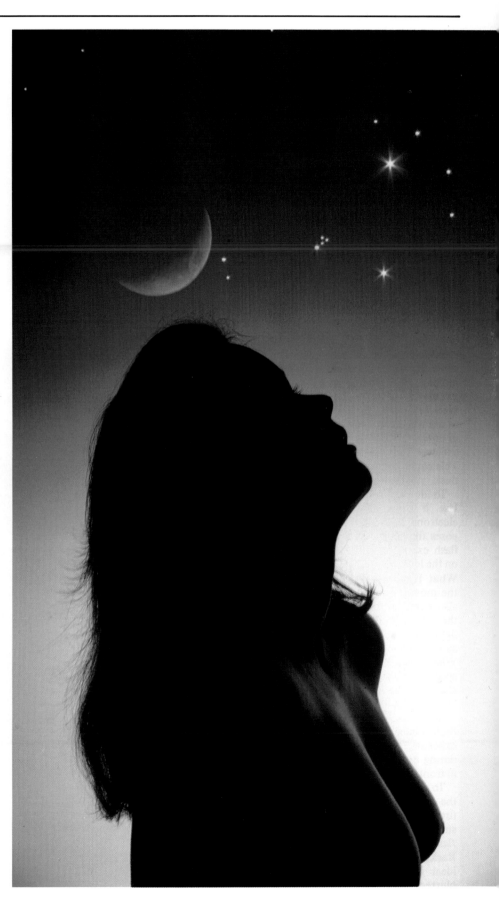

▶ Photographer Chris Alan Wilton exposed a roll of film with shots of the moon. Later he reloaded the roll and used it to photograph the model in a studio. Lighting was arranged to prevent double exposure on the moon. Pinpoints of light shot through holes in a black card represent stars.

and the blur effect you want in the picture. A lot of blur requires a bright continuous light and slow film. A little blur requires faster film and dimmer light.

When you use color film, balancing the color of the flash and continuous light is an important consideration. If you use daylight film, the flash-frozen image will be recorded in correct colors. However, the blurred image may not be. It will be orange if you use tungsten lighting for the continuous light. Light from the setting sun will also give a warm blurred image.

If this is a problem, filter the exposure from the continuous light to match the color of the flash. You can use a light-balancing filter over the camera lens or a filter over the continuous light source. Remove the filter from the camera lens before making the flash exposure. Or, use a color film balanced for the tungsten light and filter the flash to match the color temperature of the tungsten light. When filtering, be sure to take into account the light absorption by the filter. Make exposure adjustments to compensate for this.

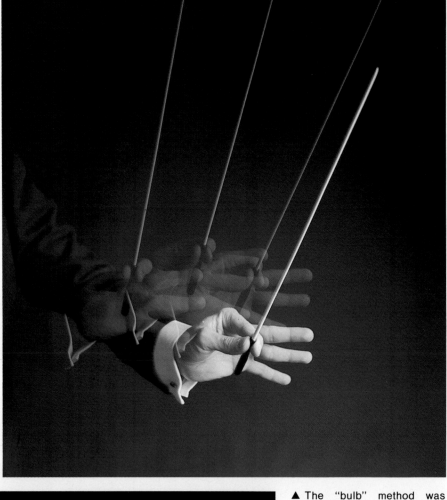

▼ This photo was made with the camera on B for multiple exposures. A flash was fired three times. The subject moved after the first and second flash. Exposure was calculated so the sum of the three flashes would add up to correct exposure.

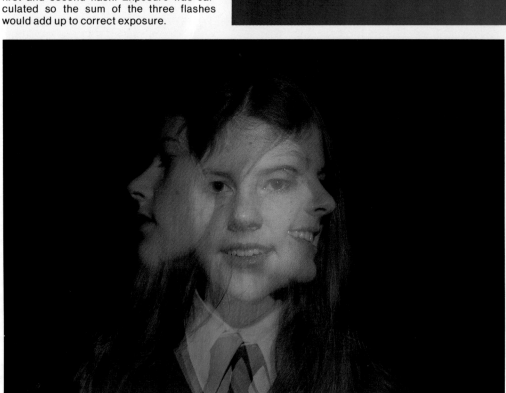

▲ The "bulb" method was used for these four exposures. The camera shutter-speed dial was set to B, and the shutter was held open for all exposures. Full exposure was calculated for the image in correct colors. Then photographer Robert Estall held a black card in front of the lens and stopped the lens down one step. Before the next three "underexposures," he used a red, blue, and green filter on the lens. He put the filter on the camera while holding the card in front of the lens.

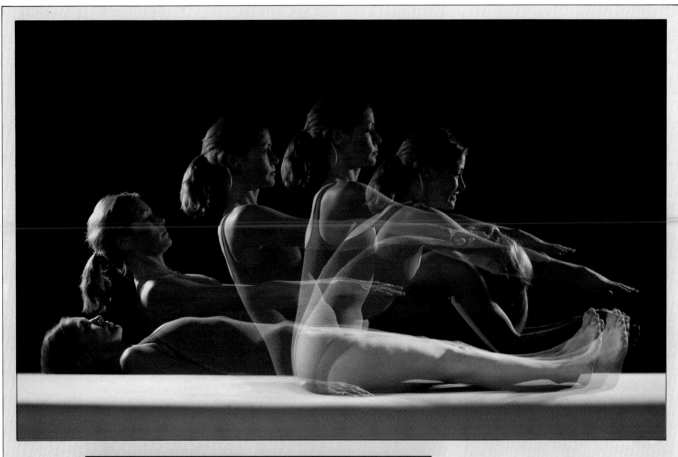

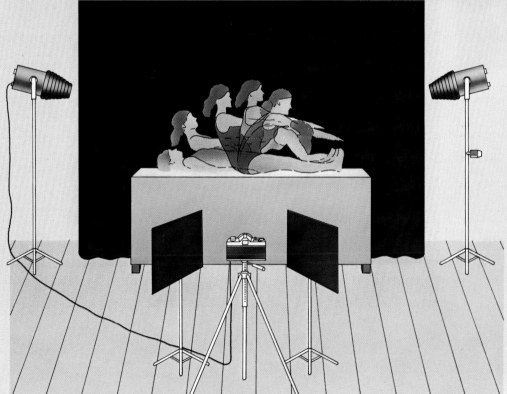

Michael Busselle used two studio flash units to make this multiple-exposure photo of six parts of a yoga exercise. The background was black velvet. Two black cards near the camera prevented stray light from reaching the film. Because there is much image overlap, Busselle calculated partial flash exposure for each segment. This underexposed each segment, but prevented gross overexposure where the six segments overlap. The flashes were fired manually while the shutter was held open on B.

STROBE FLASH

A *strobe* is a special quick-repeating flash. It gives bursts of light in intervals, freezing segments of the motion on film. This gives a series of still images that imply motion. A powerful strobe flash is a very expensive item. Less-expensive models are available from specialty-lighting stores and some scientific-supply houses, such as Edmund Scientific (101 E. Gloucester Pike, Barrington, NJ, 08007).

Backgrounds and Exposure—To avoid blending the sequence of images with

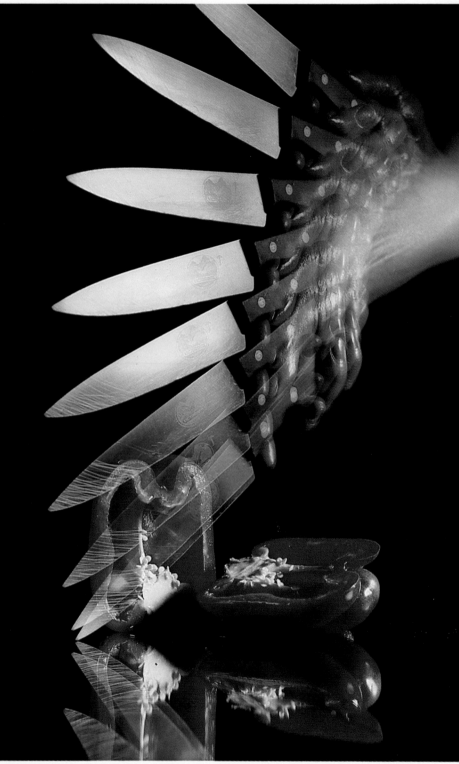

▲ ▶ These photos were made with a small strobe flash. For the photo at right, exposure was calculated so the sum of the flashes would not overexpose the pepper. The overlapping images of the moving wrist are slightly overexposed because the wrist was nearer the strobe. Different combinations of flash frequency and subject motion were tried to get this photo. Bracketing is recommended.

A similar technique was used for the photo above. The main difference is that a tungsten light source was also used. This gave extra exposure to the film. The moving subject is blurred between flash-frozen images, making the movement of the blade seem smoother than at right.

background detail, use a black background. Put the strobe to the side of the subject for strong side lighting. This helps prevent the images of the series from overlapping.

If a stationary subject is an important part of the picture, calculate exposure so the *combined* flash exposures give good exposure for it. If there is no stationary element, calculate exposure so each frozen segment receives full exposure.

Use the camera set to **B**. Open the shutter, and start the strobe and subject motion simultaneously. When the action is completed, close the shutter. Determine the best combination of flash frequency and subject speed with tests. Or, bracket extensively to get best results.

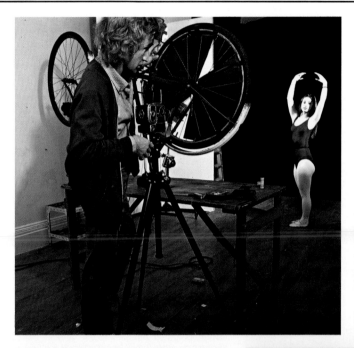
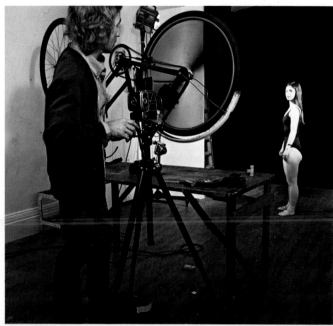

▲ An inexpensive way to make a rotating shutter is to cover a bicycle wheel with black paper, except for one or two sections. The gap should be big enough for the lens to see all of the subject when the gap is centered in front of the lens. Spin the wheel, then open the shutter. Bracket extensively and adjust rate of subject motion, speed of the spinning wheel and total exposure time.

▶ For this image, the total exposure time was 1.5 seconds. Notice that this overexposed the central part of the image, where the subject was relatively stationary.

ROTATING SHUTTER

This is a very inexpensive way to get strobe-flash effects. It is a revolving black disc or wheel with an opening. When rotating in front of a camera with the shutter open, the open part of the disc lets light through every revolution. If the subject moves during the revolution, a different image is recorded on the film each revolution.

Use a high-level continuous light, such as a tungsten-halogen lamp, to light the scene. The same background and side-lighting conditions as with a strobe flash apply here.

Use the camera set to B. Open the shutter after the disc begins spinning. Close the shutter to end exposure. Proper exposure depends on the rate of subject motion, the speed of the spinning disc, the size of the opening in the disc, the light level and film speed. This is an experimental technique requiring careful testing. For best results, bracket extensively.

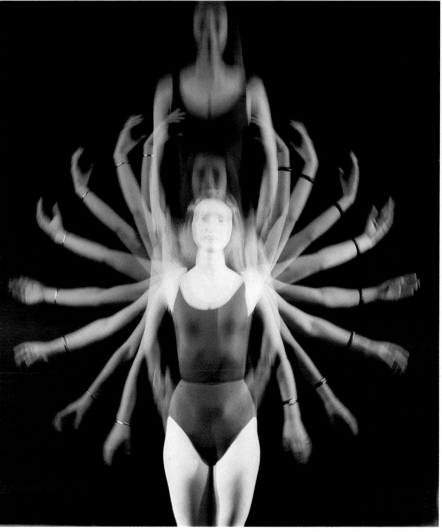

Using Your Camera

In this section you'll find explanations of photographic terms used in this book. Use it as a visual glossary to help refresh your memory.

EXPOSURE

The amount of light and its duration on film is exposure. To make good pictures, you must expose film correctly. This is one of the basic technical challenges of photography. Typically, you determine the correct amount of exposure by metering the light reflected from the scene. You control exposure with two controls—the lens aperture and the camera shutter speed.

APERTURE

This is the adjustable opening in a lens that controls the brightness of the light exposing the film. A large aperture lets in more light than a small aperture.

APERTURE NUMBERS

Aperture size is usually represented by numbers called *f-stops* or *f-numbers*. A series of these numbers (without the *f*) is usually engraved on the lens *aperture ring*. Common *f*-stops are *f*-1.4, *f*-2, *f*-2.8, *f*-4, *f*-5.6, *f*-8, *f*-11, and *f*-16.

Larger numbers represent smaller openings, and vice-versa. Each *f*-stop lets in *twice* as much light as the next smaller aperture, and half as much light as the next larger one. For example, *f*-4 lets in twice as much light as *f*-5.6 and half as much light as *f*-2.8. The exposure difference between standard adjacent *f*-stops is called one *stop* or *step*. This book agrees with the international convention that uses *step*.

Typically, the aperture ring has detents for each engraved *f*-stop. In-between detents represent a half-step of exposure.

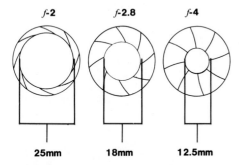

f-2	*f*-2.8	*f*-4
25mm	18mm	12.5mm

▲ This diagram shows how *f*-stops relate to the size of the aperture. The area represented by an aperture of *f*-4 is doubled when the diameter of the opening is increased by a factor of 1.4. The *f*-number decreases by a factor of 1.4 to become *f*-2.8 and the aperture lets in twice the light. Notice that an aperture of *f*-2 lets in four times as much light as *f*-4.

SHUTTER

This is the camera mechanism that controls the duration of exposure. A slow shutter speed allows light on the film longer than a fast shutter speed.

SHUTTER SPEEDS

These are the various exposure times allowed by the camera. The camera's *shutter-speed dial* controls exposure time. Standard exposure times are fractional speeds from 1/1000 second to 1/2 second and a whole-number speed of 1 second. Fractional settings are represented on the shutter-speed dial by the denominator of the fraction. For example, 1/500 second is represented by the number 500.

Each shutter-speed setting gives an exposure time half as slow as the next smaller number and twice as fast as the next larger number. For example, 250 (1/250 second) represents twice as much exposure as 500 (1/500 second) and half the exposure of 125 (1/125 second). The exposure difference between adjacent settings is one exposure step.

This doubling and halving of exposure times is the same as the doubling and halving effect of using standard adjacent apertures. Typically, the shutter-speed dial has detents for the standard shutter speeds. You can't get in-between speeds.

SHUTTER OPERATION

Current 35mm SLR and rangefinder cameras use a *focal-plane shutter*. The common version of this shutter uses two opaque blinds or curtains that move past the film when you push the shutter button. The first curtain is in front of the film when the shutter is cocked. The second is wound up on a roller, next to it.

When you push the shutter button, the first curtain uncovers the film. This lets light strike the film. After a certain time, the second curtain begins "chasing" the first curtain. The second curtain blocks light to the film.

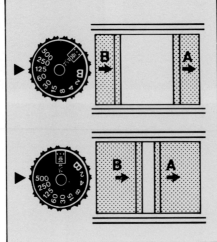

▲ This diagram shows how a typical focal-plane shutter exposes film. The top illustration represents an exposure time of 1/125 second, labeled 125 on the shutter-speed dial. The second curtain is released 1/125 second after the first and follows the first curtain, creating a traveling slit in front of the film.

The bottom illustration represents a shutter speed of 1/500 second. The second curtain is released 1/500 second after the first one, so the traveling slit is narrower than the one at the top.

Exposure time is the time between the start of the first curtain and the start of the second curtain. Essentially, a slit travels in front of the film during exposure. The width of the slit represents shutter speed. A fast shutter speed uses a narrow slit, and a slow shutter speed uses a wider slit.

For slow shutter speeds such as 1/60 second, the whole film frame is exposed to light for a short time until the second curtain begins moving, blocking light to the film.

CONTROLLING EXPOSURE

Metering a scene determines how much exposure film of a certain sensitivity requires for a good picture. You can use a variety of shutter-speed and aperture combinations to give the recommended exposure. Depending on the effect you want in the image, you can use a slow shutter speed with a small aperture, or a fast shutter speed with a large aperture.

If you are unsure of the exact amount of exposure the film requires, you can expose more than one frame to the same scene. This is called *exposure bracketing*, or just *bracketing*. Use different exposure settings for each frame. Make the first frame with an exposure based on metering. Then underexpose the next frame by a half or full step. Overexpose the next frame by a half or full step. Depending on the effect you want to preserve in the image, you can bracket by changing shutter speed or aperture.

The more unsure you are of exposure, the more you should bracket. If the scene is very unusual and unrepeatable, bracket with more than three exposures.

USING SHUTTER SPEED

Shutter speed controls the amount of subject motion recorded on film. If the subject moves during exposure, it may be recorded as a blur. The degree of blur depends on the speed of the motion and shutter speed. If the subject is not moving, you can use any camera shutter speed if the camera is firmly mounted to a tripod. If you are handholding the camera, there is a practical slow-speed limit that depends on the size and weight of the lens, and your steadiness.

To freeze subject motion, use a fast shutter speed, such as 1/1000 or 1/500 second. If you *want* blur in the photo for a certain effect, use a slow shutter speed that gives a blur on film. This requires a smaller lens aperture than when you use a fast shutter speed to freeze subject motion.

In either case, your first decision after metering a moving subject is deciding whether to freeze subject motion or not. You make shutter speed your first priority, then adjust lens aperture until the meter display indicates good exposure.

USING LENS APERTURE

The lens aperture controls the zone of sharp focus of the scene, as measured from the nearest to the farthest points of sharp focus. This zone is called *depth of field*. Small apertures, such as *f*-16, give more depth of field than larger apertures. As a memory aid, remember that large *f*-numbers give large depth of field, and vice-versa.

APERTURE SCALE

Standard *f*-stops engraved on camera lenses are shown below. The exposure difference between adjacent *f*-stops is one exposure step. The amount of light through the aperture doubles as the *f*-number decreases one step and halves as the *f*-number increases one step.

Aperture	*f*-1.4	*f*-2	*f*-2.8	*f*-4	*f*-5.6	*f*-8	*f*-11	*f*-16	*f*-22
Relative Amount of Light	256	128	64	32	16	8	4	2	1

SHUTTER-SPEED SCALE

Standard shutter-speed settings are shown below. The exposure difference between adjacent speeds is one exposure step. The amount of light on film doubles as shutter speed doubles and halves as shutter speed halves.

Shutter Speed	1	2	4	8	16	30	60	125	250	500	1000
Relative Amount of Light	1024	512	256	128	64	32	16	8	4	2	1

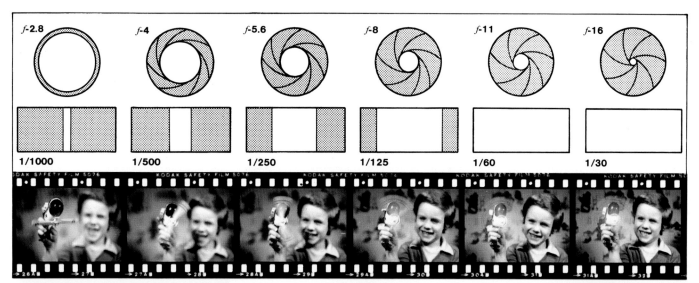

f-2.8	f-4	f-5.6	f-8	f-11	f-16
1/1000	1/500	1/250	1/125	1/60	1/30

▲ For any scene, there are different combinations of aperture and shutter-speed settings that give the same amount of light on film. The drawings at top show that with this example, a fast shutter speed is necessary with a large aperture. Conversely, with a slow shutter speed, a small aperture is used. There are also intermediate settings that give the same exposure. The strip of photos shows how subject blur and depth of field change with shutter speed and aperture.

After metering a scene, you should decide if a certain zone of sharp focus is important to the picture. For example, many landscapes look best if everything is in sharp focus. Some portraits are best if the person is in sharp focus and the background is out of focus. Choose the lens aperture that gives the depth of field you want in the picture. In this case, you make aperture your first priority. Then adjust shutter speed until the meter display indicates good exposure.

SEEING DEPTH OF FIELD

When you use an SLR, a good way to judge the effect of lens aperture on depth of field is to view the scene through the chosen aperture. To do this, push the depth-of-field-preview button if the camera has one. This button is on the lens or camera body.

When pushed, it stops down the lens aperture to the selected value. If you choose an aperture smaller than the lens maximum aperture, the viewfinder image darkens. The zone of sharp focus increases, depending on aperture. You can keep the button depressed and adjust lens aperture and the lens focusing ring until you get the effect you want.

Because the viewfinder image is small and the scene darkens, it is sometimes difficult to judge the zone of sharp focus exactly. Generally, you should use an aperture one step smaller than the aperture that *visually* gives the effect you want.

▶ This diagram illustrates how the depth-of-field scale on the lens shows the zone of sharp focus, depending on focused distance and lens aperture. You can see the same thing by observing the viewfinder image with the lens stopped down to the selected aperture by the depth-of-field preview control—if your camera has one.

At the maximum lens aperture of *f*-2, depth of field is minimal, as indicated by the depth-of-field scale on the lens.

At *f*-5.6, depth of field increases from about 1.6m to 2.8m (5.3 to 9.2 feet), with the lens still focused at 2m.

At *f*-16, depth of field is from 1.2m to 9m (4.0 to 30 feet) with the lens still focused at 2m. For maximum depth of field at any aperture, such as *f*-16, first set the infinity mark of the distance scale to the far-limit line indicating depth of field at *f*-16.

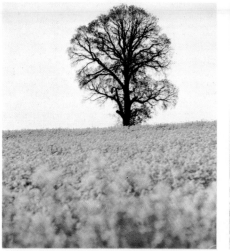

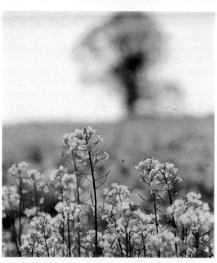

▲ With the lens set to maximum aperture, you can *selectively focus* on a subject because depth of field is narrow. This lets you emphasize different parts of the scene. For the picture at left, the photographer focused on the tree. The foreground is out of focus. At right, the tree and much of the landscape is out of focus when the photographer focused on nearby flowers.

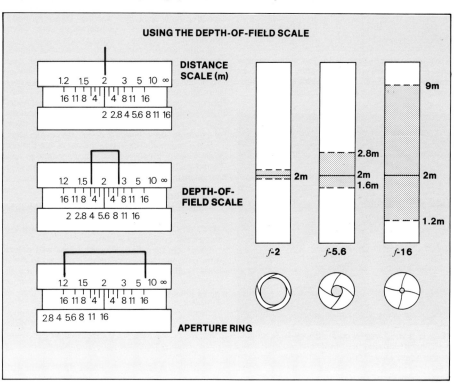

USING THE DEPTH-OF-FIELD SCALE

DISTANCE SCALE (m)

DEPTH-OF-FIELD SCALE

APERTURE RING

235

USING THE DEPTH-OF-FIELD SCALE

On most lenses a scale is between the aperture ring and the distance scale on the lens focusing ring. This is the *depth-of-field* scale. It tells you the zone of sharp focus, as determined by the aperture and lens-focus settings. The scale is marked with pairs of lines and numbers that correspond to the lens *f*-stops. The pair of lines that correspond to a certain *f*-stop point to the near and far limits of sharp focus on the distance scale. The distance scale has markings in feet and meters.

One way to use the scale is to focus on the near and far subjects that you want in focus on film. Note their distance as shown by the distance index, which points to the distance scale on the lens. Turn the lens-focusing ring until these distances are across from, or between, the lines corresponding to a certain lens aperture on the depth-of-field scale. Set the lens to that aperture, meter, set shutter speed, and expose film.

For maximum depth of field, set the infinity mark of the distance scale to the far-limit line for a certain aperture. The distance indicated by the focusing index is called the *hyperfocal distance* for that aperture and lens focal length. When the distance scale is set to the hyperfocal distance, the far limit of depth of field is infinity, and the near limit is half the hyperfocal distance.

HOLDING THE CAMERA

With slow shutter speeds the camera will shake if you handhold it during exposure. The resulting image may not be sharp.

As a rule, the slowest shutter speed you should handhold is the approximate reciprocal of lens focal length. For example, when you use a 50mm

Standing correctly can help you avoid camera shake. Stand with your legs slightly farther apart than shoulder width. Lean against a stable support when using slow shutter speeds.

Here is a good way to hold a 35mm SLR camera. Left hand focuses the lens and supports the camera and lens. The right hand grips the side. The right index finger pushes the shutter button. Notice how the elbows are tucked in for stability.

lens, you should be able to handhold the camera with shutter speeds of 1/60 second or faster. If you need to use a slower shutter speed attach the camera to a tripod or use some other firm support. With longer-focal-length lenses, the slowest handheld shutter speed is faster than 1/60 second. With wide-angle lenses, the slowest handheld shutter speed is slower than 1/60 second.

To hold a 35mm SLR, grip the side of the camera with your right hand and hold the camera to your right eye. Most people automatically close their left eye while viewing. Support the base of the camera with the palm of your left hand. Use the fingers of your left hand to control the lens focusing and aperture ring. During exposure, your left fingers support the lens. For extra stability, pull your elbows toward your body so they are in front of you.

After metering and selecting aperture and shutter speed, you are ready to take the picture. Before pushing the shutter button with your right index finger, hold your breath. Then *slowly* push the shutter button down. Don't jab the button because this will shake the camera.

When you push the shutter button, the viewing mirror swings up and blacks out the viewing image. The focal-plane shutter exposes film and the mirror swings back down, signaling you that exposure is finished. Hold the camera steady throughout this sequence of events. Resume breathing when exposure is finished.

CAMERA METERS

Current 35mm SLR cameras have a built-in light meter that measures the light after it passes through the lens. This is why these meters are called *through-the-lens* (TTL) meters. The meter automatically compensates for any light loss due to filtration or other light-reducing accessory attached to the lens. In addition, the meter sees what you see in the camera viewfinder. This simplifies exposure metering.

Cameras using TTL meters are of two basic types. With a *manual-exposure* camera, you set both shutter speed and lens aperture manually. A metering display in the camera viewfinder indicates when camera settings give good exposure. You can use the recommended exposure or set the camera for under- or overexposure.

Automatic-exposure cameras use a meter that sets shutter speed, lens aperture, or both for you automatically after metering. There are three automatic-exposure modes. *Aperture priority* means you set aperture, camera sets shutter speed. The camera sets shutter speed steplessly—it can choose standard or non-standard speeds, such as 1/386 second. Use this mode when depth-of-field considerations are most important.

Shutter priority means you set shutter speed, camera sets lens aperture. The camera can choose standard or non-standard *f*-stops, such as *f*-3.7. Use this mode when you need to select a certain shutter speed to control image blur. *Programmed* meters set *both* shutter speed and aperture steplessly. This is convenient for general-purpose photography or when you are in too much of a hurry to consider depth of field and image blur.

Some automatic-exposure cameras have more than one of these modes. These cameras are called *multi-mode.* Most automatic cameras also permit manual metering and camera operation.

FILM TYPES

There is a huge assortment of films you can use in your 35mm camera. In fact, so many are available that the choice can be confusing. There are three basic categories of film.

Color negative film reverses tones and colors after exposure and processing. It is used to make color *prints.* The negative has an overall orange color that does not appear in the print. Names for these films usually have the suffix -color, such as Fujicolor.

Color slide film yields correct tonalities after exposure and processing. It is also called *color reversal* or *transparency* film. Names for these films usually have the suffix -chrome, such as Agfachrome.

Color film is made to give best results with light of a certain color. *Daylight-balanced color film* is

designed to give best color reproduction when exposed to daylight at midday or electronic flash. When exposed to tungsten light, the film will have an orange cast.

Tungsten-balanced film is designed to give best color reproduction with photographic tungsten lights. When exposed to flash or midday light, the film will have a blue cast.

You can correct an expected color cast on film by exposing the film through a filter. See the table on page 238.

B&W film yields reverse black and white tonalities after exposure and processing. It is used to make b&w prints.

FILM SPEED

This is a set of numbers, called *ISO Speed,* that rate film sensitivity. It comprises both ASA and DIN film-speed ratings. An ISO 400/27° film has the same speed as an ASA 400 and DIN 27 film. With both ASA and DIN ratings, the bigger the

This photo was made with tungsten-balanced film and the correct type of tungsten light. Colors reproduce accurately.

Daylight-balanced film was used under the same light as above. This created an orange cast on film. You can avoid the color cast by using a blue 80A filter to absorb the excess orange light striking the film.

number, the more sensitive the film. In the ASA system, film speed doubles as sensitivity increases by one exposure step. In the DIN system, film speed increases by 3 as sensitivity increases one step. For example, an ASA 400 (DIN 27) film requires one less step of exposure than ASA 200

(DIN 24) film when used under the same lighting conditions.

FILM-SPEED RATINGS	
ASA	**DIN**
12	12
25	15
50	18
100	21
125	22
160	23
200	24
400	27
800	30
ISO Speed = ASA/DIN°	

LENS FOCAL LENGTH

This is the distance between the film and a certain location in the lens when the lens is focused at infinity. Use lens focal length as a guide to remind you how a lens will see a scene.

Focal lengths can be grouped into three main categories:

Short focal lengths	35mm and shorter
Medium focal lengths	40mm to 85mm
Long focal lengths	90mm and longer

A short-focal-length lens is also called a *wide-angle lens* because it has a wide *angle of view*—it sees a lot of the scene.

Angle of view increases as focal length decreases. Therefore, a 17mm lens has a wider angle of view than a 28mm lens, which has a wider angle of view than a 35mm lens.

A long-focal-length lens, usually called *telephoto,* has a small angle of view and seems to bring a faraway scene close-up. It magnifies the image more than a wide-angle lens. Image magnification increases as focal length increases. Therefore, a 300mm lens magnifies the image more than a 150mm lens.

A lens in the focal-length range from 40mm to 55mm is called a *standard* lens because most cameras are sold with this lens.

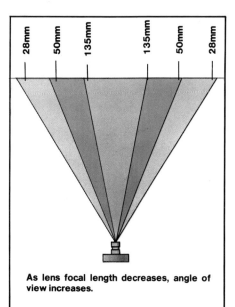

As lens focal length decreases, angle of view increases.

HOW FOCAL LENGTH AFFECTS MAGNIFICATION*

Relative Focal Length	Magnifi-cation	Relative Focal Length	Magnifi-cation
50mm	1.0	50mm	1.0
35mm	0.7	80mm	1.6
28mm	0.6	100mm	2.0
24mm	0.5	200mm	4.0
21mm	0.4	400mm	8.0
15mm	0.3	500mm	10

*This does not imply that a 50mm lens produces life-size pictures. These magnifications are *relative* image sizes, using the image produced by a 50mm lens as a reference.

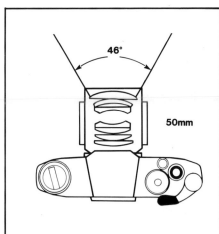

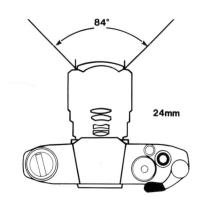

▲ When focal length doubles, angle of view decreases by half. Halving focal length doubles angle of view.

ANGLES OF VIEW FOR SOME LENSES

Focal Length	Angle of View
24mm	84°
28mm	75°
35mm	63°
50mm	46°
85mm	29°
100mm	24°
300mm	8°
500mm	5°
1000mm	3°

1000mm 3°

300mm 8°

135mm 18°

85mm 29°

50mm 46°

35mm 63°

▲ These photos were made from the same camera position. They show how image magnification increases with focal length. Telephoto lenses seem to bring the scene closer, and wide-angle lenses seem to push it away.

SELECTION CHART FOR COMMONLY USED FILTERS

FILM TYPE	DESIRED RESULT	LIGHT ON SCENE	VISUAL COLOR OF FILTER	HOYA	TIFFEN	VIVITAR	BDB FILTRAN	FILTER FACTOR (Approx.)
Any	Reduce UV exposure of film	Day	Clear	UV	Haze 1	UV-Haze	UV-Haze	1X
	Reduce amount of light 2 steps without affecting colors	Any	Gray	NDX4	ND 0.6	ND-6	ND4X	4X
	Reduce amount of light 3 steps without affecting colors	Any	Gray	NDX8	ND 0.9			8X
	Soften facial lines in portraits, soften lines in any image	Any	Clear	Diffuser	Diffusion Filter #1	Soft Focus	Soft Focus	1X
	Increase softening effect	Any	Clear	Soft Spot	Diffusion Filter #3			1X
B&W	Darken blue sky and sea, lighten clouds for contrast	Day	Light Yellow	K2	6	K2	Yellow	1.5X
	Stronger sky/cloud contrast, lighten yellow and red	Day	Dark Yellow		9	G-15		2X
	Outdoor portraits, natural reproduction of foliage	Day	Green	X1	11	X1	Green	2X-4X
	Improve contrast of distant landscapes, penetrate haze	Day	Orange	G	16	O2	Orange	3X
	Exaggerate sky/cloud contrast, dramatic landscapes	Day	Red	25A	25A	25(A)	Red	8X
Day-Light COLOR	Reduce blue effect of open shade, overcast days, distant mountain scenes, snow	Day	Very Faint Pink	1B	SKY 1A	1A	Skylight 1A	1X
	Warmer color in cloudy or rainy weather or in shade More effect than Skylight filter	Day	Pale Orange	81C	81C	81C	R1-1/2	1.5X
	Reduce red color when shooting daylight film in early morning or late afternoon	Day	Light Blue	82C	82C		B 1-1/2	1.5X
	Use with daylight film for shooting with clear flashbulbs at night or indoors	Clear Flash-bulb	Blue	80C	80C	80C	B6	2X
	Normal color when exposing daylight film under 3400K tungsten lighting	Tung-sten	Blue	80B	80B	80B	80B	3X
	Normal color when exposing daylight film under 3200K tungsten lighting	Tung-sten	Dark Blue	80A	80A	80A	80A	4X
	Reduce blue-green effect of exposing daylight film under fluorescent lighting	Fluor-escent	Purple	FL-D	FL-D	CFD	DAY FL	1X
Tung-sten COLOR	More natural color with tungsten film exposed by daylight in morning or late afternoon	Day	Amber		85C		R3	2X
	Natural color with tungsten Type A film exposed by midday sunlight	Day	Amber	85	85	85	85	2X
	Natural color with tungsten Type B film exposed by midday sunlight	Day	Amber	85B	85B	85B	85B	2X
	Reduce red effect of shooting tungsten films under ordinary household incandescent lights	Incan-descent	Light Blue	82C	82C		B 1-1/2	1.5X
	Reduce blue-green color effect of shooting tungsten film with fluorescent lighting	Fluor-escent	Orange		FL-B	CFB	ART FL	1X

NOTE: Filters made by different manufacturers are not represented to be exact equivalents even though labeled the same or designated for the same purpose. These filters should be approximately equivalent and satisfactory for the indicated uses. Filter factor may vary with brand.

Back Cover Photo:
Mike and Carol Werner.